# SEARCHING FOR THE
# SNOW LEOPARD

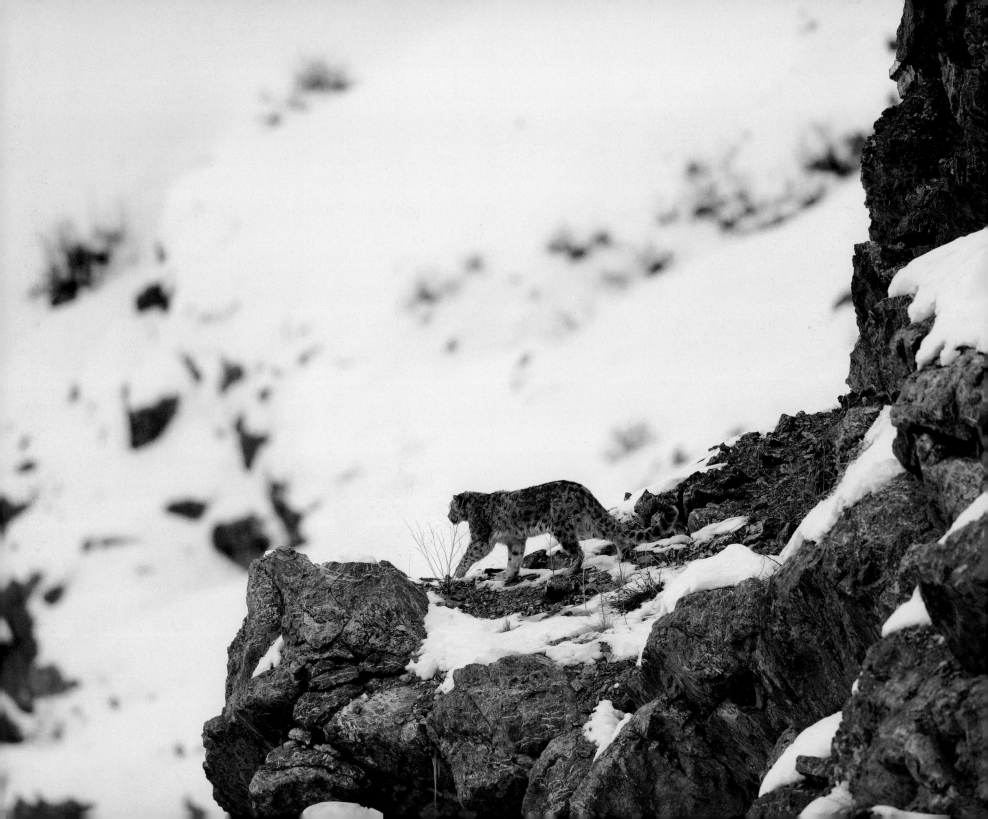

# SEARCHING FOR THE
# SNOW LEOPARD

## Guardian of the High Mountains

Edited by

## SHAVAUN MARA KIDD

with BJÖRN PERSSON

Foreword by RODNEY JACKSON

IN PARTNERSHIP WITH THE SNOW LEOPARD CONSERVANCY

Arcade Publishing • New York

First Edition

Arcade Publishing books may be purchased in bulk at special discounts for sales promotion, corporate gifts, fund-raising, or educational purposes. Special editions can also be created to specifications. For details, contact the Special Sales Department, Arcade Publishing, 307 West 36th Street, 11th Floor, New York, NY 10018 or arcade@skyhorsepublishing.com.

Arcade Publishing® is a registered trademark of Skyhorse Publishing, Inc.®, a Delaware corporation.

Visit our website at www.arcadepub.com.
Visit the Snow Leopard Conservancy's website at snowleopardconservancy.org.

10 9 8 7 6 5 4 3 2 1

Library of Congress Cataloging-in-Publication Data is available on file.
Library of Congress Control Number: 2020937402

Cover design by Erin Seaward-Hiatt
Cover photographs: Oriol Alamany (front) and Tashi Ghale (back)

ISBN: 978-1-950691-67-8
Ebook ISBN: 978-1-951627-26-3

Printed in China

*This book is dedicated to the memory of renowned mammalogist Jeanette Thomas, professor emerita of Western Illinois University. As a scientist, she conducted groundbreaking work in bioacoustics and echolocation with marine mammals and bats. As a teacher, through her imparted wisdom and guidance and the trust and belief she placed in her students, Dr. T was an inspiration and a driving force, enabling them to succeed.*

*Thomas was a vocal proponent for women in science, having been influenced by her personal experience. Her original desire was to study snow leopards in the wild, but in the 1970s, she was strongly discouraged and was told it would be too difficult for a woman. Undeterred, she instead focused her doctoral studies on Weddell seals, which took her to the Antarctic, a part of the world as inhospitable yet equally as beautiful as that inhabited by the snow leopard.*

*It is because of passionate and dedicated individuals like Thomas, who are fascinated by wild creatures and seek determinedly to understand them, that so many imperiled species like the snow leopard continue to thrive.*

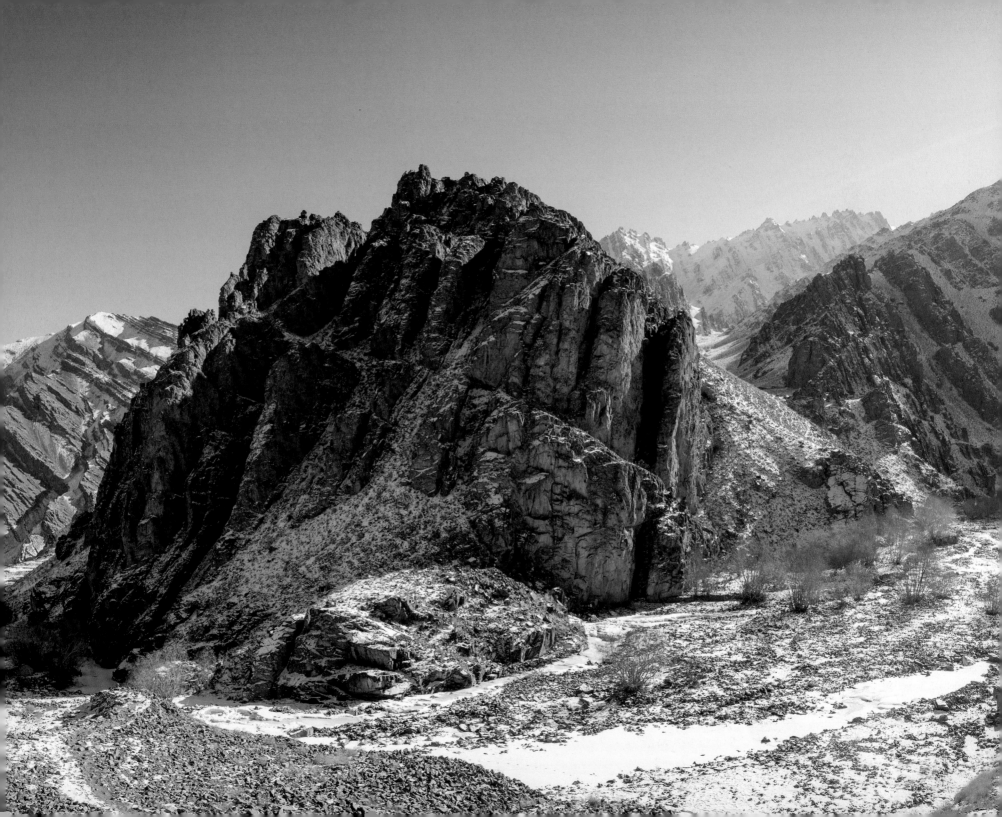

# CONTENTS

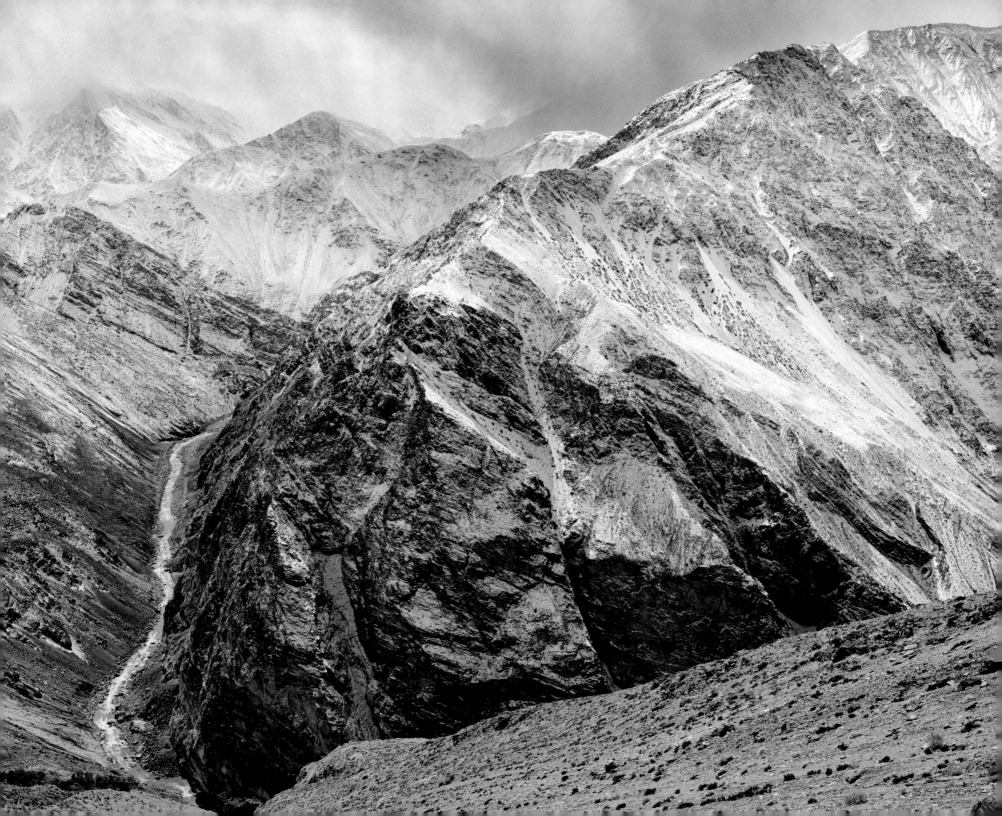

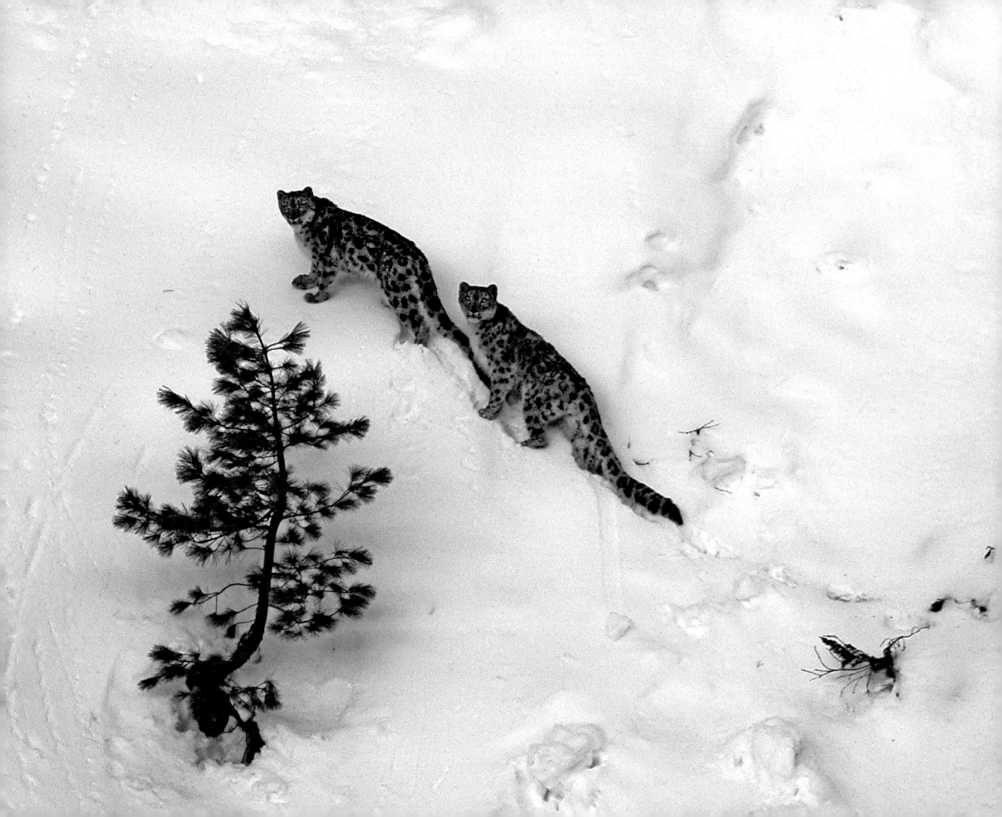

# FOREWORD

Iam delighted and honored to introduce this volume of
extraordinary essays and photographs from the men and
women who have left the comforts of home for weeks on
end and stretched their limits to go in search of the elusive
snow leopard.

The images and stories within these pages are unique
among publications about snow leopards. They eloquently
portray the challenges facing animals living at altitudes
above 15,000 feet, where temperatures can shift fifty
degrees or more in a few hours, amid the vicissitudes of
long, snowy winters and the draining heat during the short
summers. The writers and photographers collected here
bring you closer than most humans ever get to knowing
snow leopards and understanding why these beautiful big
cats have for so long been considered the most elusive and
mysterious of all.

I have devoted more than forty years of my life to stud-
ying and working for the conservation of snow leopards.
As you will discover in this book, much has changed since
the days when trail cameras used film and were triggered
by a pressure pad buried in the ground: those were the
days before fax machines, cell phones, the internet, and

Facebook.[1] But what hasn't changed is how a person feels,
whether man or woman, young or old, on seeing a snow
leopard roaming wild and free in its natural habitat. How
far you might be away from the cat really makes little dif-
ference—it's always an unforgettable experience, a magical
time long remembered.

That's what this book is about, really. But don't just
look at the pictures—read the text. And imagine your-
self in the mountains, seeing a snow leopard for your first
time!

There are times when the challenges for conservation,
especially in the face of increasing human populations,
development, and global warming, can be frustrating,
depressing, and daunting to the point of wanting to give
up. So I am heartened to see these photos and read of the
deeply personal encounters. They're an antidote, and they
give us all hope. They speak to something more than data
gathering; they speak to the spirit of the snow leopard.
They remind me of the adage: it's not what you know that
makes the difference but how you feel and what moves you
toward making the world a better place, for snow leopards
and humans alike.

Scientists recognize the snow leopard as an apex predator, a symbol of the mountain ecosystems of Asia. In southern Siberia, snow leopard is a clan and community protector; it is seen as a unifier of humanity. The spiritual form of snow leopard can choose to be seen or not. I hope it will be perceived as a force encouraging *all* humans to change destructive activities that harm wildlife and habitats and adversely affect those who depend on the mountains for their well-being, for critical resources like water, and for providing home territory to diverse, culturally rich peoples.

Back in 1982, when I had just sedated the first of five snow leopards ever to be radio-collared, I sank my fingers deep into his fur and took a precious moment to acknowledge his wildness and my responsibility for his welfare. I did not appreciate at the time that what I was feeling was a spiritual reaction to a momentous experience. That realization came many years later, in Mongolia.

It was during a particularly trying attempt to collar a snow leopard on a mountain in the Gobi Desert. Needing some time alone, walking away from the camp, I noticed a small boulder embedded in the sand. It was unlike any other boulder I had seen, with the markings of a serpent so plain I could not possibly have missed it. I went back for my camera, but when I returned to the spot, the boulder was gone. Being the scientist, I then walked several transects to try to find it again, but no luck. The more I searched, the more I realized that the boulder had vanished as mysteriously as it had shown itself, just like the elusive snow leopard.

Suddenly, a deep but tremendously calming wave swept over me, and I knew I was being sent a message to let go of the angst, that everything would be okay. And the next day, we put a collar on the resident male snow leopard, who shared his travels with us until the collar dropped off just one year later.

Thanks to its beautiful pelage, the snow leopard blends into the landscape and easily disappears into thin air. During our time in Nepal, we very rarely saw even one of our radio-collared cats. To this day, despite many thousands of field hours exploring all but one of the snow leopard countries, I have seen wild snow leopards fewer than forty times.

Digital trail cameras have been game changers, opening our eyes to the snow leopard's realm like never before, but it is also a fact that decades of conservation education and action have led to increased sightings of wild snow leopards and contributed to the capturing of the images in this book. Where not harassed, snow leopards are much less likely to hide upon spotting a human walking up the trail toward them.

But it's not enough that we can now see snow leopards more readily than ever, at least in places like Ladakh (India), Manang (Nepal), or parts of western Mongolia. In many regions of the world, we humans are losing our connection to nature, forgetting that we are not apart from, or above, the plants and animals that make our planet livable.

The Snow Leopard Conservancy has been privileged to facilitate a groundbreaking program, Land of the Snow Leopard Network (LOSL), composed of indigenous cultural practitioners such as shamans, sacred site guardians, religious leaders, and community-based conservationists, who include herders and teachers. New educational initiatives are being put forward by LOSL's spiritual leaders. These initiatives are aimed at reviving traditional ecological knowledge and restoring our connections to the natural elements and cycles of our world.

While snow leopards were reclassified from "endangered" to "vulnerable" several years ago, we cannot let up in our conservation activities. Snow leopards still need our help, and this book is intended to serve that purpose, inspiring you, the reader, to see snow leopards—and indeed the animals in your own backyard—in a new light of appreciation. Everyone can contribute to conservation! We invite you to share this book, spread the word, visit one of the twelve wonderful countries where people are working to coexist with snow leopards, make a donation, or sign up for our monthly newsletter.

On behalf of the Snow Leopard Conservancy, I wish to extend deep appreciation to all the contributors to this book for sharing their artistic and literary skills.

RODNEY JACKSON
FOUNDER/DIRECTOR
SNOW LEOPARD CONSERVANCY
APRIL 2020

# PREFACE

Nothing seemed extraordinary about an email I received in early May 2017. Darla Hillard, the education director and my supervisor at the Snow Leopard Conservancy, was writing to let me know that she'd volunteered me to work on a new project with our Australian snow leopard ambassador, Margaret Gee. She told me she thought it would be "right up my alley," but I was free to decline. Yet even after reading "you'll be on your own with this one," I eagerly accepted, not fully realizing where my hastily typed acceptance would lead.

One of the best parts of working with the Snow Leopard Conservancy is having the opportunity to be involved in a wide variety of unique projects that challenge me and allow me to work independently while being part of a fantastic organization. As on a snow leopard trek, I never know what exciting new adventure lies around the next corner, and I look forward to it.

Mine is a unique situation, in that I live halfway across the country from the Conservancy offices. It logically follows that what I do revolves around the internet. Having begun as an education intern while in grad school, I was brought on board after graduation to handle the social

media accounts, including production of the e-newsletter; to work on occasional special projects; and to continue with educational outreach. As fate would have it, I've been fortunate to be able to do all that plus much more. And when I learned the nature of this assignment, I was thrilled that Darla had sent such an exciting new project my way.

Margaret, a literary agent, had approached Darla about collaborating on a snow leopard–themed children's book on behalf of the Conservancy. Her idea was to put together a short collection of photographs where children would have the opportunity to "seek and find" a snow leopard in the wild. The images would also be accompanied by an informative text. As an outreach educator, "looking for a snow leopard" was an activity I was familiar with, and one I knew children of all ages enjoyed. Creating such a book sounded wonderful. Since I'd just had the opportunity to work with two outstanding photographers, Oriol Alamany and Björn Persson, on articles for a recent edition of our newsletter, I assured her I'd be able to obtain exactly the type of photos she was looking for. And without another thought, I jumped right into the proverbial deep end of the pool.

I began by contacting both photographers, and they agreed without hesitation to participate. Oriol and Björn are passionate conservationists and were eager to know what they could do to help. I mentioned that I'd thought of incorporating the articles they'd written for the newsletter and wondered if they would be willing to write one or two more essays for the book in addition to contributing photographs from their recent expeditions.

Björn's original essay was a reflection on his personal experience looking for and finally encountering a snow leopard. I felt this was where we could go with the theme of the book. Then Björn made a suggestion that would forever change our focus. He proposed that we should use only manually taken photographs of wild snow leopards and not include photos of captive animals. I had already started to gather photos of captive as well as wild snow leopards, as they're equally beautiful and portray both the mystery and the majesty of the big cat. I'd also planned to use some of the Conservancy's images obtained through camera-trap technology. But I had to agree with Björn: despite the importance of camera-trap images to scientific research, using only those photographs taken when the photographer was in the presence of a snow leopard in its natural setting would best exemplify the message of personal experience.

Remarkably, in one email exchange, the vision of a small children's activity book had grown into a full-length text for all ages, one that would explore what it was like to look for and be in the presence of a snow leopard in the wild and, inspired by Björn's original essay, one that carried with it a message about our human connection with this elusive species.

The core of the book would remain a section for the reader to "seek and find" the snow leopard. But now the essays and photographs would tell the story of the journey from the perspective of the searcher. My job would be to provide the natural history of the snow leopard and information about conservation. Björn offered to contribute to the text, and from there our book started to take shape.

I soon realized that my little pool was beginning to take on Olympic proportions and that I needed to increase the size of my team. So I approached an artist and writer from Canada, Susan Leibik, who shared our love of snow leopards and had previously collaborated with the Conservancy. She would contribute both a beautiful drawing and a story based on her experience of looking for a snow leopard.

I also contacted one of our range-country partners, Tashi Ghale. Tashi, a naturalist, has spent his life living in the mountains of Nepal, working with local conservation NGOs. He was introduced to camera-trap technology by Snow Leopard Conservancy founder and director Rodney Jackson. Since then, he's become an outstanding and recognized wildlife photographer. Notably, he obtained camera-trap images that showed, for the first time, evidence of the Pallas's cat being present in Nepal.

Although Tashi is a native of a country in the snow leopard's range, he has recorded a limited number of live sightings, with only his fifteenth occurring in February 2020. While that may not seem so unusual given the shy nature of the snow leopard, what is truly remarkable is

the close proximity from which he's able to obtain his photos. Whether that's attributable to his skill and experience or to the very personal connection he has with his mountain home, Tashi is allowed into the secret world of the snow leopard. I knew his would be an invaluable contribution.

Continuing my search, I asked independent snow leopard researcher Katey Duffey if she'd be interested in participating. I'd read her blog and was convinced that her straightforward and entertaining writings would be a terrific asset to the text. She would add a different yet essential perspective to the story that would shed light on the reality that not every snow leopard expedition ends in sightings and pictures of the big cat. Although she's not a professional photographer, I asked Katey for photographs. She had some documenting her work, but I was excited to hear she would contribute some taken of people and domestic animals who live with snow leopards as their neighbors. We needed to include images of the human element to tell the whole story.

To round out the team, I contacted photographer Jak Wonderly, who had just completed a successful expedition to India to photograph the snow leopard on behalf of the Conservancy. His experience was quite different from what most people imagine when they dream of seeing the snow leopard in the wild. His story and the photographs that accompany it lend themselves to a serious discussion about the human-predator conflict that exists between apex predators like the snow leopard and local people and the need to find a way to resolve it. But that same story also reveals a kinship we have with the mysterious feline predator that stalks the high Asian mountains. Jak's participation was meant to be, as his contribution brought the two ends of the conservation spectrum together—scientific and traditional knowledge.

Once Jak was on board, our team was complete. Although, at times, bringing them together was like herding cats, their contributions complemented each other remarkably as we worked to create this book. From their unique perspectives and styles representing a broad spectrum of backgrounds and bodies of work, it might seem unlikely that their stories would be so similar. But they all shared one thing: personally experiencing that singular, ethereal connection humans have with the snow leopard. And though we may never fully understand it, that connection signifies the cultural importance of this big cat and provides a strong motivation to preserve it.

SHAVAUN

# ACKNOWLEDGMENTS

There are many people we would like to acknowledge for helping to make this book a reality.

First, we would like to thank Margaret Gee for her inspiration, continued guidance throughout the process, and determination to bring our project to fruition—she is an amazing ambassador for the snow leopard. Likewise, we are fortunate to have had the opportunity to work with Cal Barksdale of Skyhorse Publishing and are grateful for his gifted editorial eye.

Most importantly, we would like to extend our thanks to Katey Duffey, Oriol Alamany, Eulàlia Vicens, Jak Wonderly, and Tashi R. Ghale for graciously donating their photography and writings to this endeavor and for their personal dedication to conservation. They are individually making a difference for so many wildlife species in peril.

We would also like to recognize Susan Leibik for her literary contribution and the use of her charcoal drawing, *Shan*, that artistically exemplifies the beauty, power, and mystery of the snow leopard.

And we would be remiss if we did not acknowledge the guides who lead our expeditions into the mountains in search of snow leopards. Without their assistance, these treks would have been much more difficult if not impossible. Familiarity with the terrain together with their significant knowledge of and skill at locating local wildlife were essential to the successes of the various expeditions. We salute them for their enormous contribution to conservation.

Finally, to Rodney and Darla, who many years ago went in search of the Guardian of the High Asian Mountains and who have continued to devote their lives to its study and survival, we cannot express our appreciation adequately. They have been and remain an inspiration for conservationists worldwide. We are honored by their participation and the opportunity to follow in their footsteps as they lead the way in protecting the magnificent snow leopard.

SHAVAUN AND BJÖRN

# SEARCHING FOR THE
# SNOW LEOPARD

Shrouded in the swirling snow, she magically appears, climbing effortlessly across the high ridge. Her presence is felt even when not seen. The humans who have gone in search of her know they are not alone. She is there—watching, guarding, unseen in her frozen realm of rock and snow.

# INTRODUCTION

## Why Snow Leopards?

Beyond the ecological importance of a top predator like the snow leopard, there is something inherently mystical that draws us to these powerful big cats. Their ability to survive in one of the world's harshest climates, combined with their beauty and ethereal quality, has been the impetus for humans to not only respect and admire them but also revere them. Over the centuries, the snow leopard has become part of local culture and traditions and has been elevated to the position of a "sacred species." This elusive cat is considered by indigenous wisdom to be "a protector of sacred mountains, a unifying force and a source of spiritual power and wisdom."[2]

## Transforming Knowledge into Solutions

As a top predator competing for resources in today's world with other predators, in particular humans, the snow leopard species is not guaranteed to survive despite its cultural status. A necessary step in its preservation is creating awareness of the snow leopard's ecological as well as cultural importance. To do this, we need to develop

*Shan*

a solid, inclusive knowledge base about this big cat that defines both the positive effect the snow leopard's presence has upon its ecosystem and the significant role it plays in the culture of indigenous people.

*Snow Leopards*, a volume in the series *Biodiversity of the World: Conservation from Genes to Landscapes* is a collaboration of snow leopard experts from around the world. It presents a thorough synopsis of the current knowledge about snow leopards. But, as renowned biologist and conservationist George Schaller notes, the information we have is incomplete, and if we are to understand what the snow leopard needs to survive, there is still much to learn.[3]

## A Slow and Difficult Beginning

Over the last thirty years, we've increased our knowledge about the snow leopard,[4] but we've only just begun to scratch the surface. The species' elusive nature and large home ranges are certainly a deterrent, but there are other factors that have limited study. Snow leopard research is daunting. Together with the expense and complicated logistics are the physical challenges. The severity of the environment has discouraged many a researcher. The high altitude, the extreme cold, and the rigors of mountain trekking are not for everyone.

In the early days of snow leopard research, political barriers were often more impenetrable than the mountains themselves.[5] Border disputes between countries, civil uprisings, limited accessibility, and permits that were difficult if not impossible to obtain were serious roadblocks.

In addition, confrontations with military patrols and ever-changing rules and regulations, compounded by bureaucratic suspicion, limited the study of snow leopards.[6]

Significant research wasn't performed until George Schaller led an expedition to Pakistan in 1970 to study an important caprid prey species of the snow leopard, bharal (*Pseudois nayaur*),[7] a relative of the goat with sheep-like traits[8] that is commonly referred to as blue sheep because of the bluish tint of its coat. When Schaller wrote about his initial encounters with the "ghost cat" in a 1971 *National Geographic* article[9] and later in his book *Stones of Silence*, the snow leopard finally made its debut on the world stage.[10] In 1973, naturalist Peter Matthiessen accompanied Schaller on a subsequent trip to the Dolpo region of Nepal. Although Matthiessen never saw more than a paw print, his National Book Award–winning *The Snow Leopard* was an inspiring look into the spiritual aspects of working in the land of the snow leopard that created a desire for many to know more about this fabled cat.[11]

In January 1982, biologist Rodney Jackson began three and a half years of research in the mountains of Nepal after receiving the 1981 Rolex Enterprise Award for his proposal to radio collar and study snow leopards in the wild.[12] A June 1986 *National Geographic* cover story documented his success at being the first to implement VHF radio collar technology with this species.[13] The monitoring of five cats produced an extensive body of information on diet, preferred habitat, home range size, abundance and density, and marking behaviors that are specific to the snow leopard.[14]

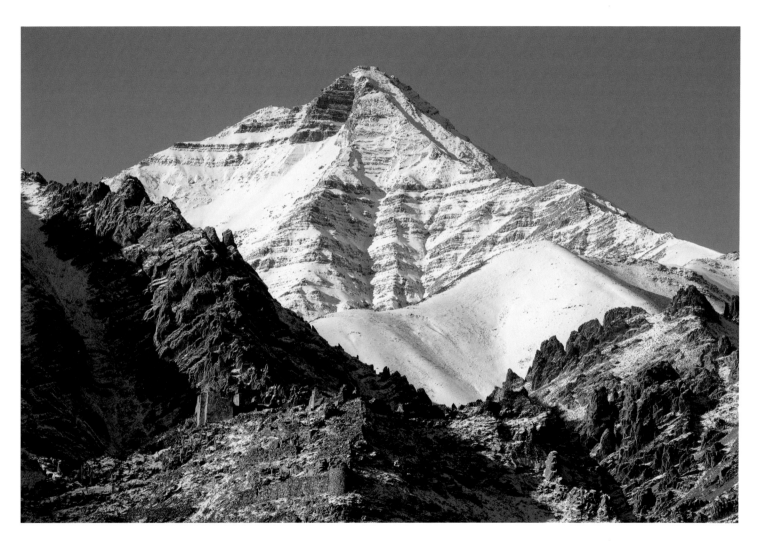

Following Jackson's work in the field, biologist Tom McCarthy conducted a four-year study in the 1990s in the Gobi Desert of Mongolia.[15] Since that time, snow leopard research has steadily continued, albeit slowly. Today, with more than a dozen conservation organizations that focus in part or entirely on snow leopards,[16] work proceeds in only a small portion of their range, and researchers face many of the same difficulties today as those encountered

decades ago. However, they are undeterred. The challenges they face, together with the air of mystery that surrounds the snow leopard, only seem to inspire them in their work.

## The Intricacies of Snow Leopard Conservation

Conservation of wildlife is not a simple endeavor. It begins with research to gain an understanding of what a species needs to survive, but there are other considerations. The next step is to identify the effect that the presence of humans has on the imperiled wild animal—and, conversely, how that particular animal affects human communities, both economically and culturally. Finally, the conservationist seeks to create solutions to neutralize any negative impacts while capitalizing on the positive, with the understanding that what works for one community may not work for another.

With all this in mind, it became clear that more than individual efforts would be required to save the snow leopard, whose range extends over twelve diverse countries. So, in 2013, the first Global Snow Leopard and Ecosystem Protection Program (GSLEP) forum was held. All twelve of the snow leopard range countries participate in GSLEP, which, according to their website, "seeks to address high-mountain development issues using the conservation of the charismatic and endangered snow leopard as a flagship."[17] To do this, GSLEP brings together both governmental and nongovernmental organizations with representatives from the local communities, including spiritual leaders.

## Local Community Involvement

By working with the local communities, whose main source of income is the raising of sheep and goats, conservationists have been able to gain an understanding of the difficulties of coexisting with an apex predator.[18] The human-predator conflict poses a significant threat to the survival of the snow leopard, and conservation measures are focused on its mitigation.[19] Conflict stems mostly from livestock losses that have been incurred due to depredation, although equally at play is the perception of a potential threat to livelihood.[20] On the other hand, many factors influence people's tolerance of the big cat, including "religious beliefs, income status, and educational level."[21] Reinforcement of cultural and spiritual traditions can, therefore, help to bring about a change in attitudes so the snow leopard is thought of in a positive light rather than as a nuisance or a threat,[22] but that's only a starting place. To ensure long-term success, it's important to create a feeling of ownership within the rural communities. Encouragement of participation in community-based conservation initiatives empowers the local people and leads to better coexistence between humans and the snow leopard.[23]

A variety of strategies have been implemented in snow leopard range countries.[24] Community-managed insurance and credit programs lessen the negative economic impact of depredation by snow leopards.[25] Alternative sources of income such as homestays, snow leopard treks, and the sale of handicrafts reduce economic dependence on livestock.[26] In addition, improved methods of animal husbandry, including predator-proofing corrals[27] and engaging

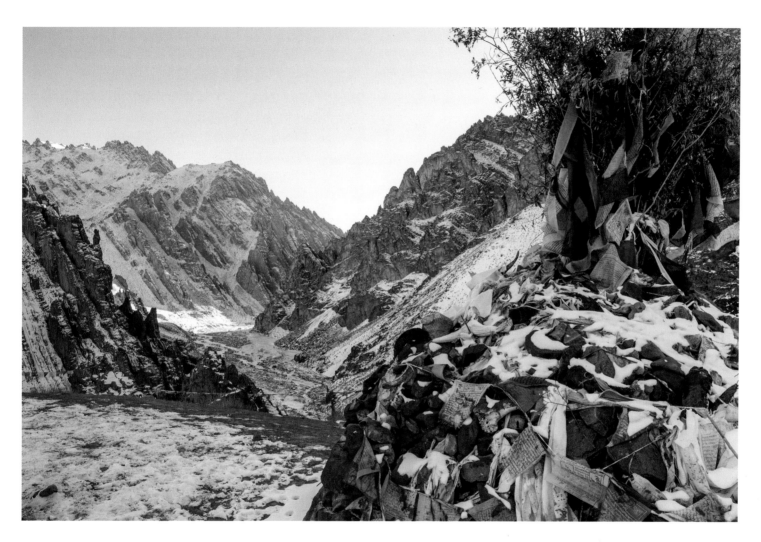

in thoughtful pasture and grazing management,[28] directly mitigate conflict and reduce losses. As there is a general lack of knowledge about the snow leopard, both locally and worldwide,[29] conservationists also focus on creating awareness through educational outreach.[30] The snow leopard remains less familiar than other charismatic felid species such as the tiger or lion, which often results in less funding and ineffective laws for its protection.[31] Thus, education plays an important role in securing a future for the snow leopard.

## Aspects of Working in the Snow Leopard's Range

Inherent to snow leopard conservation is the unique experience of searching for one. While the focus may be on working with people, the hope is to have an opportunity to see this elusive cat in its natural habitat.

A trip to snow leopard territory takes extensive planning, but unanticipated obstacles do still arise. Unless you've been there before, it's difficult to know how you will handle the rugged terrain and high elevation, not to mention the remoteness, intense quiet, and feeling of isolation. You can pack warm clothing and sturdy boots, but those won't prepare you physically or mentally for surviving at the roof of the world. Enduring the challenges often transforms a snow leopard trek into one of personal discovery. Some gain an enhanced appreciation of nature. For others, there is a realization of how we humans fit into the ecological picture.

The indigenous communities of the high Asian mountains represent a broad cultural diversity, yet there is a commonality of understanding of their relationship with the environment.[32] The members of those communities recognize that their culture and spirituality are interwoven with the natural world.[33] Simply put, people are a part of nature.

This perspective may be unfamiliar to visitors. Many of us who live in more urban settings experience nature with a sense of detachment, viewing it from within the confines of a zoo or botanical garden. There is also a disregard for our natural world, along with increasing attempts to control it or exploit it in pursuit of economic gain.[34] But for those living in one of the most rugged and remote landscapes on the planet, survival requires working with instead of against the elements. As Kamil Mamadaliev, an indigenous cultural practitioner from the Altai Republic, says, it is our responsibility to care for the environment and protect it as it has provided for us.[35]

For trekkers, having an opportunity to experience this relationship firsthand and perhaps rediscover the human connection to nature can be illuminating and inspiring, especially when that connection extends to the snow leopard itself.

## Sharing the Experience

The stories and images that follow are from conservationists and photographers who have traveled to the high mountains of Asia to study and photograph the snow leopard. They are a recreation of their personal experiences. Interwoven with their stories are the knowledge they have gained through painstaking observation and their reflections on what it will take to save this iconic species.

Accompany them as they learn firsthand about the life of the snow leopard; experience what it is like to search for one against a background of rock and snow; and explore the intangible connection between humans and this sacred cat.

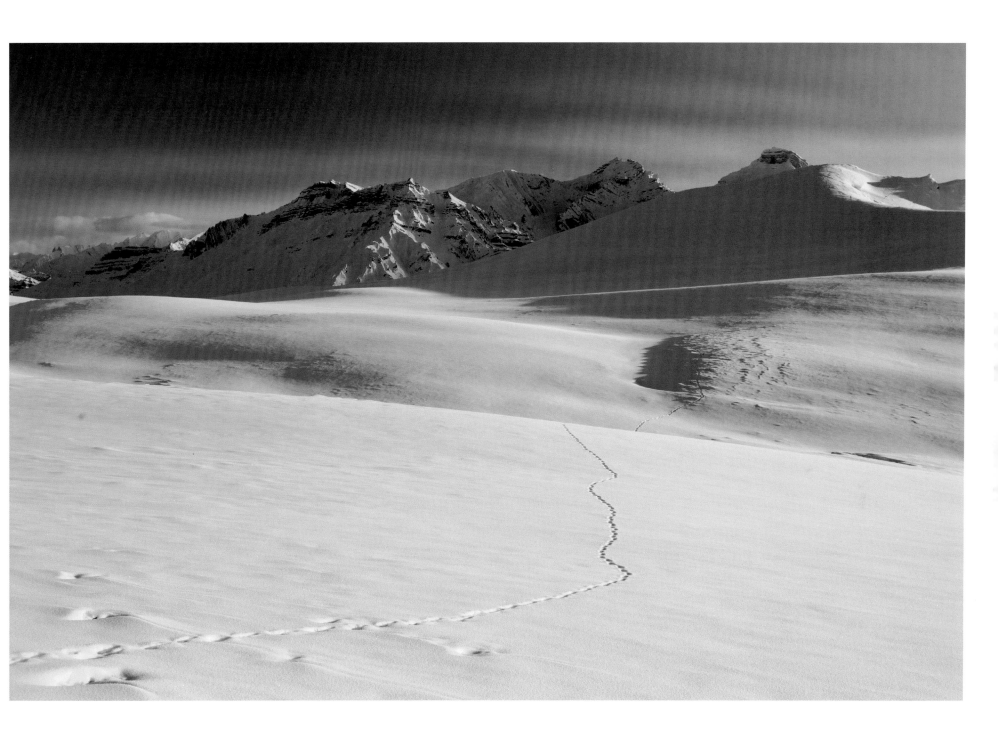

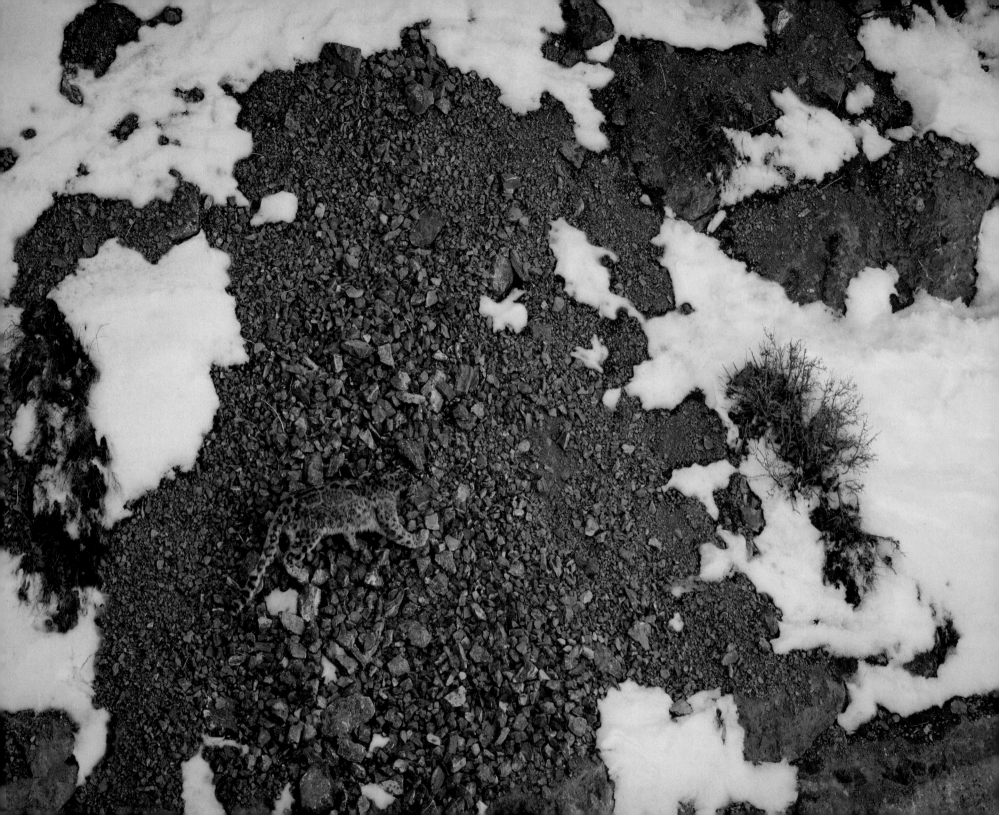

# THE CHALLENGE

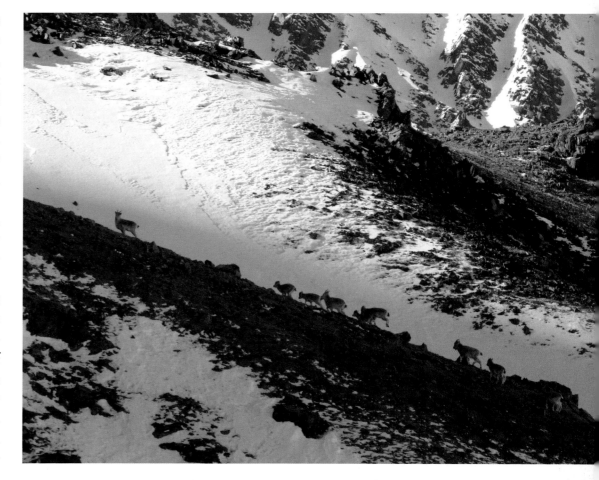

Of the iconic terrestrial predators, *Panthera uncia*, the snow leopard, remains one of the most difficult to locate, observe, and film. A member of the genus *Panthera*, which also includes the leopard, jaguar, lion, and its closest phylogenetic relative, the tiger,[36] only the snow leopard lives at extremely high elevations. Because of a unique physiological ability, it can tolerate low-oxygen conditions. In the Himalayas, the snow leopard is found above 10,000 feet and upward to 18,300 feet when crossing high passes, while in Mongolia it may range as low as 3,000 feet. Typical elevations for the big cat on the Tibetan-Qinghai Plateau are above 14,000 feet.[37] There, among the rocky and boulder-strewn landscape that provides perfect cover for hunting, the snow leopard is at home.

However, the snow leopard is not the only felid that inhabits the mountains of Asia. *Panthera pardus*, the common leopard, is occasionally seen on camera-trap photographs above 3,000 feet, within the lower elevations of the snow leopard's range.[38] Although both species are able to survive at this elevation, the common leopard is better adapted to living at lower elevations in the forest[39] and savannah, whereas the snow leopard's hunting method is more suited to a steep and rugged terrain, defined by

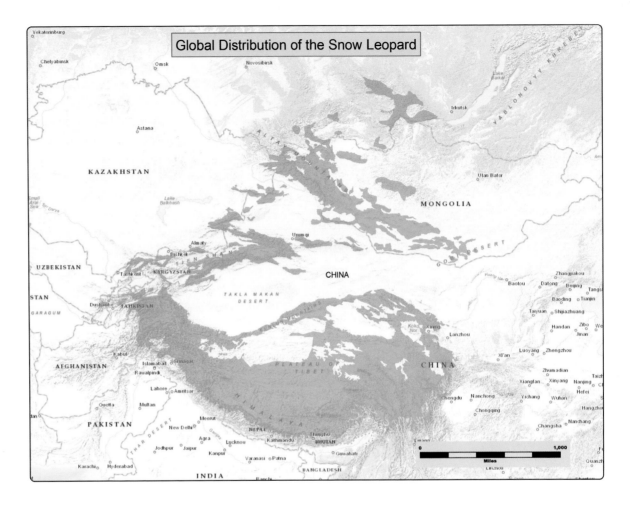

Global Distribution of the Snow Leopard

cliffs, ridges, and gullies.[40] *Panthera tigris*, the tiger, also shares a small portion of the lower elevation of the snow leopard's territory in Bhutan,[41] the only country where all three of these big cat species occupy the same habitat.[42] A smaller felid species, the Eurasian lynx, is found across much of the snow leopard's range up to about 14,500 feet but, like the common leopard, is a forest dweller.[43] There are several other small felid species that occupy parts of the snow leopard's range, among them the diminutive and little-known, five-to-ten-pound Pallas's cat,[44] which

lives in a variety of habitats from grass- and shrublands to deserts at altitudes of 5,000 to 16,500 feet.[45]

As an inhabitant of the high mountains of Central Asia—the Altai, Tian Shan, Kun Lun, Pamir, Hindu Kush, Karakorum, and Himalayas—the snow leopard lives at the roof of the world,[46] where its territory encompasses a vast landscape of more than 1.2 million square miles[47] and includes the twelve countries of Afghanistan, Bhutan, China, India, Kazakhstan, Kyrgyzstan, Mongolia, Nepal, Pakistan, Russia, Tajikistan, and Uzbekistan.[48]

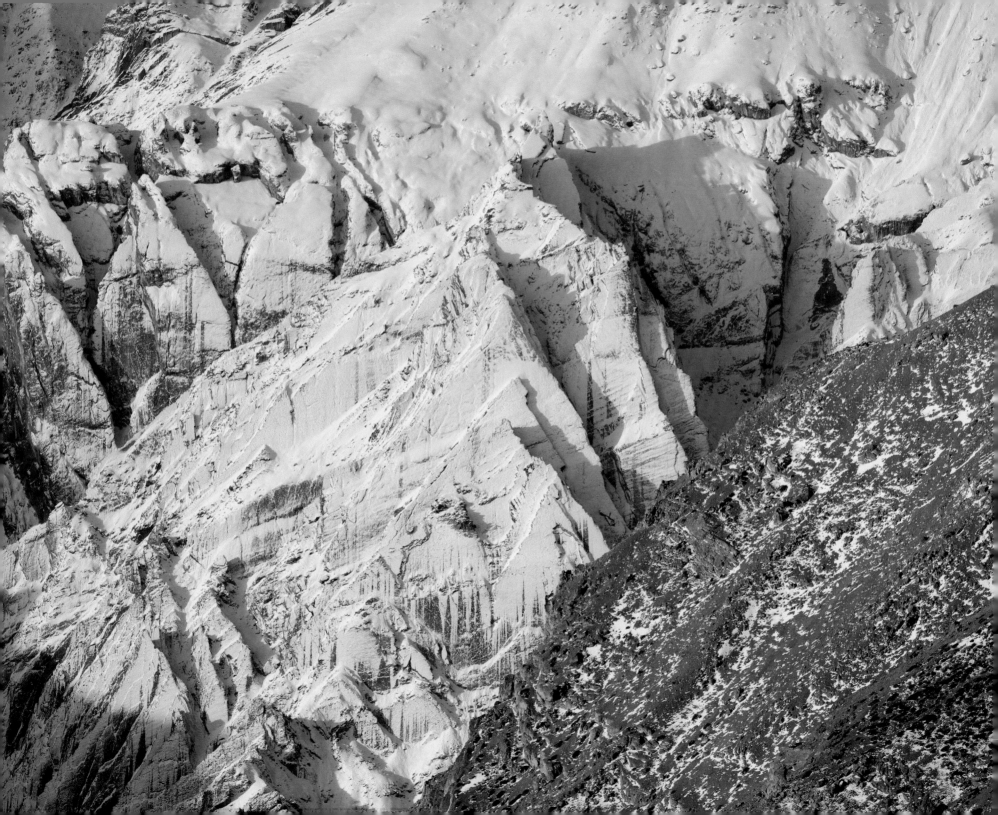

The high altitude and rugged terrain might seem enough to dissuade most who yearn to see a snow leopard in the wild, but there are more obstacles to consider: temperature extremes, unpredictable weather conditions, limited electronic communication, precarious footing, and even possible illness or injury. Not to mention that the logistics of obtaining funding, applying for visas, hiring guides, securing park permits, and arranging for transportation, supplies, and accommodations make locating and filming the snow leopard one of the most difficult endeavors a photographer can undertake.

But the rewards more than outweigh the difficulties.[49] To locate and photograph this elusive predator in the wild is the ultimate accomplishment.

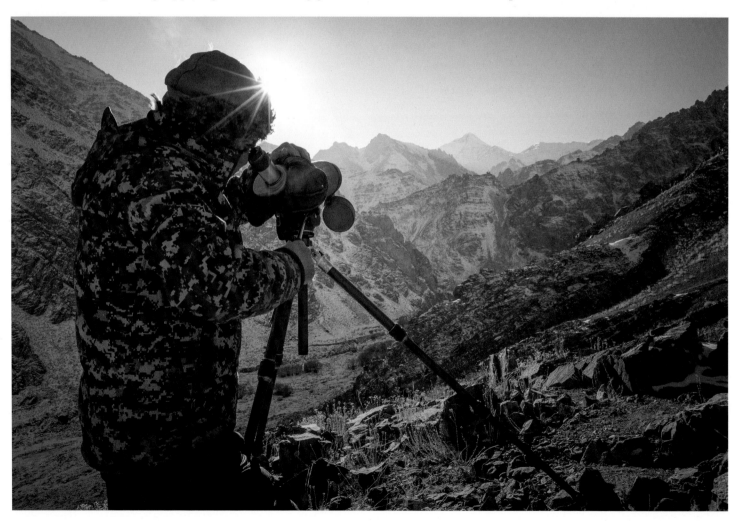

Success is not guaranteed, however. There's no promise, after months of planning and weeks of sitting on top of mountain ledges in the brutal cold, that the photographer will have even one moment to observe this perfectly camouflaged feline. Many return home with nothing in their cameras but pictures of sheep and goats, expansive landscapes, and perhaps a footprint or two.

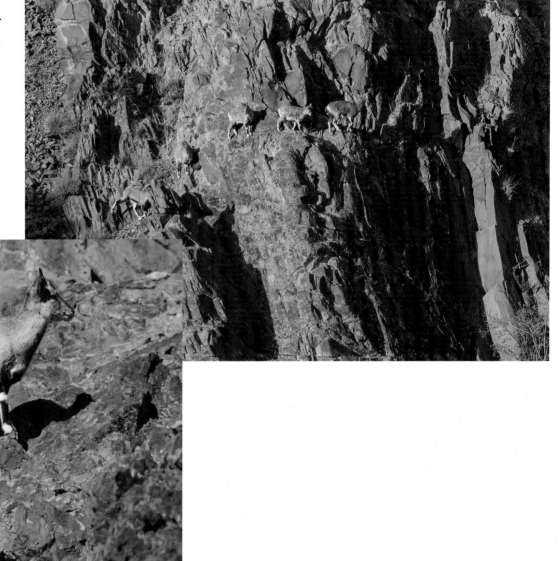

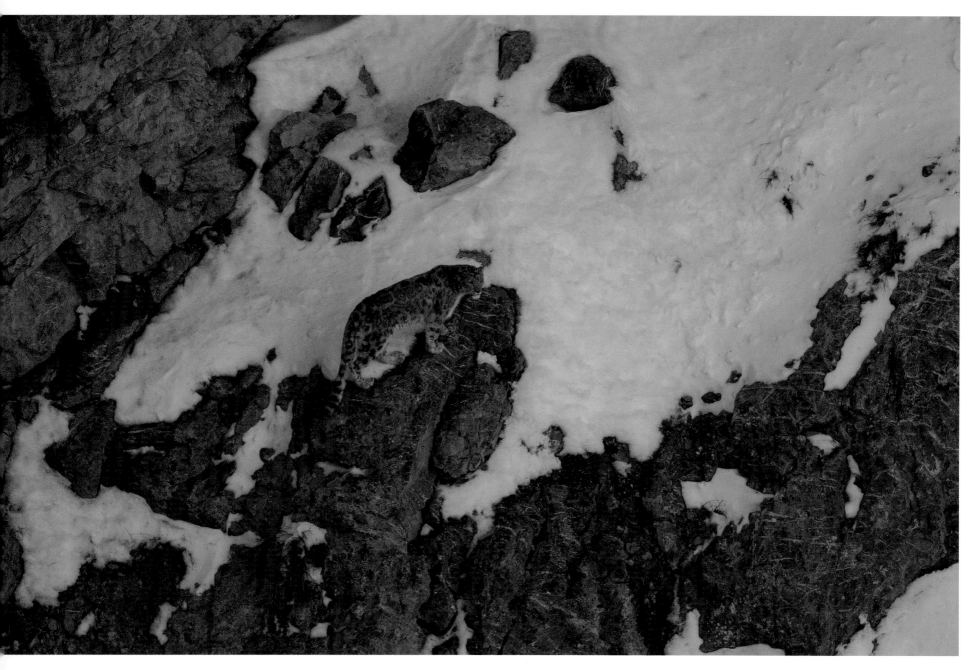

# THE JOURNEY

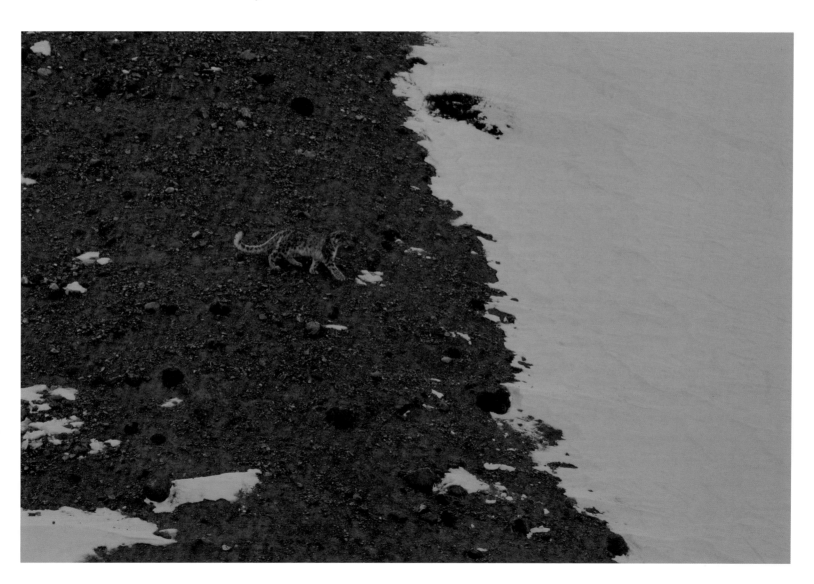

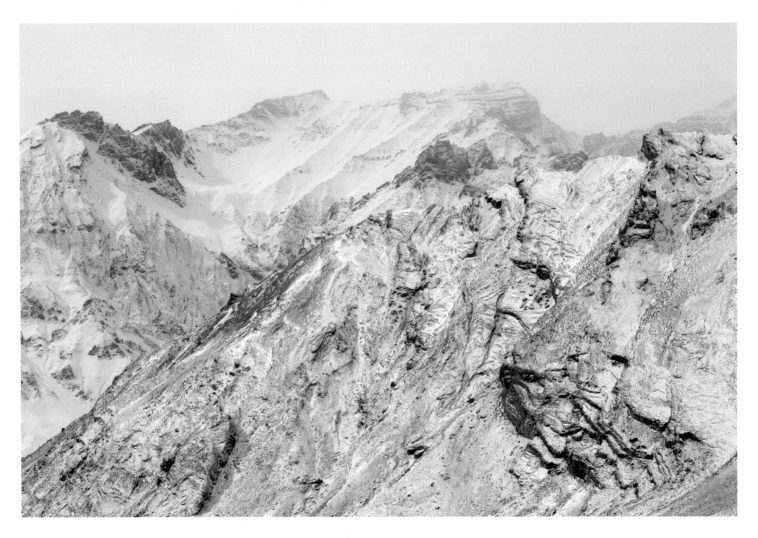

For those who go in search of the snow leopard, the expedition may hold unexpected discoveries. Though their goal is to observe and photograph one of the most elusive predators on the planet, they may also witness a magical transformation of the stark frigid landscape to one of true beauty and experience the interconnectedness of nature and the human spirit.

# LEARNING TO SEE

## BJÖRN PERSSON

Upon taking my first step into the Hemis National Park in India, I knew I was faced with a challenge like I had never experienced before. This world of inhospitable ice and rocks had no welcoming signs. The mountains greeted me with a snowstorm so severe I could hardly see more than a foot in front of me. The first few days were unbearable, and the sharp, slippery rocks were my worst enemy. Most frustrating of all, there was not one sign of a snow leopard.

The long hours of waiting in the chilling wind wore away at me, but just as I was on the brink of giving up, something began to happen. I let go of my expectations. Instead of frantically looking for this iconic predator, I started to discover the beauty around me. I saw the sun reflecting in the snow, resembling a sea of diamonds. I began to appreciate the fresh northern wind against my face, and I realized that what I first thought was a freezing cold, lifeless hell was in truth a paradise.

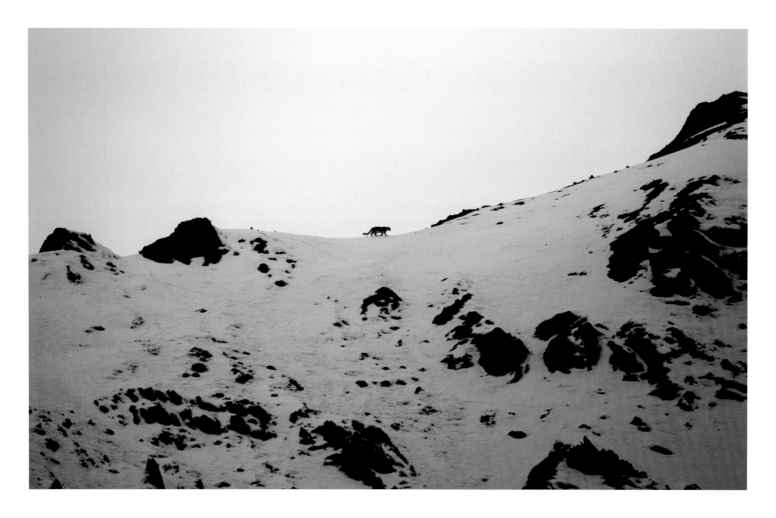

I felt a peace begin to grow within myself. My determination and selfish eagerness were replaced with an overwhelming feeling of gratitude for just being there. I turned my thoughts inward; the long days of waiting gave me the opportunity to contemplate who I was and what really mattered in life. I believe I was discovering my soul. Ultimately, I didn't think about the snow leopard at all. That same day was the first time I saw one.

Encountering this ethereal feline is not only about thorough preparations, hard work, and fighting the elements; it's about erasing all your apprehensions. It's not about desperately searching for it; it's about opening your soul and seeing with your heart. Only then will you be successful in finding a snow leopard.

# ENHANCEMENT OF STUDY THROUGH PHOTOGRAPHY

Camera-trap motion-sensitive photography has become an effective noninvasive tool for monitoring wildlife, especially animals that are difficult both to find and to observe, such as the snow leopard.

Despite the advantages afforded by advances in remote photographic technology, wildlife photographers still accompany conservationists and researchers into the field to enhance their studies.

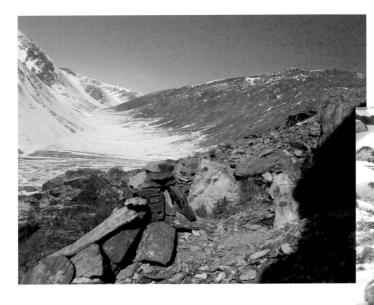

A photographer behind the lens of the camera, seeing and reacting to the animal and being in the moment, lends itself to something more intimate and personal than the images obtained with a camera trap. Knowing the photographer was actually in the presence of a snow leopard gives a context to the image that the remote camera cannot.

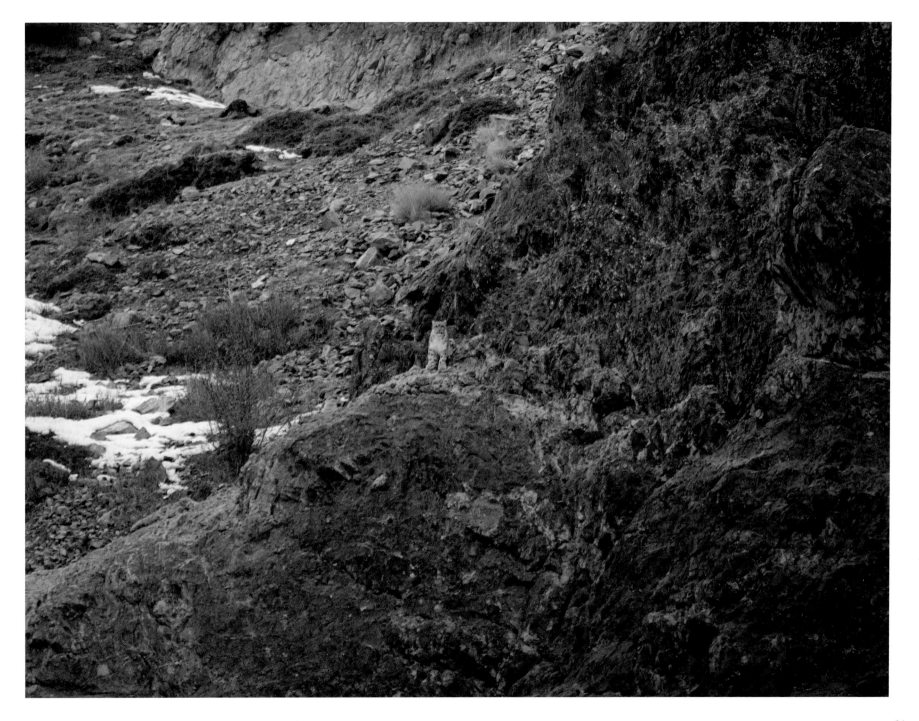

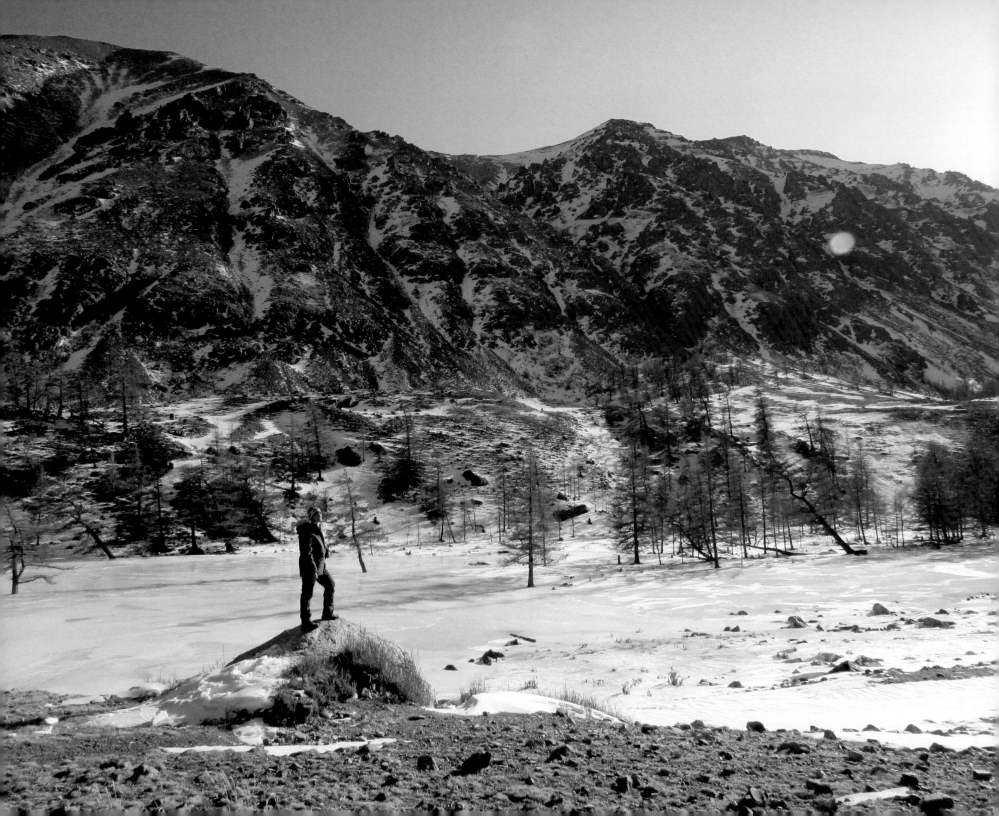

# IN THEIR FOOTSTEPS
## KATEY DUFFEY

Chances are, you may never see a snow leopard. "Why would you study something you don't see?" I have been asked this question dozens of times. When I first fell into snow leopard research, I was aware that the snow leopard is referred to as the "ghost of the mountains" for a reason. My particular fieldwork is noninvasive, meaning my focus is on finding and recording sign, collecting scat for analysis, setting camera traps, and working with local herders. I have never worked on a project that catches and collars the cats like so many of my colleagues do, and that's okay.

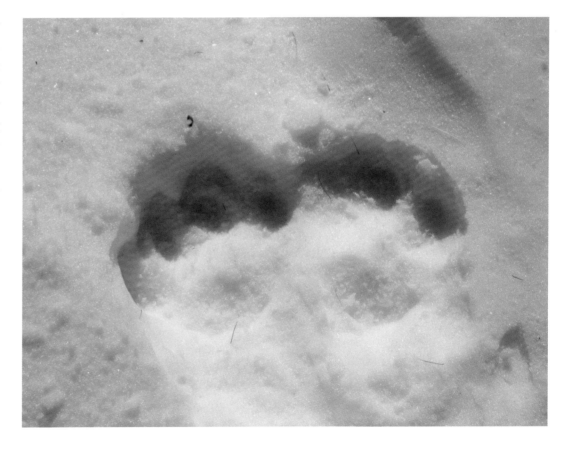

Snow leopard research is more than simply seeing and touching your study species. The real meaning comes from the experience of the trek. Hiking in the footsteps of this elusive cat through remote, rugged terrain in unforgiving conditions, you get more of an appreciation for the persistence of this species. You become more in tune with what it takes to survive in one of the planet's harshest environments. It's a place that seems untouched by time, where nature reminds you just how mortal you are. The mountains expose your true self. There is no place for ego here, and no place for hastiness. Everything happens in its own time. If the mountains wish to reveal their most sacred guardian to you, they will. Until then, all you can do is just be.

# SIGN OF THE GHOST

Given that visual observations of snow leopards are infrequent, often from great distances, and sometimes quite brief, researchers like Katey Duffey look for sign or evidence that snow leopards are present. Sign is found in the form of paw prints or claw scrapes in the dirt and gravel or on solitary trees. Scrape markings can remain present for more than a year,[50] but the big cats will regularly visit and refresh their markings.[51] Snow leopards also frequently leave spray markings on rocks. From these olfactory messages, which have been found to remain pungent for more than a month,[52] they are able to gather a great deal of information that helps them avoid unnecessary confrontations with other cats who share their territory.[53] Spray-marking rocks serve as good locations for camera traps, which provide valuable information on the number of snow leopards and their movements within a given area.

Discovering sign of the snow leopard elicits conflicting feelings. One would think it would be encouraging to find paw prints in the snow or spray markings on a boulder. But to come so close and not see a leopard is a discouraging reality researchers and photographers often face.

However, knowing they're walking where the snow leopard has walked and realizing that at that very moment a snow leopard may be watching heightens the anticipation and makes the desire to see this mystical creature even stronger.

# A VOICE IN THE SILENCE

## KATEY DUFFEY

I bent down to look at a pugmark in the powdery snow. The dryness of the climate had perfectly preserved each of the billions of snowflakes, allowing the individually unique icy stars to sparkle under the cloudless sky. Just as I was trying to estimate when the snow leopard had crossed this valley and observe which way it had headed, a chill ran up my spine at the sound of a piercing cry that echoed among the peaks. My teammate and I froze. The overwhelming silence of the land was replaced with the rapid thumping of my heart in my chest. One more time, the yowl reverberated into the valley. I stood, looking at my teammate in awe, with two words being trailed by a puffy cloud of my frozen breath and a huge grin on my face: *snow leopard*.

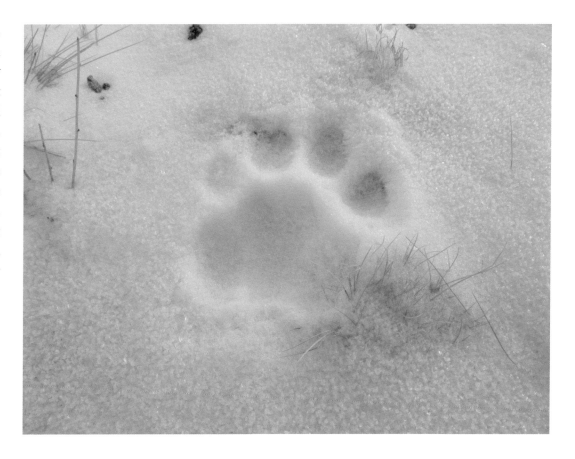

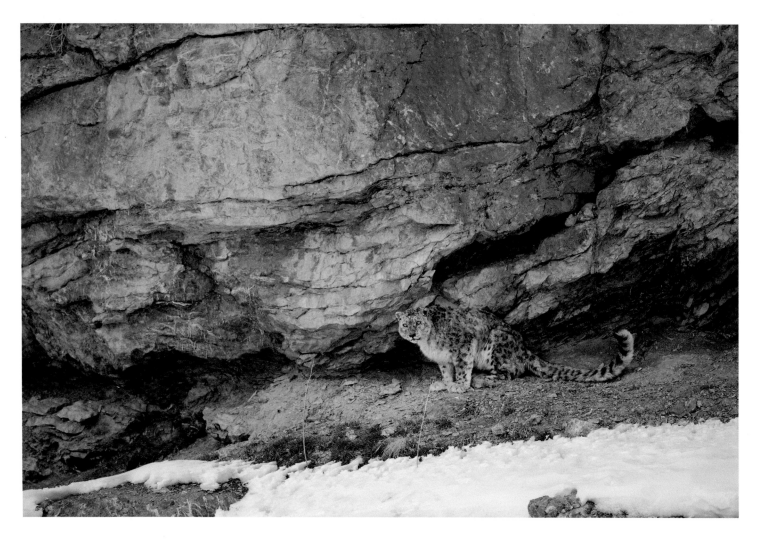

Unlike the other members of the *Panthera* genus, the snow leopard is unable to roar. Its larynx differs anatomically in that it does not have the fibroelastic ligament found in the other great cats that gives them this ability.[54] The snow leopard isn't silent, though. In fact, it is capable of making a variety of other vocalizations, including puffing, hissing, growling, screaming, yowling, and even purring.[55] Its distinctive main call, made during the breeding season, is easily heard as it reverberates off the cliffs and across the valleys.[56]

# THE REAL THING

Today, many of us spend a great deal of our lives behind screens. Whether it's our computer, laptop, or phone, we are constantly fed a flow of perfected imagery and special effects. But the problem with today's visual world is that anything is possible.

It doesn't matter if we want to see a close-up of the *Titanic* at the bottom of the sea, a remote tribe in the Amazon, or the sun rising over Mount Everest. It's all there, just a click away on our electronic device. We are becoming visually spoiled.

Nature documentaries feed us great close-ups of rare cats hunting and walking on sunlit ridges with beautiful music playing in the background. They're often better than reality.

Because of this, hardly anything surprises us anymore. But trekking for snow leopards is a unique experience that's hard to match. Nothing can compare to seeing a snow leopard in its natural habitat.

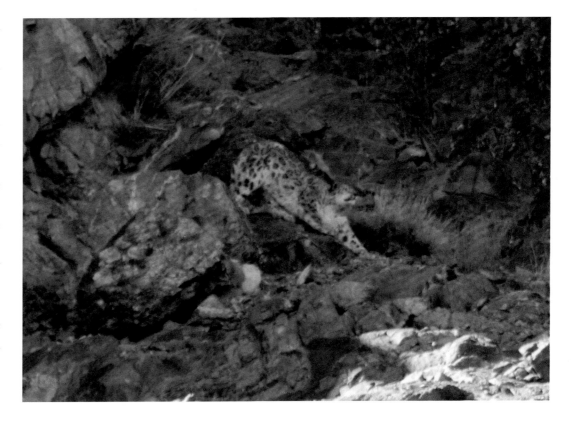

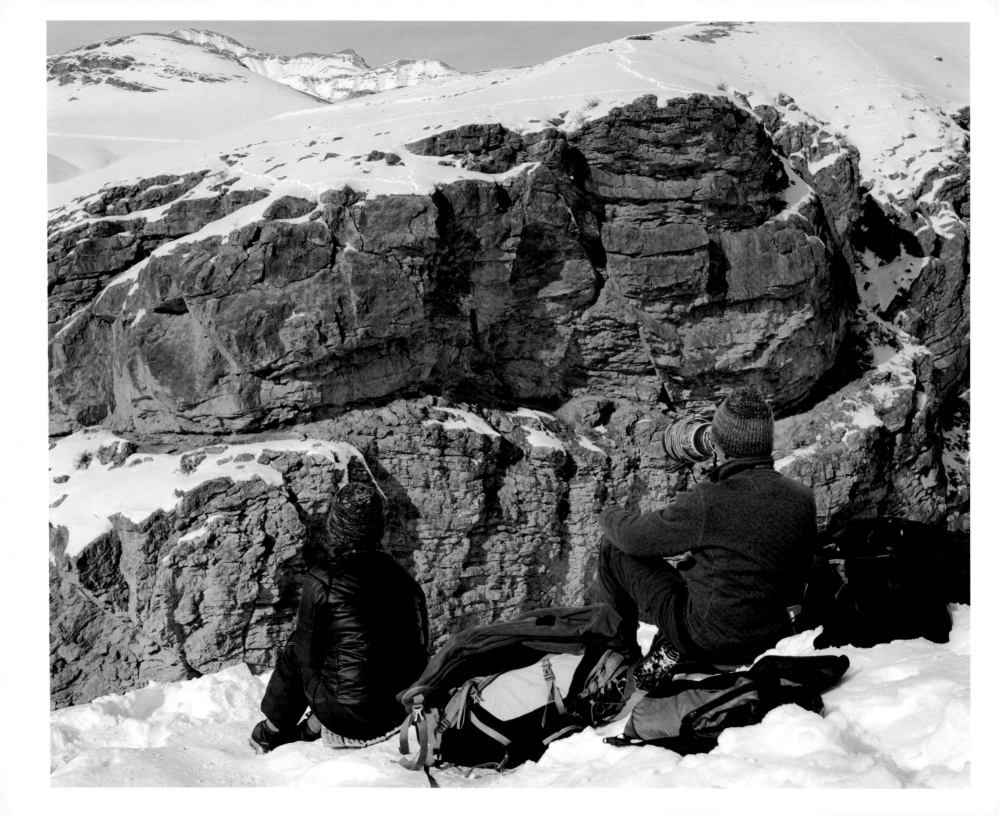

# THE PRIVILEGE OF SEEING
# A SNOW LEOPARD

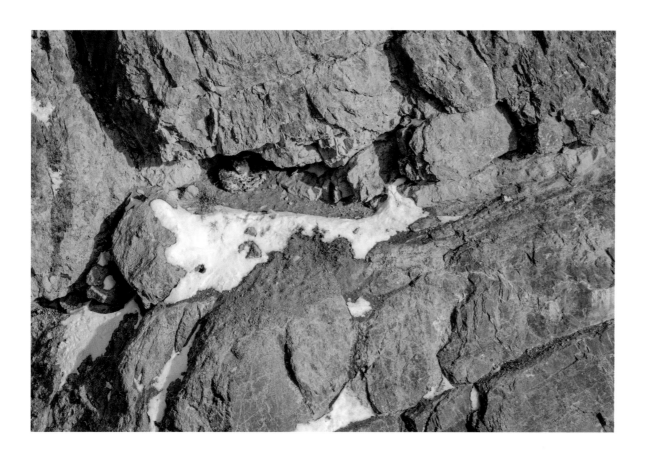

I f you are fortunate enough to see a snow leopard, it will most likely be through a telescope and then from a great distance, miles away.

That doesn't matter, because even if the snow leopard appears as a little black dot high up on a mountain ridge, the feeling of joy and excitement is greater than any you will receive from looking at an enhanced computer image.

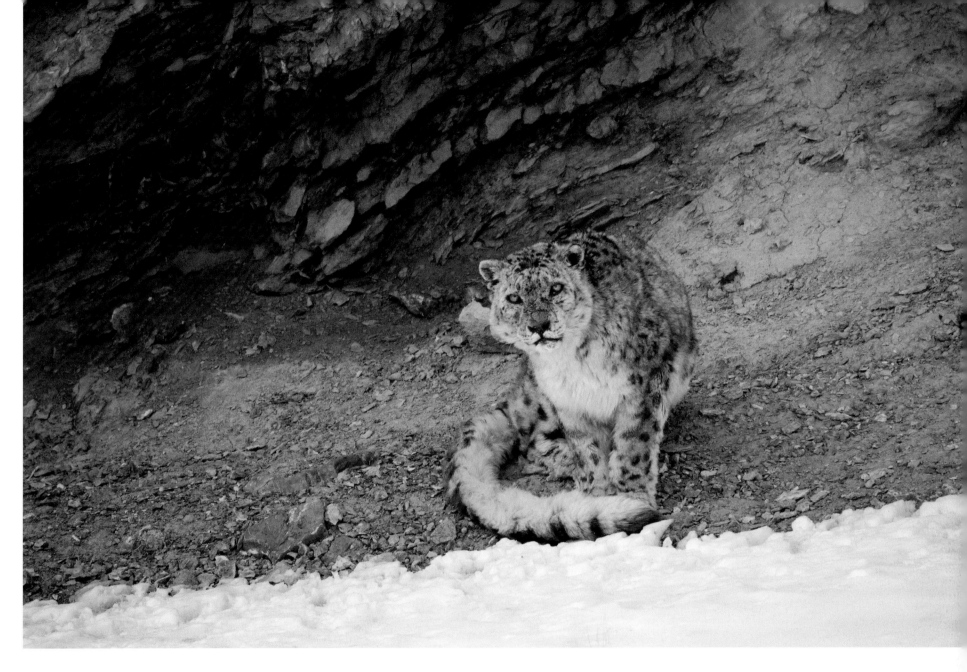

You are one of the lucky few who has had the privilege of seeing a snow leopard in the wild.

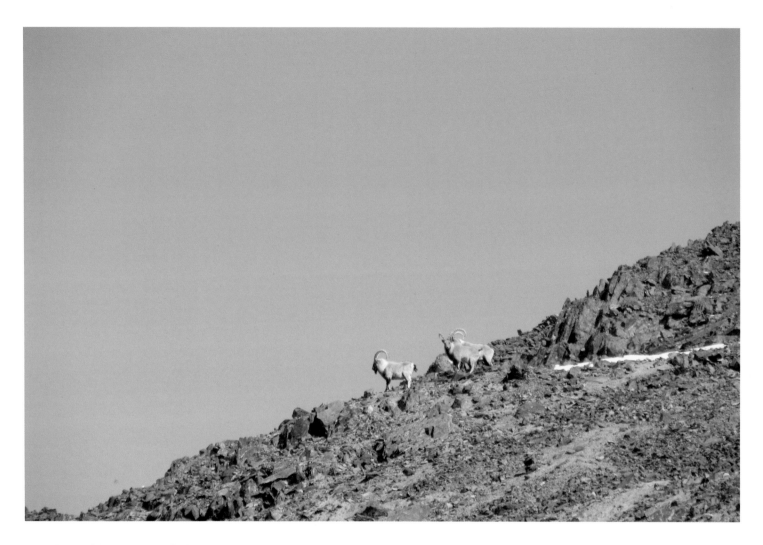

The wild animals of the high mountains of Asia at times seem otherworldly. Though they are obviously aware of and visibly curious about human visitors, there is something in their observed behavior and demeanor that creates an intangible separation between them and their world and that of the human interlopers. The guardian of their realm, the snow leopard, even appears to choose when it will be seen, if at all.

# THE PHANTOM

## KATEY DUFFEY

Tracking snow leopards often involves as much luck as it does having knowledge of their behavior. Some people may be on their first expedition for mere hours before seeing a cat, while for others it may take years of extended trips before a sighting. Regardless of when people are honored with the privilege, the experience of seeing a snow leopard always comes when least expected.

Snow leopards are a transboundary species that may cross borders between countries as part of their home range. Logistically, these border regions are difficult to study due to complications between government security clearances, lack of roads, unknown routes that locals may not even explore, and isolated wilderness. They also tend to be on the outskirts of main study sites and protected areas that are neglected because of the uncertainty of significant populations of species. There is a lack of research done within these areas.

The Altai Mountains, located between Mongolia, Russia, China, and Kazakhstan, are a transboundary range for snow leopards and a new project site for my fourth year of studying these elusive cats. The following is an account from an unforgettable day in the field while working in the Altai.

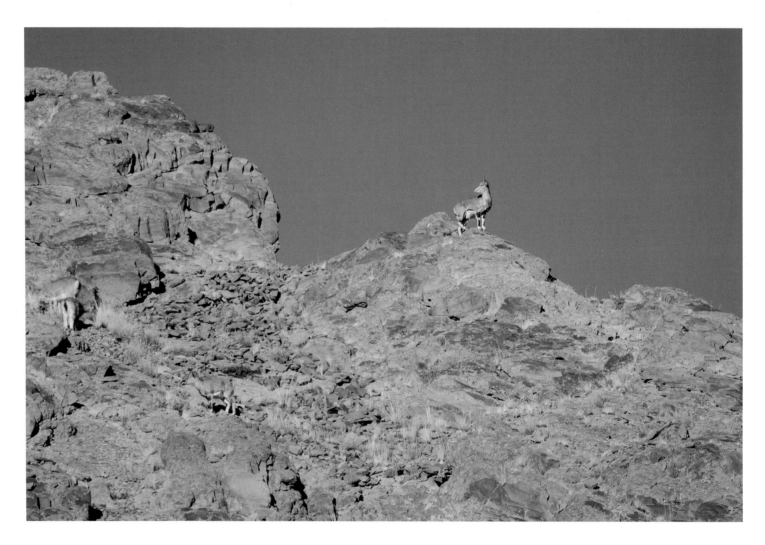

I gazed upon the blue glaciers and incredibly steep slopes, far from where others go, and got a true sense of wilderness as it is meant to be. Here among the valleys where even livestock don't often stray are ibex and argali that haven't developed more than a cautious wariness of humans. From a safe distance up a slope, they watch you with as much curiosity as you watch them, standing guard as sentries between worlds.

A teammate (my translator) and I stopped to rest as we carefully navigated our way down thick, loose scree. Going down a mountain is harder and more dangerous than going up. We were exhausted from our transect, and our legs shook to maintain control of our balance against gravity and the shifting terrain, where rolling rocks threatened to trap an ankle. We sat to double-check the fresh snow leopard tracks and scat we recorded before heading back to the jeep to meet the other pair from our team, who was finishing up a transect along a different ridge.

I heard rocks tumble nearby, no more than a few hundred meters away. A couple of ibex landed to scope out the area, aware of our presence but not spooked. Their ears swiveled around and focused right at us as their nostrils flared to release fogs of breath to float downwind of us. My teammate and I held as motionless as possible, careful not to even exhale too loudly. Certain that the coast was clear, the ibex continued on, galloping expertly down rocks that took us an excruciating effort to descend. Then more of the wild goats followed. A large herd of around forty ibex swiftly ran down the slope, across the valley, and up the next mountain. Their soft grunts to each other could be heard as they passed. We remained where we were for an extra few minutes, appreciating what we saw as the silence of the valley overtook the echoes of hooves knocking against stones.

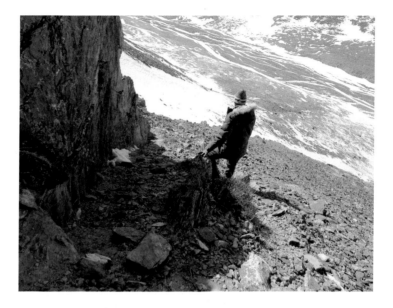

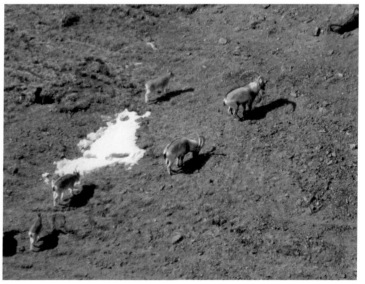

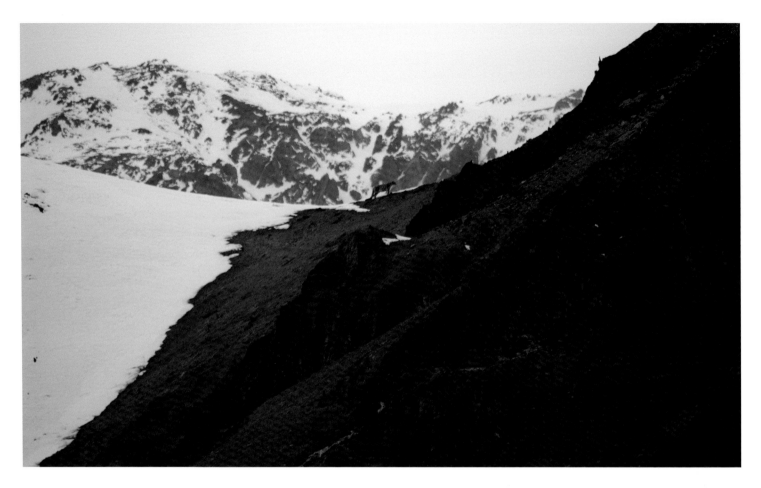

About an hour later, my team piled into the jeep to leave the valley. The sun was going down, and we didn't want to risk getting stuck on the frozen river at night. Just as I was about to settle in for the drive to that night's host family, one of my teammates yelled repeatedly for the driver to stop the jeep. When I saw him quickly bring his camera (which at that point had completely dead batteries) up to zoom in on something, I hopped to his side of the vehicle to find what got his attention. There, up on the mountain right next to us, was a smoky feline figure, perfectly blending in with the rocks, leaping from boulder to boulder before vanishing into a cave, its long tail trailing behind as a clear giveaway to the identification of the animal.

Stunned, we sat there, knowing exactly what we had seen but going through the list of other possible native species anyway. We were the only two on the team who had seen it. The ranger, driver, and translator were in disbelief, waving off our sighting as wishful thinking or from being tired, saying that it was probably just a fox. We knew what we had seen.

The next day, my team climbed to where the phantom creature was last seen. Sure enough, there were fresh tracks. They confirmed that the two of us had, in fact, seen a snow leopard. The sighting was only a brief glimpse, and although we were unable to get a photo of the cat, it was an experience of a lifetime that we will never forget.

We had been in that valley all day. We had hiked and climbed along all those surrounding ridgelines for hours. Yet the snow leopard chose to remain hidden. It watched the strange trespassers in its territory until the peak of twilight, when our vision's ability to focus was at its weakest. It emerged from a throw of boulders just in time to seem surreal before disappearing with the sun and blending into our dreams.

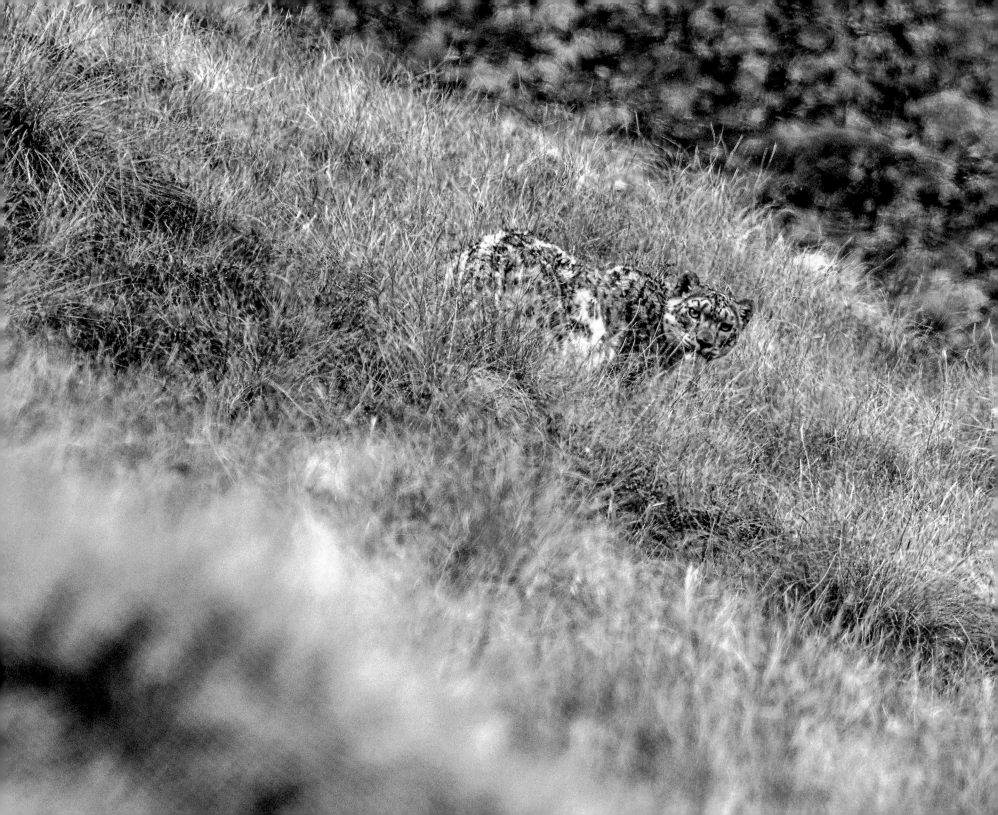

# AN UNEXPECTED ENCOUNTER

## TASHI GHALE

On a late September morning around 9:00 a.m., Mark Filla, a PhD fellow at the University of Göttingen, and I were doing a double-observer blue sheep count in the Tilicho basecamp area. Mark was studying the human–snow leopard conflict in the Annapurna Conservation area in collaboration with the Third Pole Conservancy. On the last session, while looking carefully, I saw some movement. It turned out to be a snow leopard at a distance of around six hundred meters to the southwest. Soon after my initial observation, it became hidden in the grass. We waited forty-five minutes for the snow leopard to come out, but it didn't. So we approached the location of the sighting, and there was the snow leopard, looking at us! I managed to quickly take a few pictures before it crossed the ridge and vanished.

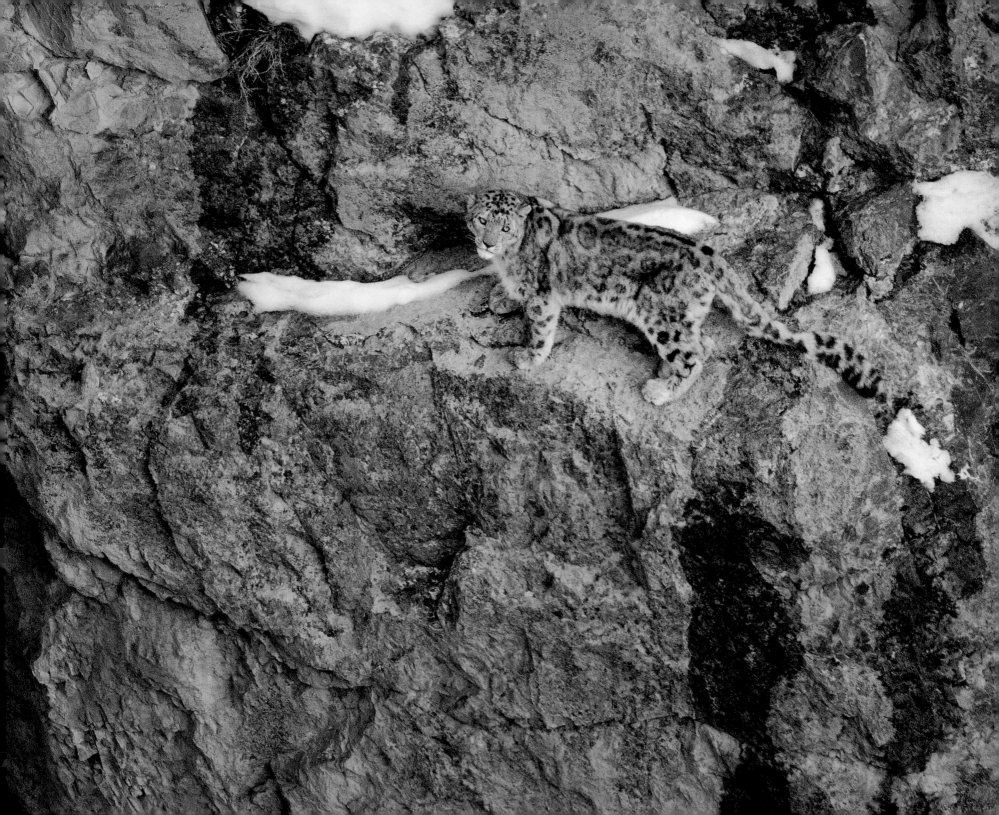

# WITNESS TO A HUNT
## ORIOL ALAMANY AND EULÀLIA VICENS

After three trips to the Himalayas, my wife, Eulàlia Vicens, and I decided that the time had come to attempt a photographic work on the elusive snow leopard, our dream subject. We spent a lot of time studying the potential locations, and eventually, we traveled back to the Himalayas.

It is not easy to get around these mountain ranges in winter due to the cold (0 to –30ºC), the altitude of 4,000 to 5,000 meters (13,000 to 16,500 feet), and the poor conditions of the roads, accommodation, and food. But, working together with local naturalists and trackers, we had the privilege of watching and photographing three different snow leopards, sometimes for hours.

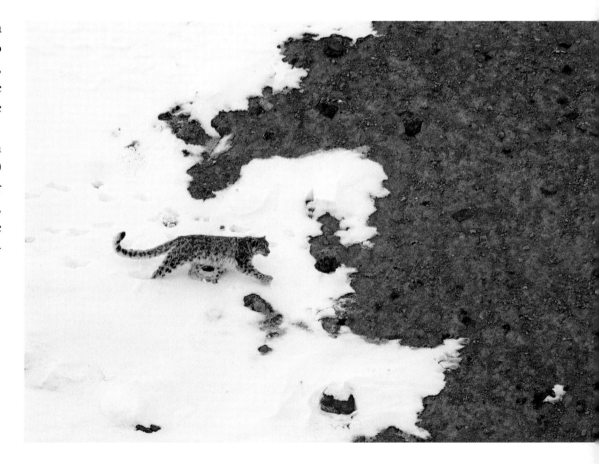

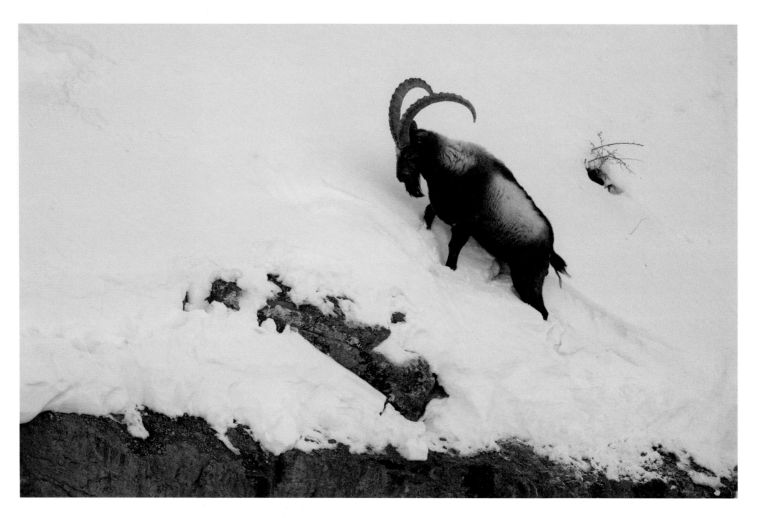

The second of our sightings was particularly outstanding. After several hours of walking and waiting at around 4,100 meters (13,500 feet), on the snow at dusk, we were able to observe one snow leopard trying to kill a Siberian ibex, *Capra sibirica*. The leopard first studied the ibex herd for a long time, taking advantage of the camouflage provided by a few brown earth patches in the totally snowy mountain slope.

After half an hour of patient stalking, he ran through the deep snow behind the ibex, who fled in terror until jumping over the vertiginous cliffs, with the leopard behind them.

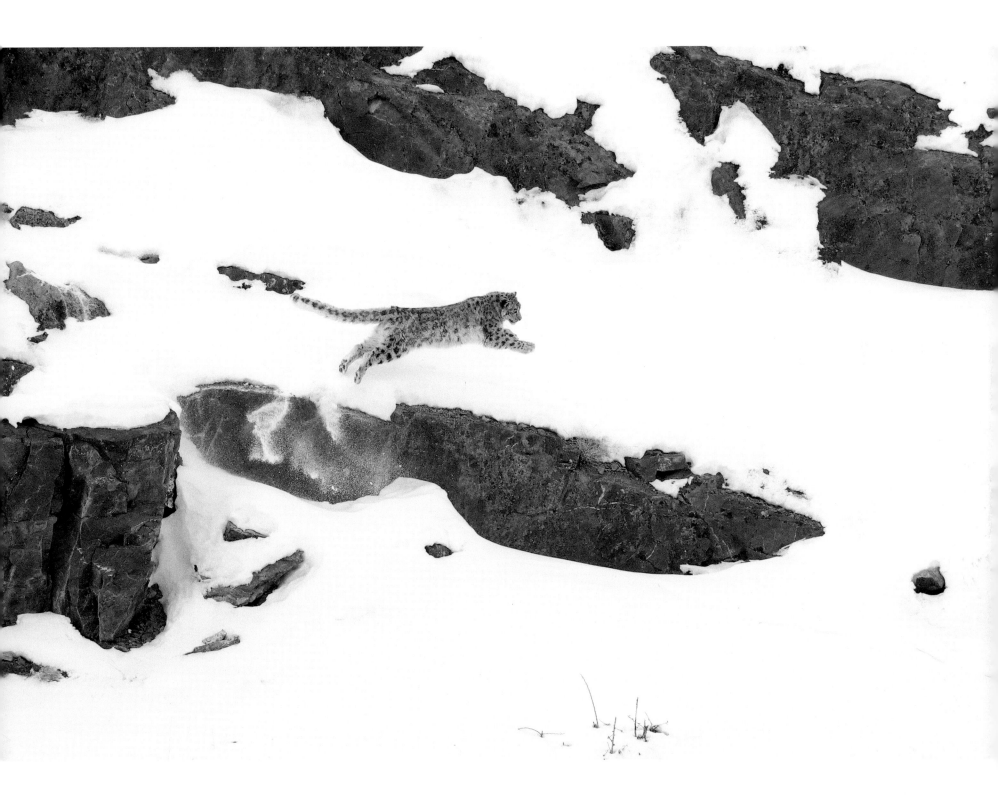

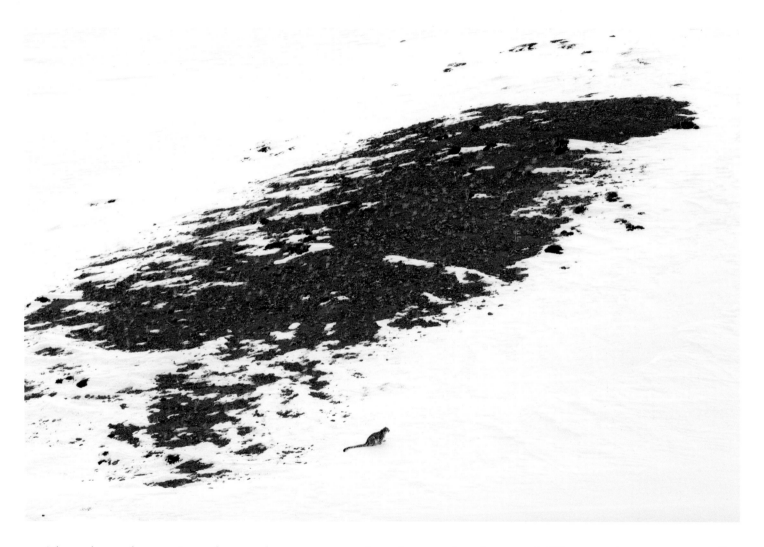

Throughout the evening, the attacks were repeated twice more without success. I was shivering, maybe from the intense cold, maybe from the excitement. As a wildlife photographer, it was a thrilling experience; as a naturalist, an interesting behavior observation.

# IT'S NOT ALL ABOUT THE CAMERA

Photographing a snow leopard is not about aperture, clarity, or shutter speed. It's not about big lenses or the latest technology. That might work on a safari in Africa. There, you are so spoiled by the rich and abundant wildlife you can just sit back, relax, and with every click of the camera comes the perfect photograph.

A snow leopard trek to the mountains of Asia is a completely different story. It's about you and the snow leopard, together in a grand and breathtaking land of rock and snow. Then the magic happens.

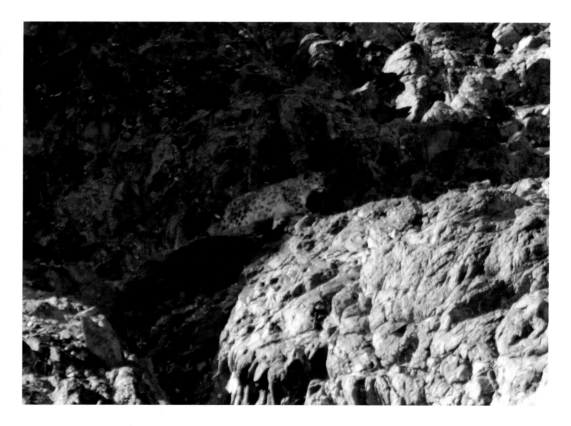

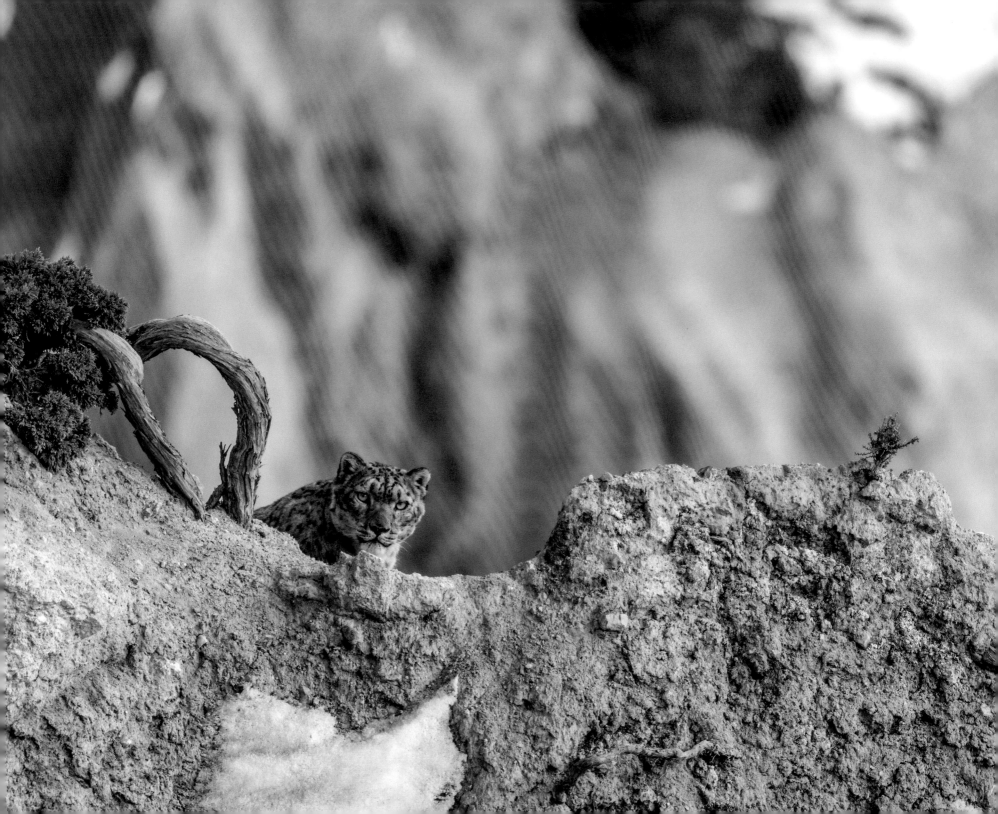

# BEFORE THE MAGIC

Extensive planning is necessary before embarking on a snow leopard trek. Every aspect of dealing with the environment must be considered.

First, there is the cold. Every minute of the day your body is shivering, and the icy winds go straight through to your bones, unlike the snow leopard, whose many adaptations allow it to withstand the brutal cold. Its fur, which is longer and denser than any of the other *Panthera* cats', provides excellent insulation.[57] Its tail, which is as long as its body, is used as a blanket to protect it from the icy winds.[58] Its diminutive ears minimize heat loss while reducing the chance of frostbite. And its enlarged nasal cavity is an excellent mechanism for warming inhaled cold air.[59]

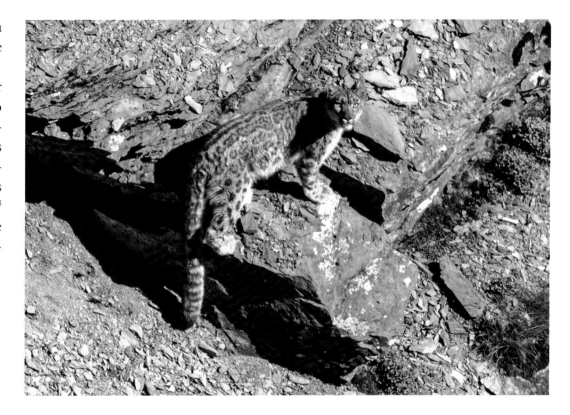

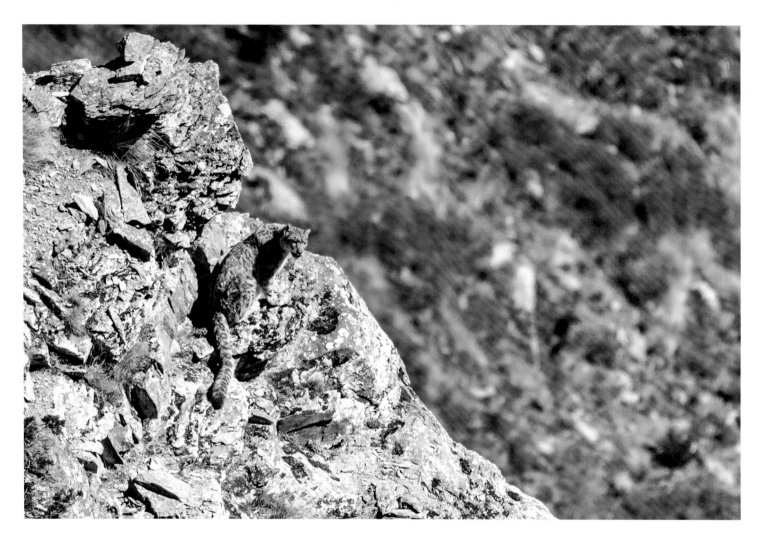

Then there is the altitude. Every step feels like a round of heavyweight boxing, and the lack of oxygen keeps you in a constant state of vertigo. For the snow leopard, the altitude isn't a problem. With a unique blood chemistry, it's able to maximize the oxygen in its bloodstream and still conserve heat energy.[60] And with large nasal openings, the snow leopard is able to inhale more air with each breath, thus increasing the amount of oxygen it receives.[61]

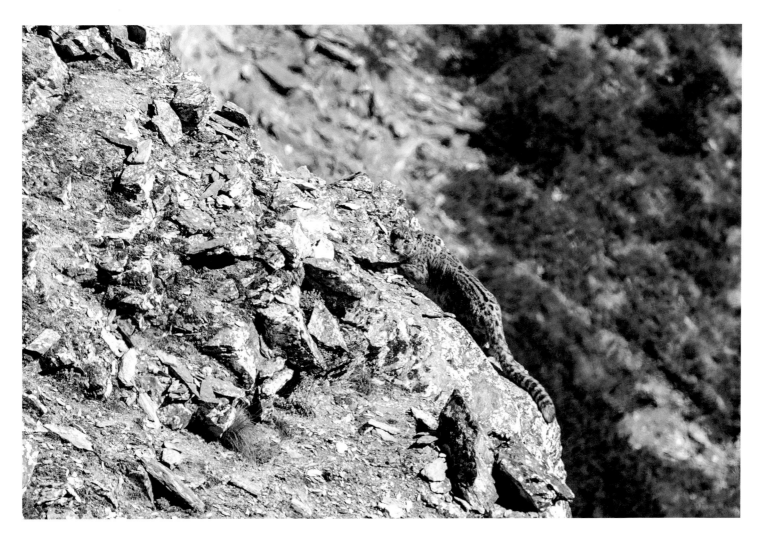

Finally, there's the terrain. Every step you take is precarious and could result in a turned ankle, a tumble down a slope, or even a plunge down the side of a mountain. But the snow leopard's muscular, 50 to 115-pound body[62] seems to be perfectly made for steep, rocky slopes and deep snow and ice. Its huge paws are like snowshoes,[63] and its strong, flexible body allows it to leap great distances, make sharp turns, and accelerate powerfully and quickly while giving chase.[64] Even its tail serves an important function, acting as a rudder as it races up and down the side of a mountain.[65]

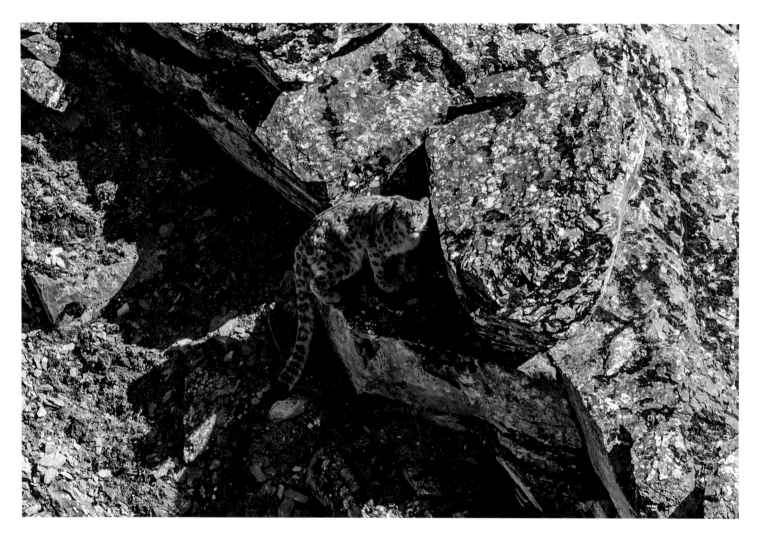

The obstacles one faces when searching for a snow leopard are undeniably difficult, and the pictures obtained are a reflection of the extensive planning and hard work that goes into their taking, complete with the frustration, blurry vision, and numb, frostbitten fingers. But there is more to a snow leopard trek than overcoming physical challenges. It's also a test of human character, one that calls for courage, patience, determination, and, perhaps most significantly, humility.

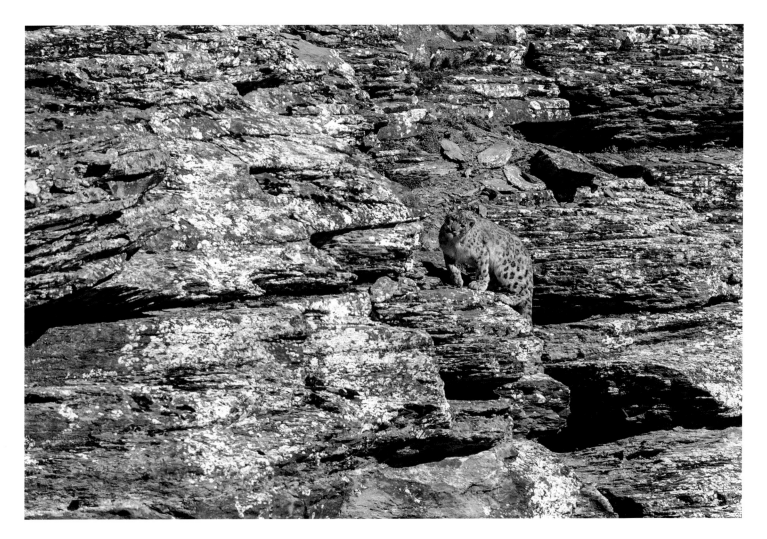

Obtaining an image of a wild snow leopard is less about skill and the employment of the latest equipment and techniques and more about respect—for the mountains, for the cat, and, in the words of geneticist Jan Janecka, for its "strength to not only survive but to thrive under challenging circumstances."[66] That moment when you at last see a snow leopard in the wild is transformative. The sense of accomplishment becomes less important and is replaced by a deep feeling of gratitude for being allowed to see this most special cat in its wild habitat.

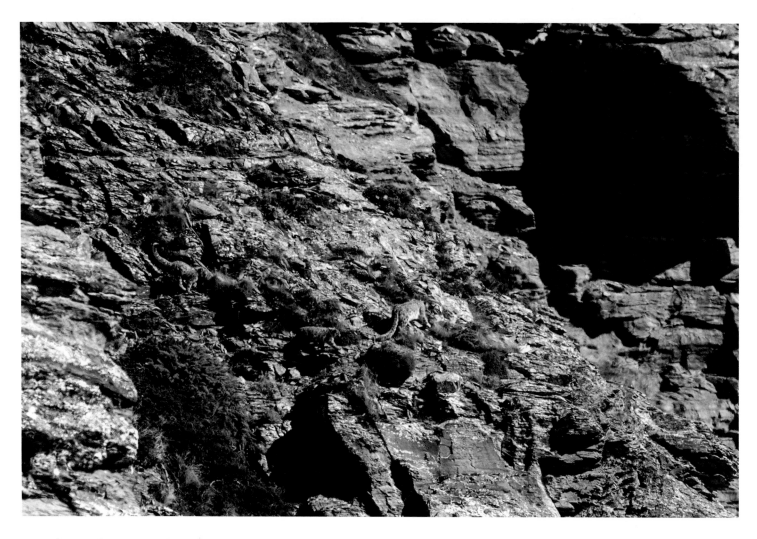

Ultimately, a snow leopard quest isn't about personal recognition, and it isn't about getting perfect pictures. It doesn't matter if they were taken from too great a distance or without enough light. It doesn't matter if they're grainy or slightly out of focus. Instead, what matters is that the images authentically portray the strength and exquisite beauty of the snow leopard.

# INTIMATE MOMENTS WITH A MOTHER SNOW LEOPARD AND HER TWO CUBS

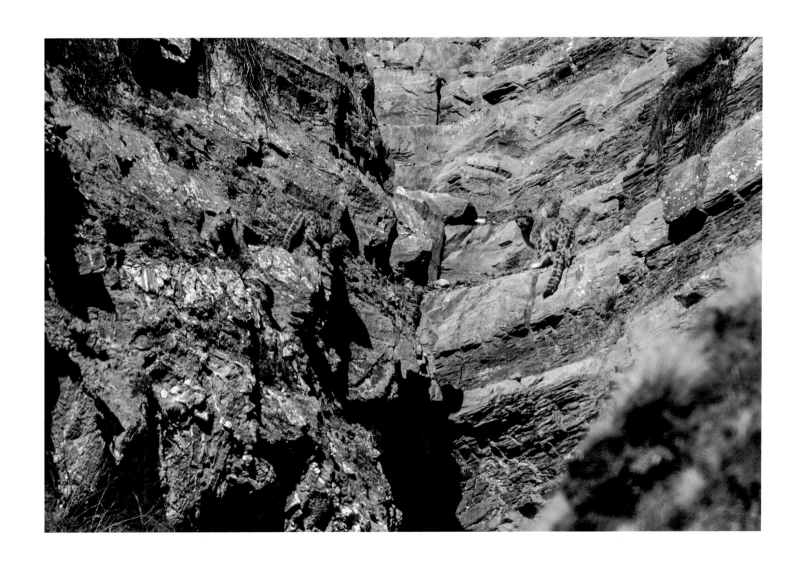

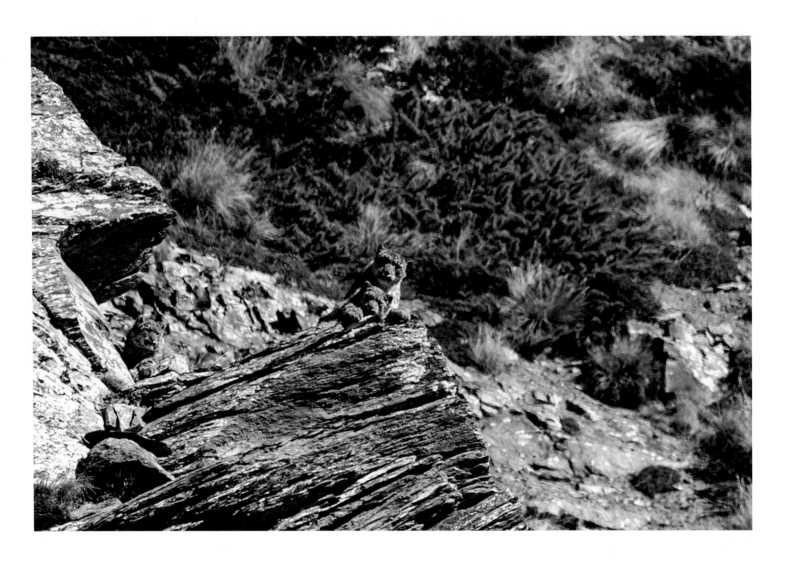

Photographer Tashi Ghale discovered this family of snow leopards at an elevation of 14,000–15,000 feet above sea level in the Annapurna Conservation area of the Nepal Himalaya. Tashi has lived his whole life in the mountains of Nepal, studying snow leopards, but this was only his seventh live sighting and the first time he'd seen a mother snow leopard with cubs.

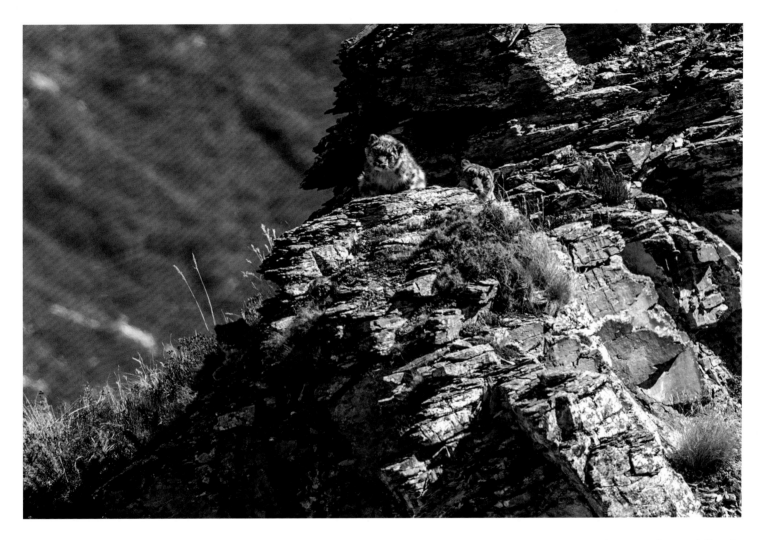

The snow leopard mother and her two, approximately six-month-old cubs watched the photographer with curiosity as he spent three hours at midday observing and taking photographs. At one point, the snow leopard family allowed him to come as close as 200–300 feet from their resting place.

Spotting the snow leopard mother and her cubs from a great distance was difficult, even for an experienced mountain man and wildlife photographer like Tashi. Hidden among the rocks and shadows, they were almost completely concealed.

Their multicolored coats allowed them to blend in with their surroundings. But with the aid of a keen eye, binoculars, and a telephoto lens, this special snow leopard family was brought into focus.

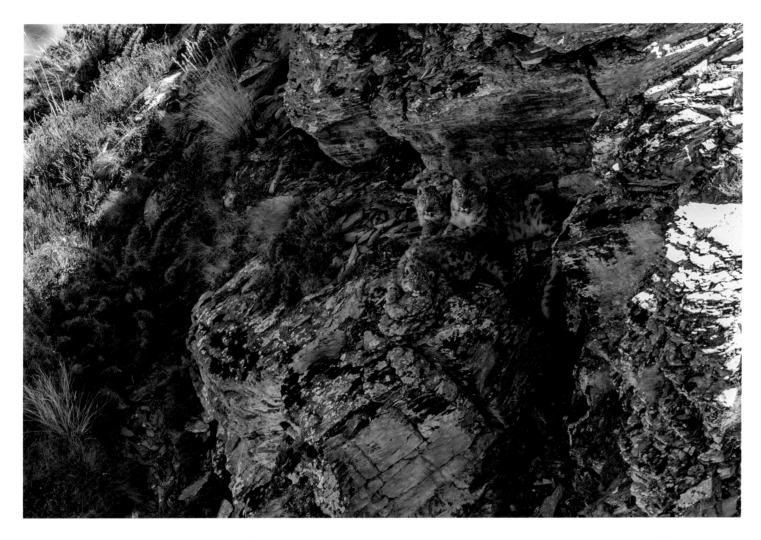

Other than family groups of cubs living with their mother, such as the one Tashi had the opportunity to photograph, adult snow leopards lead solitary lives,[67] avoiding each other except during the mating season, which falls during the winter months of January, February, and March.[68] For the remainder of the year, they communicate through their scent-marking messages.

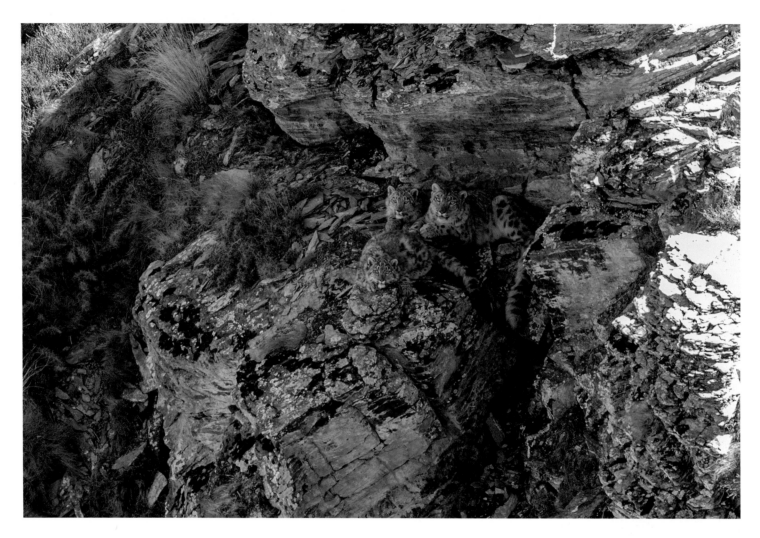

The mating season is when the majority of photographic expeditions take place. During the winter months, snow leopards follow the sheep and goats down into the lower elevations where grazing is better,[69] which makes them more accessible to humans. So, despite the colder temperatures and the possibility of heavy snowfalls at that time of year, the chances of spotting a snow leopard are greatly increased and make it worth braving the challenges of winter weather in the mountains.

Once the mating season is over, the adults will go their separate ways. If mating has been successful, after a gestation period of about a hundred days,[70] the mother snow leopard gives birth to a litter of usually two or three cubs, who stay with her for eighteen months to two years.[71]

The mother snow leopard devotes herself to the care and protection of her cubs until they are able to fend for themselves. During that time, they are dependent upon her for food, but she will skillfully teach them how to hunt and survive in the challenging environment they call home.

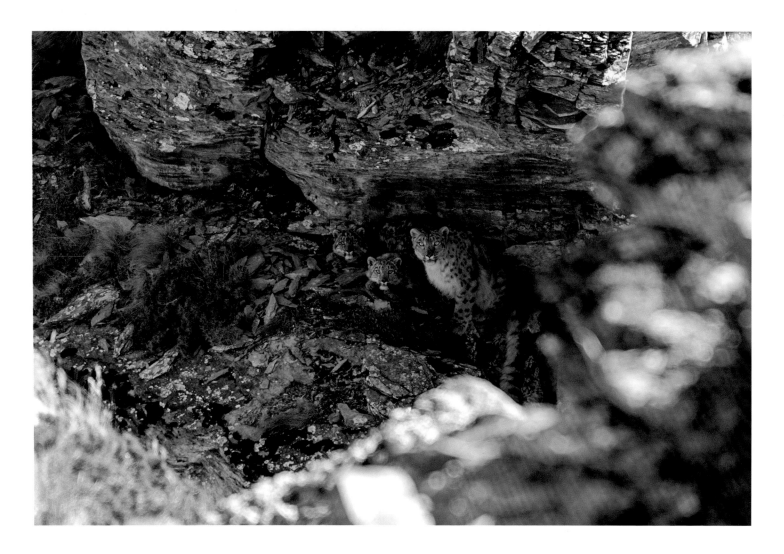

Snow leopards are crepuscular,[72] as are other large felid predators, doing most of their hunting during the early morning hours and at dusk. Adult individuals are able to take down animals up to three times their size,[73] but being an opportunistic carnivore,[74] their diet ranges from prey animals as small as a marmot or a woolly hare[75] to larger prey like bharal, Siberian ibex, argali, markhor, or the Himalayan tahr.[76] Snow leopards may stay with their kill for close to a week[77] and, if the animal is large enough, can go ten to fifteen days[78] before their next meal. Their stalk[79] and ambush style of hunting is ideal for the rugged terrain where they pursue their prey, virtually unseen among the rocks. But they can also rapidly accelerate when giving chase down the nearly vertical face of a mountain and have been seen leaping as far as fifty feet from one boulder to the next while in pursuit.[80]

# THE ELUSIVE LEOPARD
# OF THE ROCKS

Those who search for the snow leopard face the test of being able to find it among the rocks and snow. But before you set off on your quest, mentally don your down-filled jacket, pull on your sturdy mountain-climbing boots, secure your binoculars and camera with its high-powered lens to your pack, and carefully begin to make your way up the side of the mountain. Once you've found a safe vantage point, settle in for a long, cold day of silently scanning the snowfields that blanket the rocky face of the mountain that rises perhaps a thousand feet or more in front of you across a deep, boulder-strewn gorge. Wait, did that shadow move? Quickly and as quietly as you can, pull your binoculars from your pack, calm your breathing, steady yourself, and, after wiping the wind and emotion-driven tears from your eyes, focus on that spot where there was movement. And with a bit of luck, you will find it.

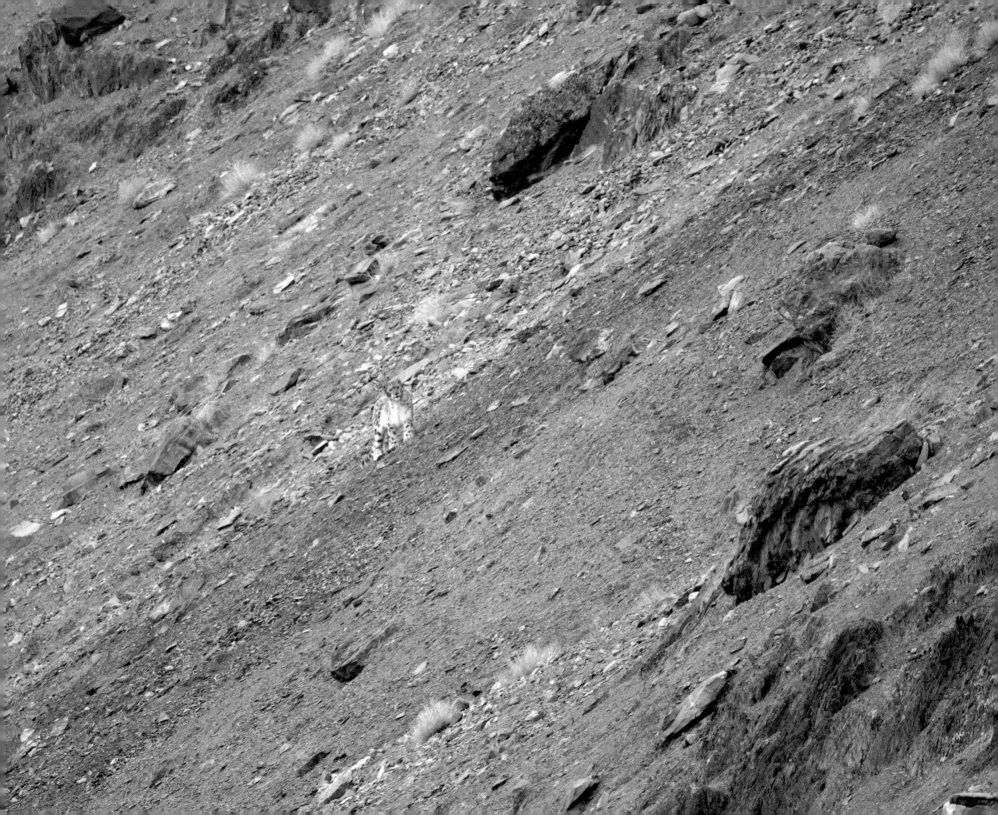

Finding a snow leopard is as difficult visually as it is physically. Because the snow leopard is an extremely elusive animal, living in one of the most remote places on earth, the chances of seeing one are already slim. That, combined with its ability to seemingly disappear into the rocky landscape, makes spotting one nearly impossible.

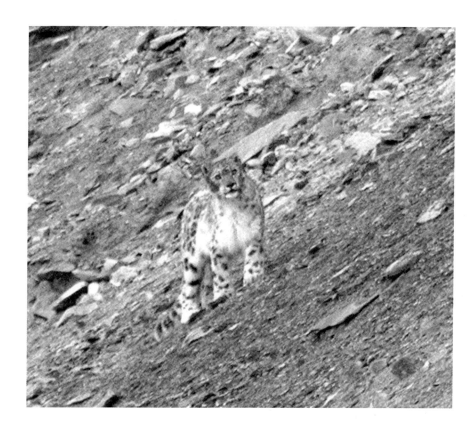

The snow leopard's beautiful pelage is one of its most useful adaptations, as it provides the cat with a natural camouflage. The color of its coat ranges from a pale or smoky gray to a cream or even golden color, occasionally interspersed with areas of reddish brown.[81] The fur under the chin and on the belly, extending back to the underside of the tail, is white.[82] Rosettes of dark brown or black adorn most of the snow leopard's body. These spots help the big cat to hide in plain sight,[83] an ability that has earned the snow leopard the moniker "ghost of the mountains."

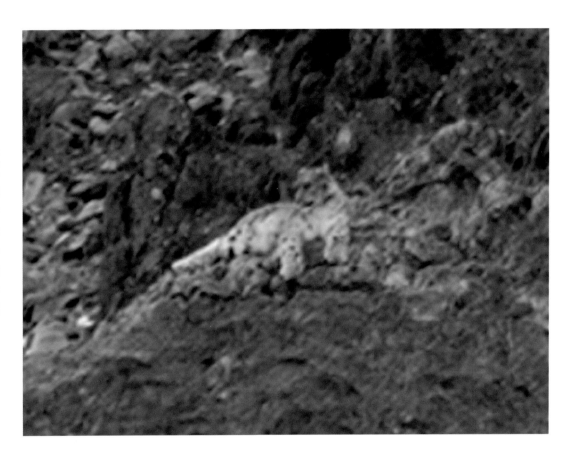

The snow leopard is a master of concealment not just by way of its inherent camouflage but also because of its ability to move soundlessly and with great control. You can peer through a telescope all day long and never see the snow leopard. Then, without warning, it appears right in front of you as if it had materialized out of thin air.[84] With movements so subtle you weren't aware of them, the snow leopard is suddenly visible.

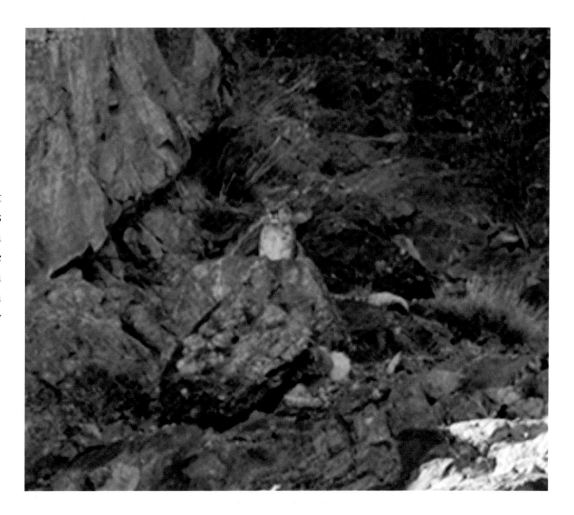

Stealth is the snow leopard's forte. This skill, which researchers believe a snow leopard cub learns from its mother,[85] combined with keen senses and a remarkable capacity for patience, makes it an excellent hunter.

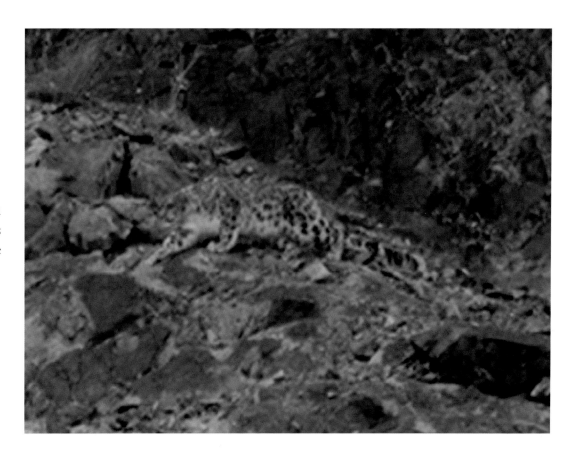

Although this stealthy predator is strong, fast, and fully weaponized, the snow leopard is not known to be aggressive toward humans.[86] True to its secretive nature,[87] it does its best to avoid confrontation, preferring to remain hidden. On the rare occasion it is discovered, the snow leopard will most often just walk away.[88]

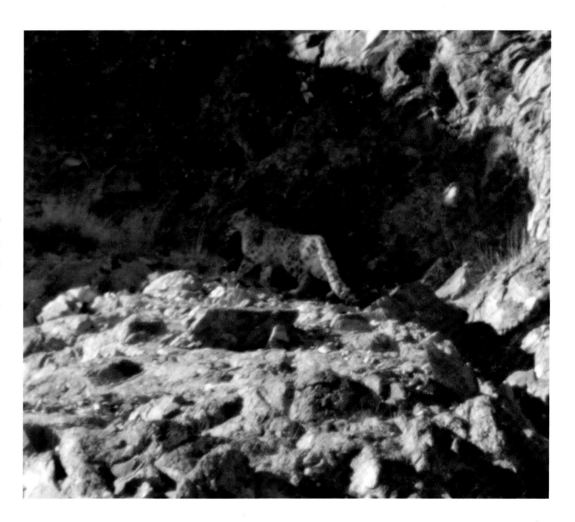

There are times, however, when the snow leopard seems to allow itself to be seen while taking a moment to observe the observer,[89] perhaps out of curiosity.

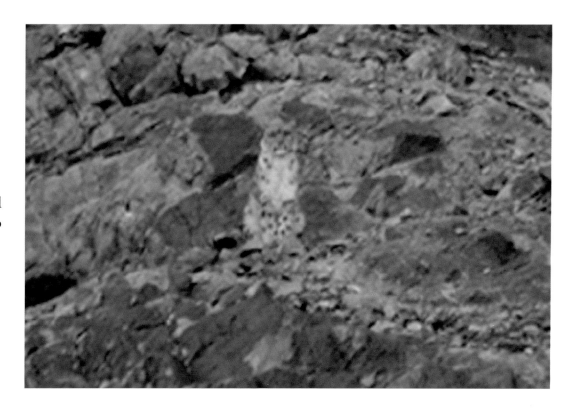

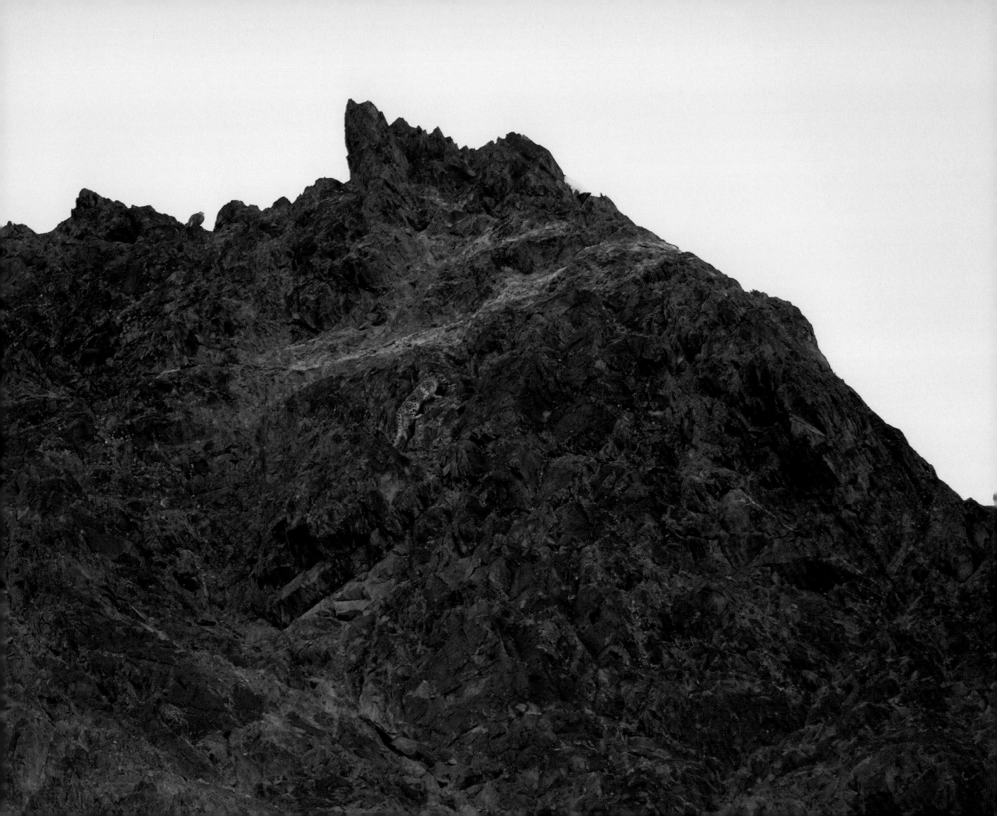

Although, if given the choice, the snow leopard would undoubtedly prefer to remain unseen.[90] With that in mind, those who search for this reclusive cat should remember that they are but visitors to its home, and if successful in their search, they need to take care to be respectful and observe without disturbing.

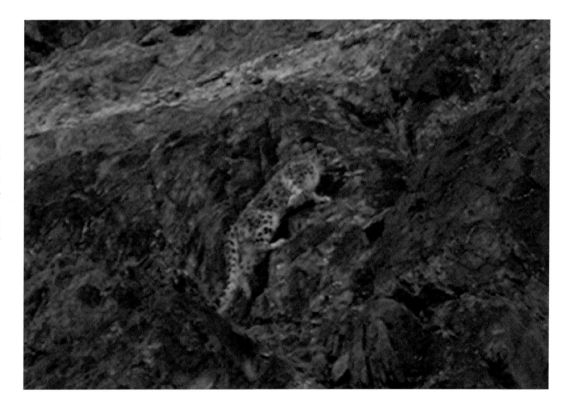

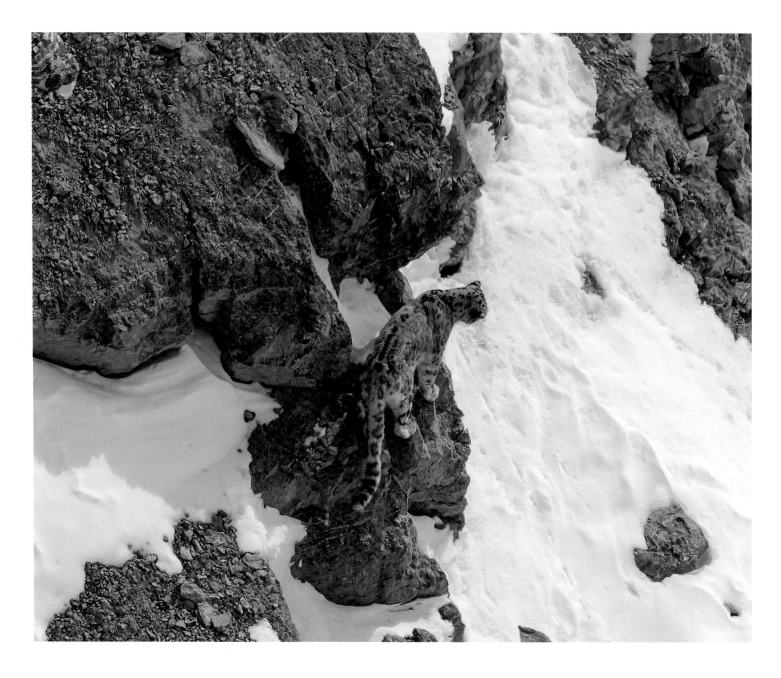

It takes a lot of patience and a great deal of practice to become proficient at spotting a snow leopard. But for those who have faith and persevere, the mountains will from time to time reveal their precious treasure.

# THE REWARD

Every day we are witness to the inexplicable beauty of our natural world: a sunrise, a sunset, a rainbow, the northern lights. Some are common occurrences we see often enough to take for granted, while others, like watching a baby being born or seeing a wild species in its natural habitat, are perhaps once-in-a-lifetime experiences. The reason some of these move us so profoundly is not always clear, but they leave us with a deeper appreciation for the universe's incredible design.

There is a great deal we still don't understand about our natural world in general and about the snow leopard in particular, but hopefully, as we learn more, some of the mystery will remain. It isn't always necessary we learn all there is to know in order to understand the importance or appreciate the beauty of something, especially this magnificent cat. Not every question has to be answered, not every puzzle piece put in place. The unknown brings with it an incomparable thrill and beauty that touches us.

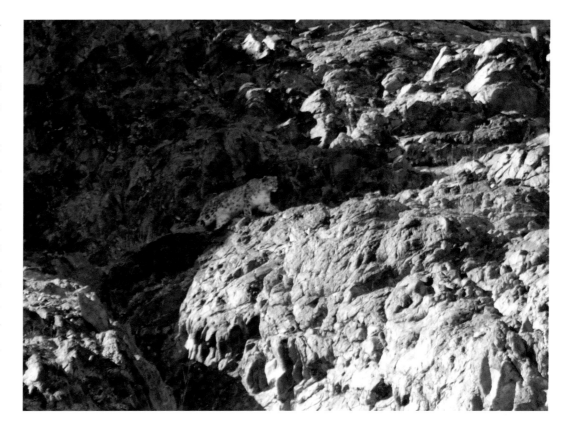

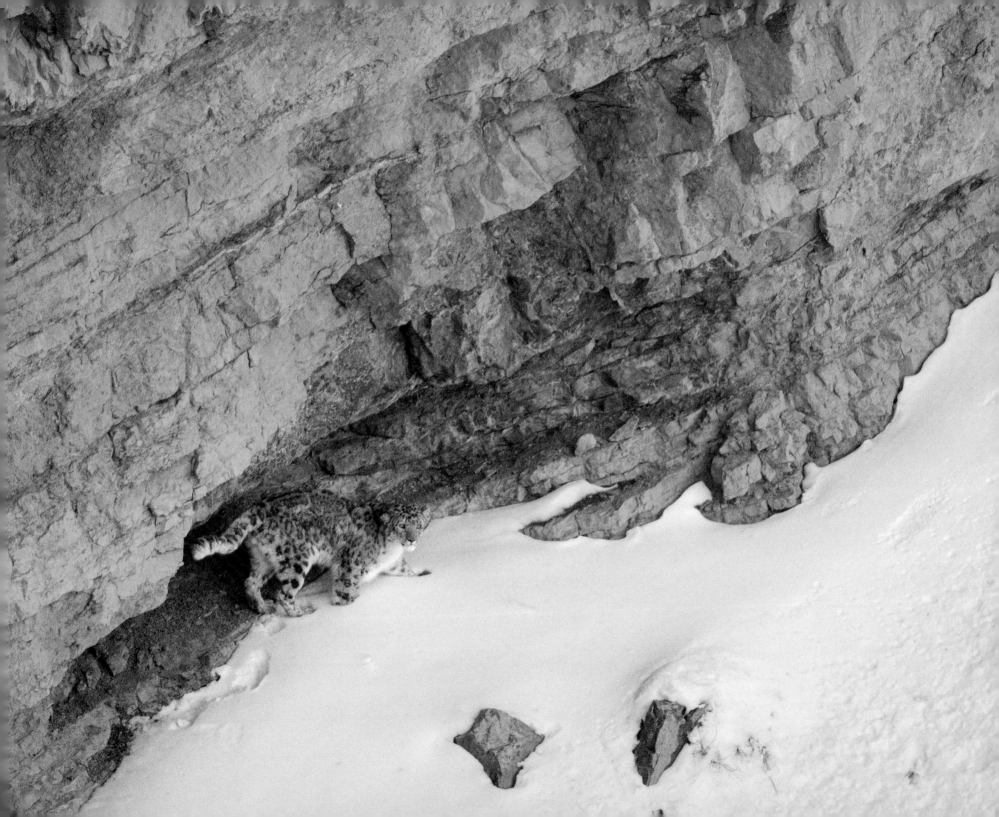

# WATCHING FROM AFAR
## ORIOL ALAMANY AND EULÀLIA VICENS

The alarm clock rang at seven o'clock in the morning, and after getting out of my sleeping bag, I paused to look at the thermometer outside the window of my room: 7°F. Following a quick breakfast, my wife, Eulàlia, our guide, and I went up the mountain to survey over the small village that constituted our base in this area of the Himalayas. Halfway up, one of the local trackers who had left early in the morning appeared. From a distance, he signaled that we should hurry: they had located a snow leopard.

Accelerating the pace when you are at 14,000 feet is difficult. Although we had been in the mountains for several days, our bodies still suffered from the lack of oxygen in the air. But after an hour's walk, we came to the ridge of the mountain. The trackers had located a female with two cubs, a family they hadn't seen for a month.

Without time to catch my breath, I mounted the tripod and installed my 500mm telephoto lens, but where were the leopards? An immense rocky canyon stretched out before us—at such a great distance, locating the exact spot was very difficult. At last, the tracker, Tenzin, took my telephoto lens and pointed it at a ledge in the middle of the opposite wall of the valley, and there was a bundle of fur that turned out to be a mother cuddling her two cubs to protect them from the cold.

It was nine thirty in the morning, and we decided not to move from there all day. As the hours went by, the sun shining on the ledge caused the leopards to move apart, and we could see them better. But they still did nothing but sleep and sleep while we froze on top of the ridge. A sip of hot milk tea brought from the village in a thermos becomes a real luxury in those conditions.

The hours passed. While the leopards slept, oblivious to the interest they aroused, we enjoyed a golden eagle that was carrying branches to build a new nest, some Himalayan vultures that flew past, and the imposing lammergeier, also known as the bearded vulture.

At nightfall, after nine ice-cold hours of observation, the felines finally sat up and began to groom themselves, an obvious sign of the beginning of activity. Suddenly, the mother began to walk up the rocky path, followed joyfully by her two cubs.

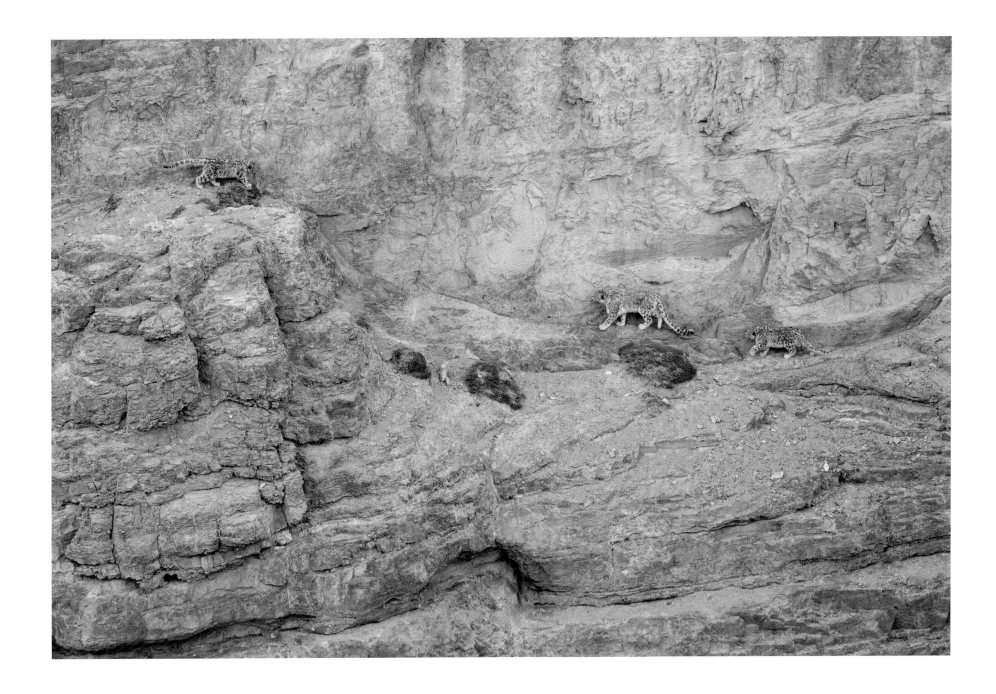

The way was difficult; they had to climb the rocky cliff to access the high plateau that extended above it. We were amazed by the power of the mother snow leopard as she climbed the vertical rocks with a few jumps, and the attempts of the little ones trying to climb and falling while following their mother made us laugh. It was twenty-five minutes of climbing rocks until they reached the top of the cliff. There the walk was easier for them.

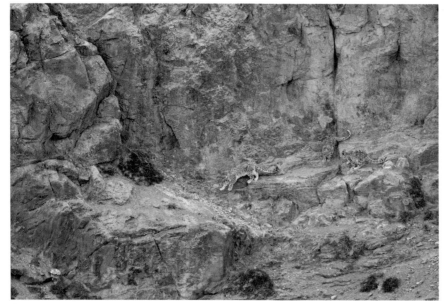

The family went toward the crest, where it was possible they would be silhouetted against the background of the snow of the mountains. *I hope so*, I thought, while I followed them through the viewfinder of my camera in the dimness of twilight.

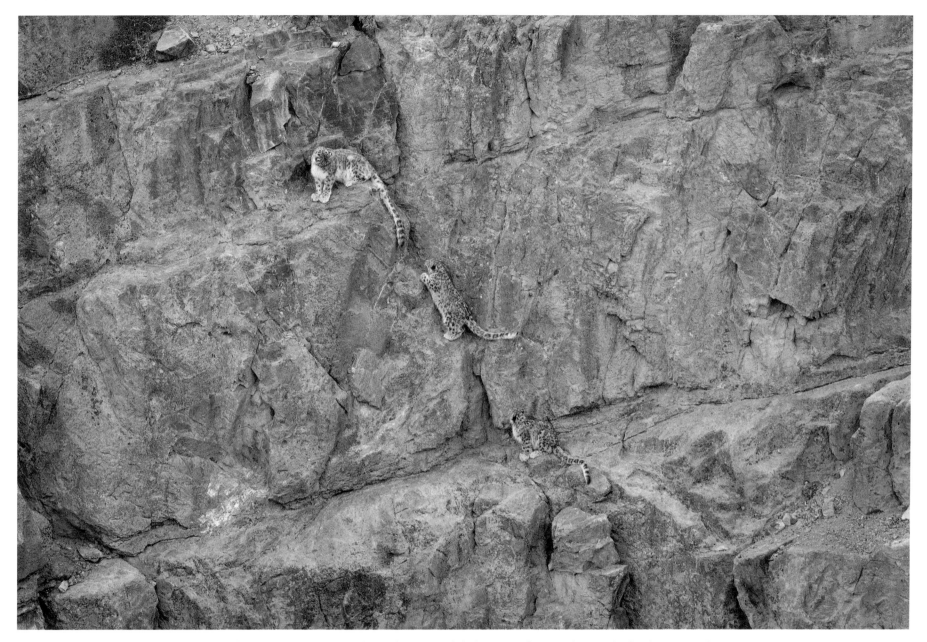

Finally, the mother appeared on the ridge, and I pressed the shutter: it was the last shot of the camera, the last photograph of the day. From a great distance, yes, but watching the natural behavior of snow leopards for hours without interfering in it had been a privilege and a tremendously rewarding experience.

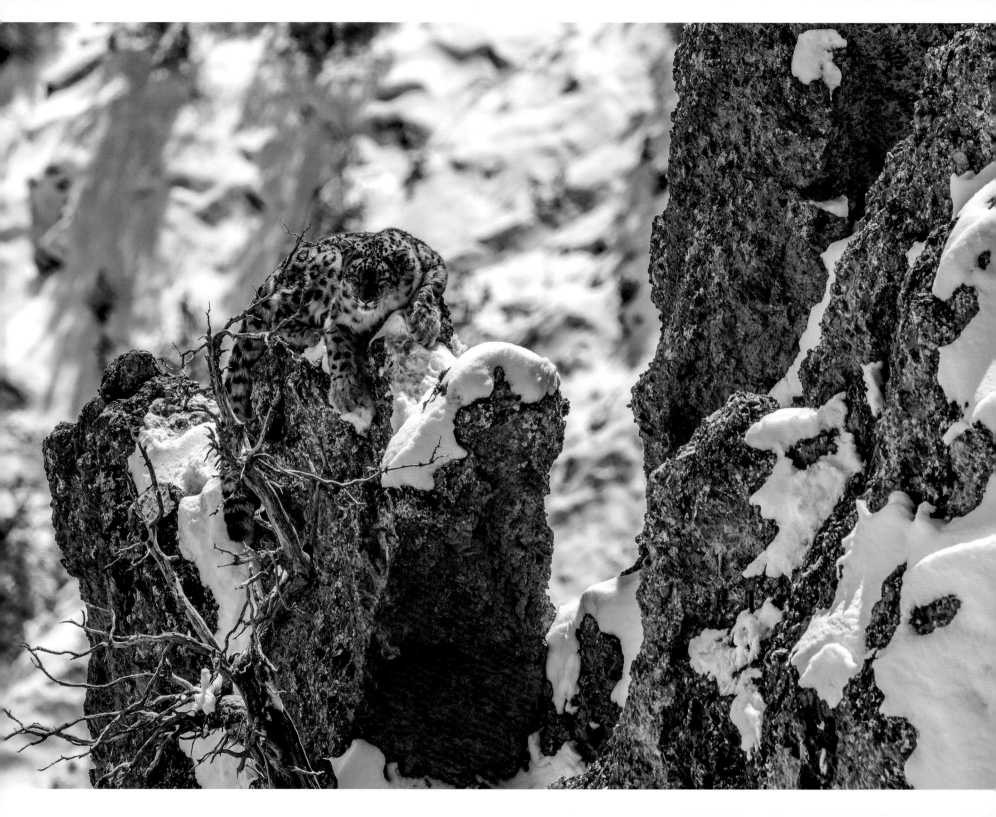

# THE PHOTOGRAPHER, THE SNOW LEOPARD, AND THE MOUNTAINS

## BJÖRN PERSSON

After days of waiting and contemplation, we finally spotted a snow leopard passing by on a remote top. Seeing the mysterious ghost of the Himalayas was an unforgettable experience in and of itself, but I wanted more. Somehow, I felt this was the day I had been waiting for my whole life. When the snow leopard finally disappeared over the ridge, I asked the guide if it was a good idea to trek to the other side of the mountain. He said no. It was already getting dark, and most likely the big cat would be gone by now. But the voice in my heart told me otherwise. I decided to get to the other side on my own. Deeply concerned, he explained that it was at my own risk, but before he had even finished his sentence, I was gone.

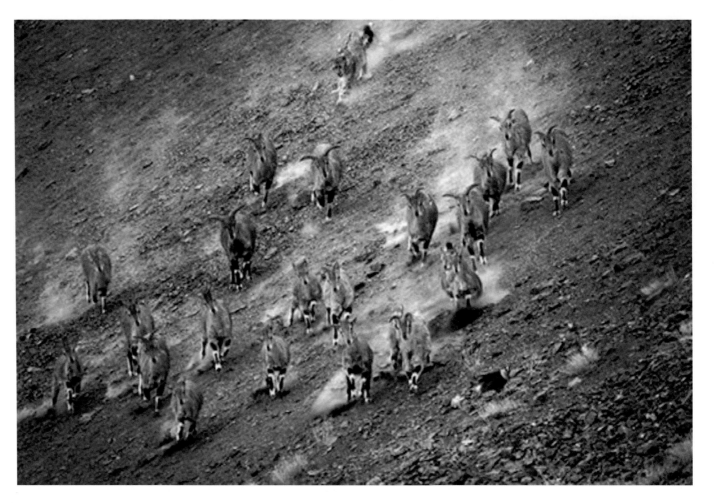

One hour later, and after a steep, strenuous climb up the mountainside, I lay down on the ridge to wait. Below me was a valley with some blue sheep grazing. Through my binoculars, I studied the terrain but couldn't see a thing. The sun was going down, and my whole body was shivering from the icy winds sweeping through the gorge. Another thirty minutes went by—nothing.

I was just about to give up when I realized that the blue sheep had frozen in their positions. Their ears pointed straight up, and they were all looking in the same direction. My heart started pounding. I still couldn't see anything, but now I knew it was there. Suddenly, a big dust cloud appeared before my eyes, and out came the snow leopard. He was pursuing the sheep, and in blind panic they started running up the hill straight toward me. Some of them passed so close they almost trampled me.

The hunt was over in a few seconds, and when the leopard realized it wasn't his lucky day, he stopped and started to make his way up a mountain in front of me.

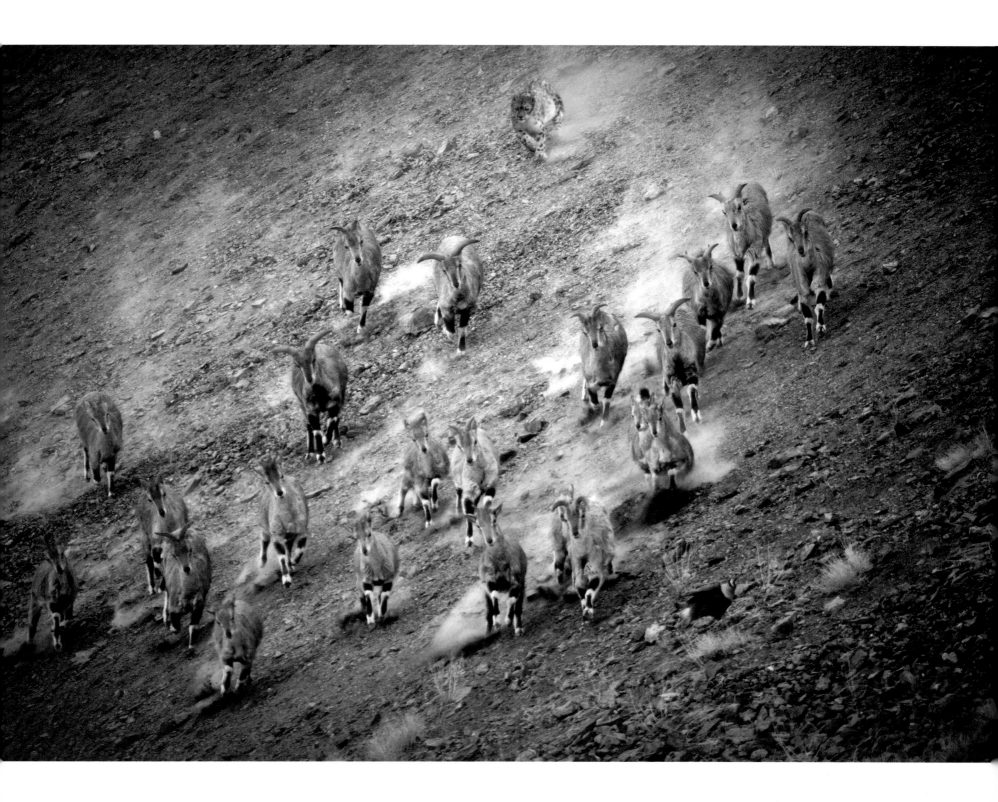

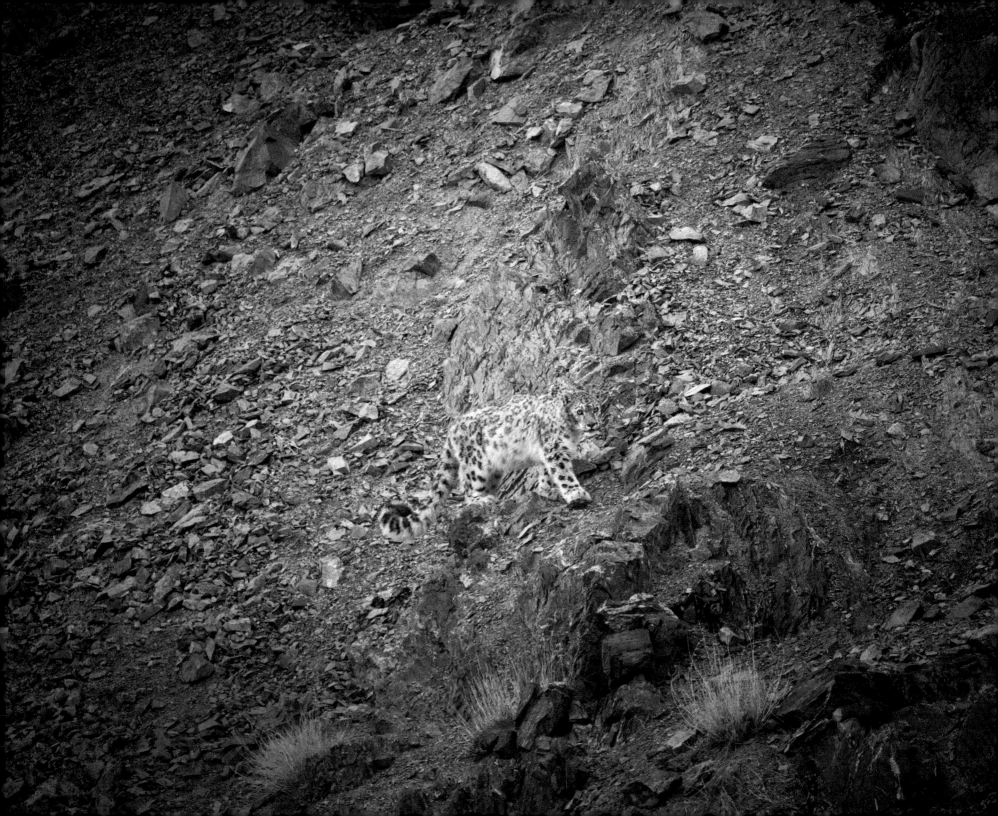

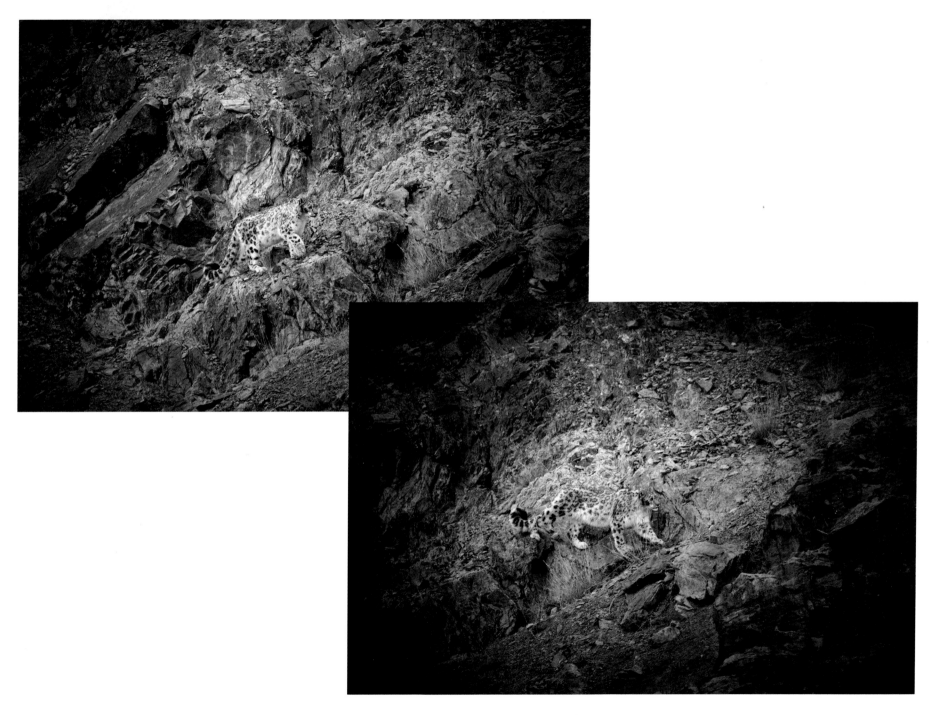

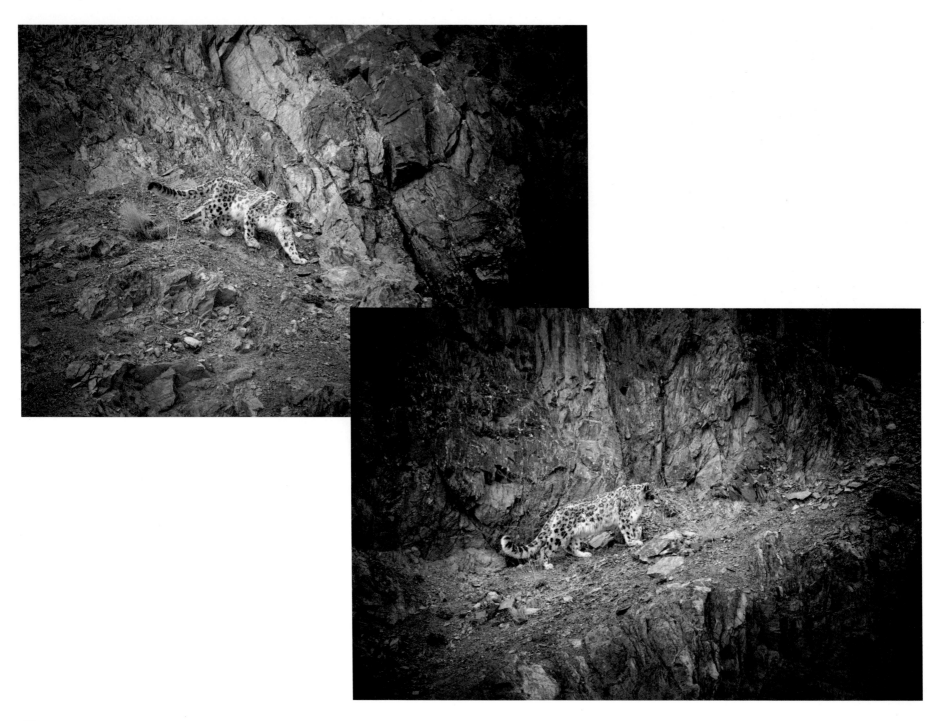

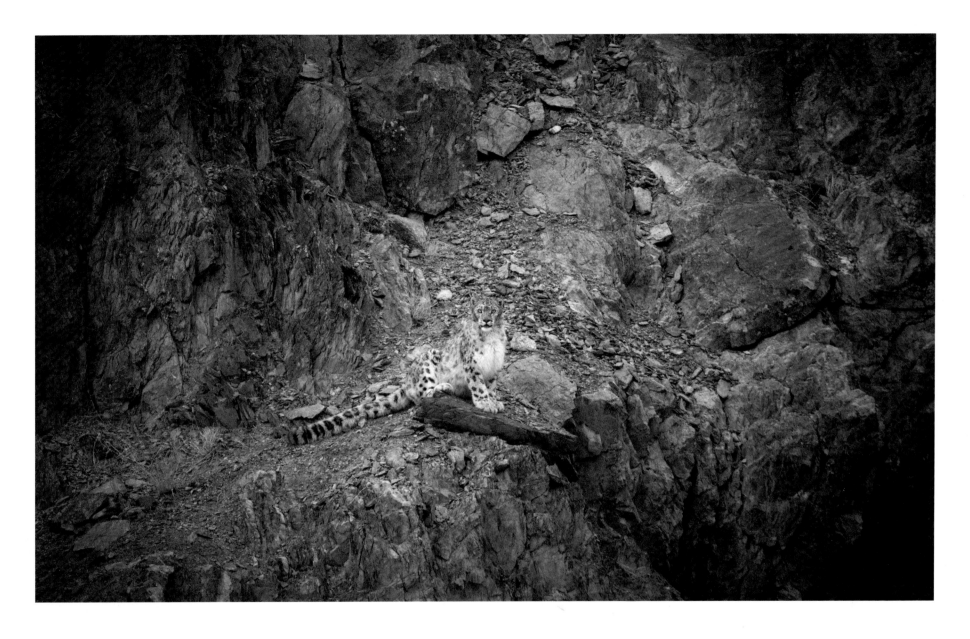

At this point, the distance between us was less than a hundred meters. But despite my big red down jacket, he didn't seem to notice me. Peacefully, he just walked up the side of the hill, sat down, and began to survey his territory for other prey. I couldn't stop taking pictures. It was the most beautiful thing I had ever seen.

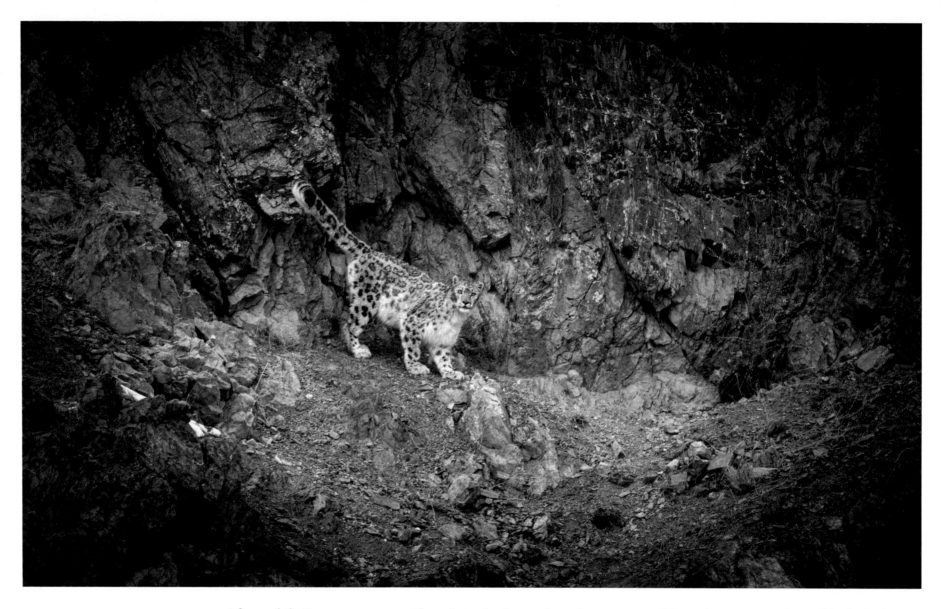

After a while, I put my camera aside and simply observed him. The moment was too good to be experienced through my lens. It was just me, him, and the mountains. A lot of people talk about having religious experiences. This was as close to one as I'd ever been. It was almost like he had come to me, not the other way around. And somehow it felt like he was now rewarding my determination by revealing himself to me.

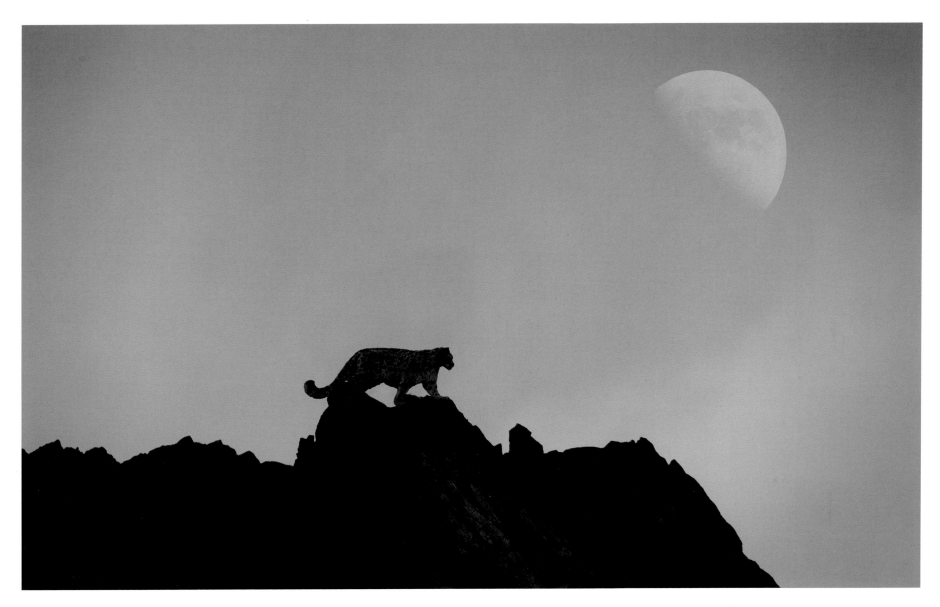

Ultimately, he was lit only by the moon, but even though my legs were so frozen I could hardly feel them, I didn't leave. Despite all the bad things going on in the world, there is pure, divine beauty to be found, and I was the fortunate witness. When he finally started making his way farther up the mountain, tears started welling up. Call me a softy, but this was the best moment of my life.

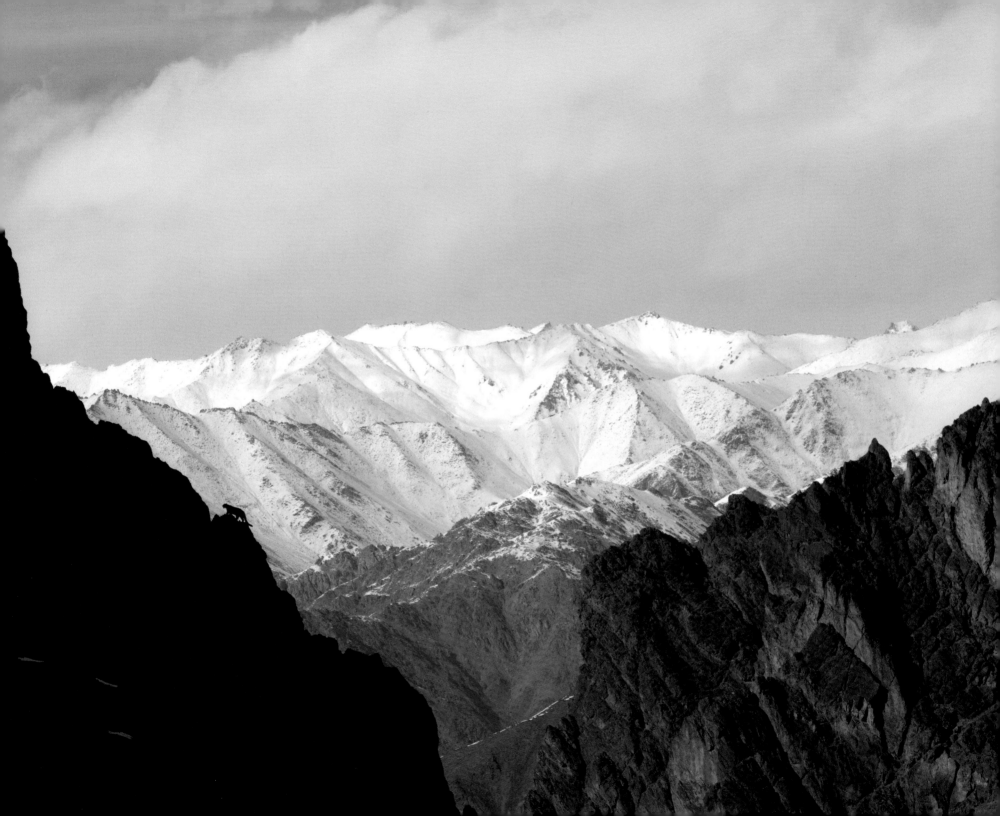

# THE BOND

It's −4°F, and the sun is starting to go down. For almost an hour, you've been lying, dead still, observing the snow leopard making its way up the mountainside. Only about two hundred feet away, it suddenly stops. Anxious not to be discovered, you hardly dare to breathe. Your frozen body is in pain, and ultimately you have no other choice than to change position. There is only the slightest sound of your movement, yet the snow leopard has reacted, your presence having been revealed. Glimmering in the approaching darkness, the snow leopard's icy blue eyes meet yours. Transfixed, you experience a silent communication with the great cat. For no more than a moment or two, it studies you, then turns away and moves on, having acknowledged the presence of its uninvited guest.

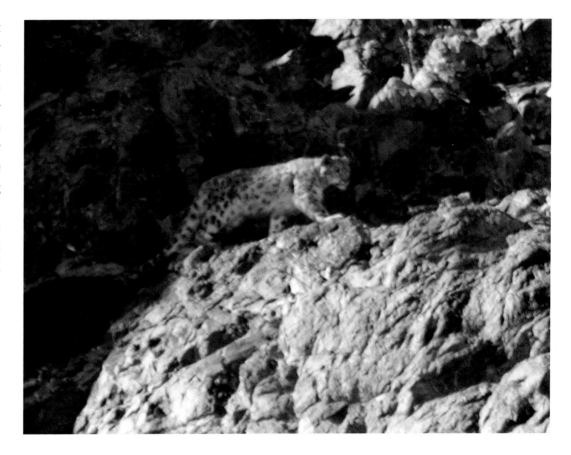

# THE SPIRIT ANIMAL

## SHAVAUN KIDD

Legends, symbols, and spiritual beliefs abound demonstrating the bond people have had for centuries with the spotted cat of the Asian mountains. Ancient petroglyphs found in Kyrgyzstan depict what are thought to be snow leopards hunting with humans.[91] However, Kyrgyz indigenous cultural practitioner Japarkul Raimbekov believes that to be a cursory interpretation. He sees the rock drawing, which traces a line between a snow leopard and a man holding a bow, as a metaphorical representation of the need for people to learn from the wisdom of the snow leopard and, by doing so, to overcome the destructive nature of the human species in order to bring about harmony and balance with the natural world.[92] In either interpretation, this petroglyph represents the deep connection people have long had with the snow leopard.

Throughout history, the snow leopard has been regarded as a spiritual being. Since ancient times, it has been thought of as a totem animal or spirit guide and worshipped as the lord of the celestial mountains.[93] As a source of spiritual power, it represents a "link between the spirit and the natural world."[94] In some ancient traditions, the snow leopard was seen as an animal that purified the human environment, and therefore it was forbidden to hunt, kill, or violate it in any way.[95] Today's indigenous cultural practitioners, calling on those ancient beliefs, look for ways to protect the snow leopard species from persecution while at the same time seeking to revive the cultural heritage of the communities they represent. Through their efforts, whether speaking one-on-one with individuals of the community or officiating at ceremonial gatherings, they remind the local people that the snow leopard is a sacred animal[96] and the protector of sacred mountains.[97]

Culturally, there is an abundance of evidence throughout the region that the snow leopard remains in high regard today. Its likeness is represented on coins, currency, and postage stamps. Sculptures of the great cat can be found throughout the twelve range countries. There is even a bronze sculpture of the snow leopard in Gorky Park in Moscow.[98] Hockey teams in Kazakhstan have taken names related to the snow leopard, and the mascot for the 2011 Asian Olympic Games was a snow leopard cub named Irby.[99]

The cultural importance of this mysterious cat is also evidenced by the superstitions that revolve around it. A recurrent theme of local legends is that if a person does

harm to a snow leopard, harm will come to them and their entire family. Variations of this legend have been told again and again in many different languages by people from most if not all of the range countries. They are perpetuated by multiple reports of actual illnesses, accidents, and injuries of some or all the members of a family responsible for killing a snow leopard in retaliation for livestock losses. Even coincidental deaths have been reported. Such occurrences only serve to reinforce this superstitious notion associated with the snow leopard.[100]

The communities of the Pamir-Hindu Kush mountain region, which encompasses the countries of Tajikistan, Afghanistan, and Pakistan, represent a diversity of language and culture. However, they share indigenous knowledge centered around their interdependence and interactions with the environment—the land, weather, and wildlife.[101] A widely held belief of this region is that there is a spiritual separation of the alpine terrain, which is considered to be a place of purity and spiritual beings, from the lower elevations where humans dwell. Plants such as the primrose and animals like the argali, ibex, and snow leopard that inhabit the higher elevations are, by association, also of a pure and spiritual nature. The supernatural beings said to inhabit the high mountains are referred to as *pari* and, notably, are female. Mountain people living in Pakistan, China, Afghanistan, and Tajikistan called the Wakhi use the term *mergichan* to describe the supernatural beings of the *mergich* realm, the land of mountains and high pastures. Community members are allowed in this area only during the summer and only after ceremonial requests to enter. Though the *mergichan* are

not thought of as evil, they are viewed as overseers, ensuring that the environment isn't harmed by the actions of humans. Maintaining positive relationships with these beings is seen as a means to guarantee successful husbandry of their domestic flocks and successful hunting of wild game.[102]

A remarkable aspect of this belief is that the *mergichan* are able to assume the form of a *mergich* animal, which personifies the nature of that supernatural being, in order to help or harm humans. The snow leopard, being powerful yet secretive and elusive and rarely seen by or interacting with people, is a perfect example of a *mergich* animal.[103]

A Wakhi story told to John Mock of the American Institute of Afghanistan Studies, Boston University, during his research in northern Pakistan concerned an incident involving a *mergich* animal that appeared to a man's father and the father's uncle. In the story, the *mergichan* first appeared to the man's father as a woman with a white scarf who vanished before anyone else had seen her. Then that evening as the men slept, two horses and their riders appeared to his father in a dream. The first horse passed him by, but the second horse stopped and bit him on the leg. After dreaming this, the father woke to find that a snow leopard was lying on top of him, and he couldn't move. After the cat got up and left their hut, his father discovered that he had been bitten and was bleeding profusely. The men were frightened and throughout the night attempted to scare the snow leopard away by placing a stone in front of the door to the hut and building fires.

But the snow leopard was not dissuaded and continued to harass them. Eventually, his father's uncle was going to shoot

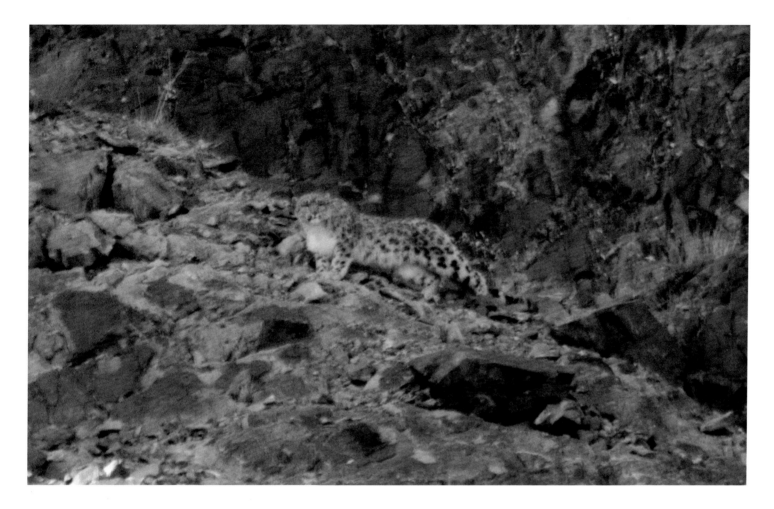

the cat, but the father passed out. While he was unconscious, the snow leopard assumed the form of a horse and went away. The next day, the men went for help and got a dog to take back with them to the hut. That night, the snow leopard came again and attacked the dog, and then stayed near them the rest of the night, keeping them awake. According to Mock's account, from that time on, the snow leopard continued to come to the man's father, never harming him again but rather seeming to befriend him. Appearing in his dreams, the snow leopard would advise him where to hunt. The spiritual leader of their village told the man that it was a *pari* that had disguised itself as a snow leopard. Until the father's death, the snow leopard stayed with him. But after the father died, they never saw the snow leopard again.[104]

Indigenous cultural practitioner Norbu Lama also encountered a *pari* or *mergich* animal. This event occurred one afternoon after he officiated at a spring gathering held at Mönkh Saridag, the highest mountain in the Republic

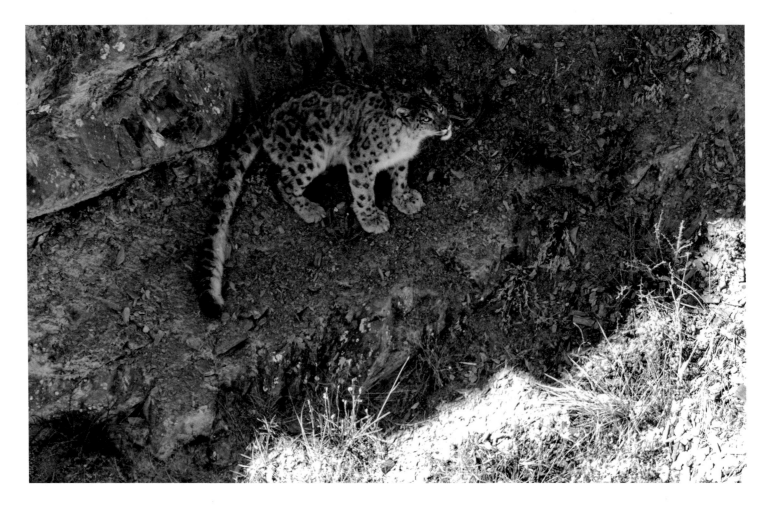

of Buryatia in Russia, to pay homage to the snow leopard. Norbu, his teacher, and their companions were the last to leave. As they were driving up a pass near Lake Baikal, they saw someone moving along by the side of the road. When they slowed down to offer the person a ride, they realized it was in fact a snow leopard, which was now sitting on a rock, looking at them curiously as they approached. They stopped and got out of the car, staying with the snow leopard for almost an hour. They watched as it played and jumped from rock to rock. Norbu noted how elegantly it moved and how beautiful its pelt was. He described how as it turned from side to side, they could see the golden tones of its fur and then, from a different angle, the bluish tones. It was apparent to them that the snow leopard was undisturbed by their presence and instead chose to stay and silently commune with its human guests.

Norbu described this occurrence as a "secret communication." His teacher explained to him that "it was the sacred spirit of the mountain that had appeared as a snow leopard."[105]

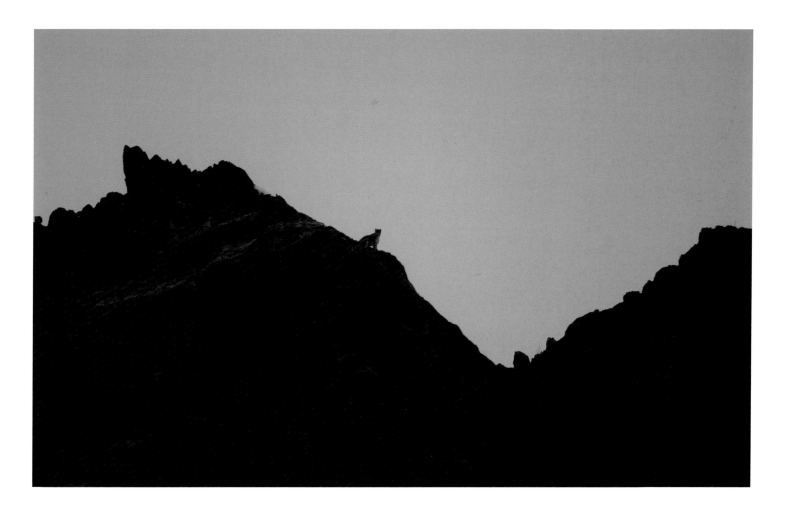

Stories such as these carry the powerful message that although the snow leopard is of great ecological importance, what resonates with local community members is its cultural and spiritual significance. Based on their beliefs that nature and religion are inextricably linked, they see the snow leopard as an overseer of the landscape—one that not only maintains the balance of its ecosystem but is a spiritual guardian of the plants and animals that inhabit it as well.

Snow leopard conservationists work with community-based conservation organizations within snow leopard range countries to incorporate these indigenous beliefs into a relevant conservation message that seeks to preserve the landscape by reviving and strengthening the cultural history and beliefs of the people living with snow leopards.

To acknowledge the relationship we have with the snow leopard, to not only admire and respect it as a species but develop a kinship with individual animals, is an important step toward successful coexistence.

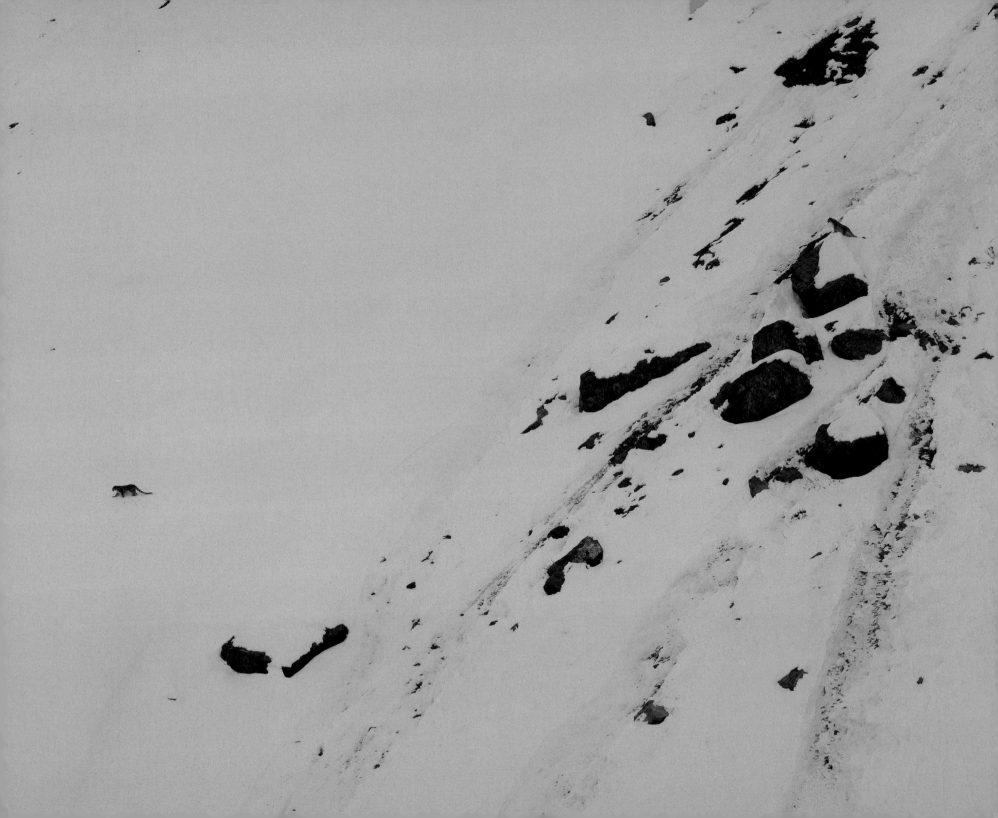

# A DAY WITH A SPECIAL FAMILY

## ORIOL ALAMANY AND EULÀLIA VICENS

During our third winter trip to the Himalayas in search of "our" beloved snow leopards, Eulàlia and I spent a few days in an area on the Indo-Tibetan border that we were familiar with from previous years. This time, the ground was covered with snow like we had never seen before. Fortune favored us again this winter, however. On the previous day, we had seen a male snow leopard from a great distance at the top of the valley. So, early the next morning, trudging through the knee-deep snow, we went up the valley, hoping to find him again.

At mid-morning, one of our local spotters discovered a snow leopard. It was difficult to see even with the aid of binoculars, but there it was, lying on an extremely distant ledge on the other side of a deep, rocky canyon. The snow leopard was sunbathing—although the day was clear, at an altitude of 4,400 meters (14,400 feet), the temperature was only around 10 °F.

But it wasn't the male from the previous day. We were surprised to discover not one, but three snow leopards! From time to time, the other two, which were hidden

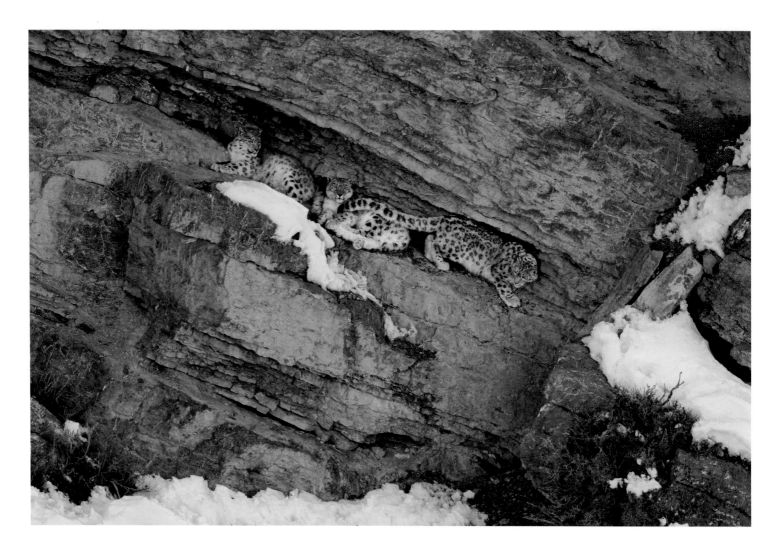

from view behind the rocks, would raise their heads. Remarkably, the group turned out to be the mother and two cubs Eulàlia and I had observed in the same place the winter before. Our local partners had lost track of them for many weeks and had had no news of their whereabouts. But there they were again, the snow leopard accompanied by her cubs, which were already as big as their mother.

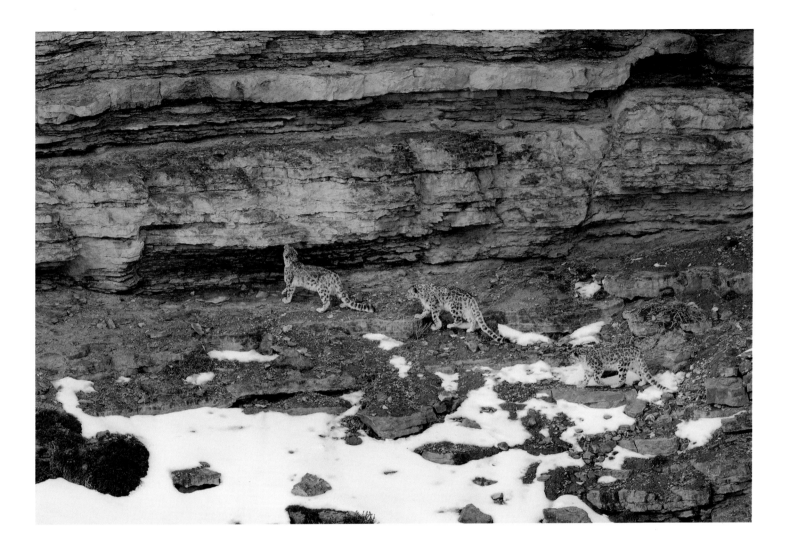

Rarely have I been so happy to encounter a particular wild animal. And what a joy it was to be able to acknowledge this mother's accomplishment. While living in extreme conditions, she had successfully seen her cubs, who were now about twenty-one months old, through another year.

We sat in the snow, and after half an hour of waiting, the mother snow leopard got up and began walking, followed by her two offspring trailing behind single file.

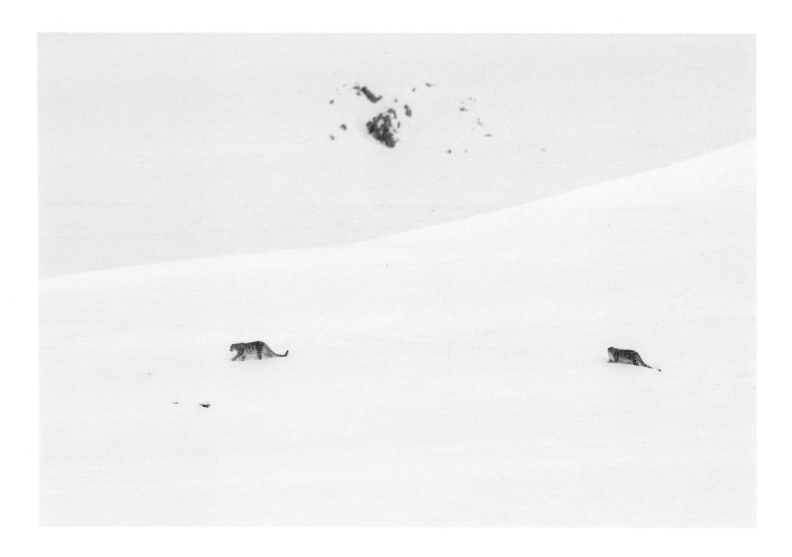

Through my camera's powerful telephoto lens, I observed them as they crossed the snowy high plateau while a golden eagle flew overhead. Seeing these magnificent creatures moving through the deep snow was an epically beautiful image.

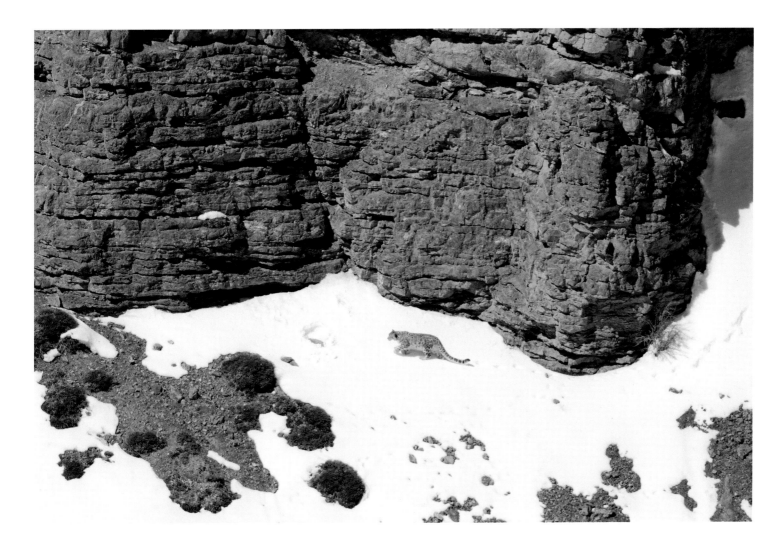

As they made their way through the snow, one of the cubs whirled around and began to lag behind. He ended up following a different path that descended down the canyon walls. His mother and sibling continued along the upper edge of the cliff, ignoring his absence. As the cub traveled farther and farther away from his family, we wondered if we were witnessing the beginning of his independence.

After almost two hours, the adventurous cub seemed to suddenly realize that nobody was following him. He was alone on a snowy ledge that hung over the void. He looked around and meowed loudly for his family, but they were already a great distance away and had stopped to rest on some rocks. The youngster repeated his anguished calling, which echoed through the canyon: "Where are you, where are you?" He then started retracing his path up the canyon. As he climbed, he inspected each shelf, looking desperately. We were getting worried: Would he be able to find them?

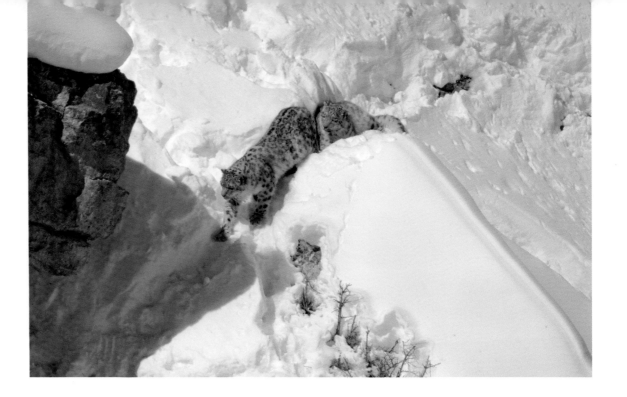

When they had spent more than two and a half hours apart, the cub suddenly appeared next to his sister, whom he greeted with head rubs. We breathed a sigh of relief. It did not seem to have been an easy task for the cub to find them in the immense landscape of mountains and snowy canyons.

For the remainder of the afternoon, the two cubs played games of chase and rolled in the snow as their mother guided them down the valley. It was apparent that she wanted to leave the area, probably in search of food, as we hadn't seen any ungulates that would serve as prey for the snow leopard and her grown cubs.

As the sun went down behind the mountains, the temperature fell, and the snowy landscape began to turn a shade of blue. Undeterred by the approaching night, the snow leopard family continued to descend down one side of the canyon as we followed on the opposite side, attempting to keep up. We knew we should return to the village before it was completely dark, but our guide Tenzin alerted us: "Look, there is a group of blue sheep. Let's wait a little longer."

Suddenly, the snow leopard mother shot out, chasing one of the sheep. It was almost dark, and through the view-finder of my camera I could hardly see what was happening. But Tenzin yelled at me, "Shoot, shoot!" I quickly pressed the camera shutter, without knowing what I was shooting. But in the imperfect and grainy image, the success of the pursuit was visible. It was not a good photo, but it was an incredible experience.

The next day, we would go out once again to the mountain to follow the life of this special family.

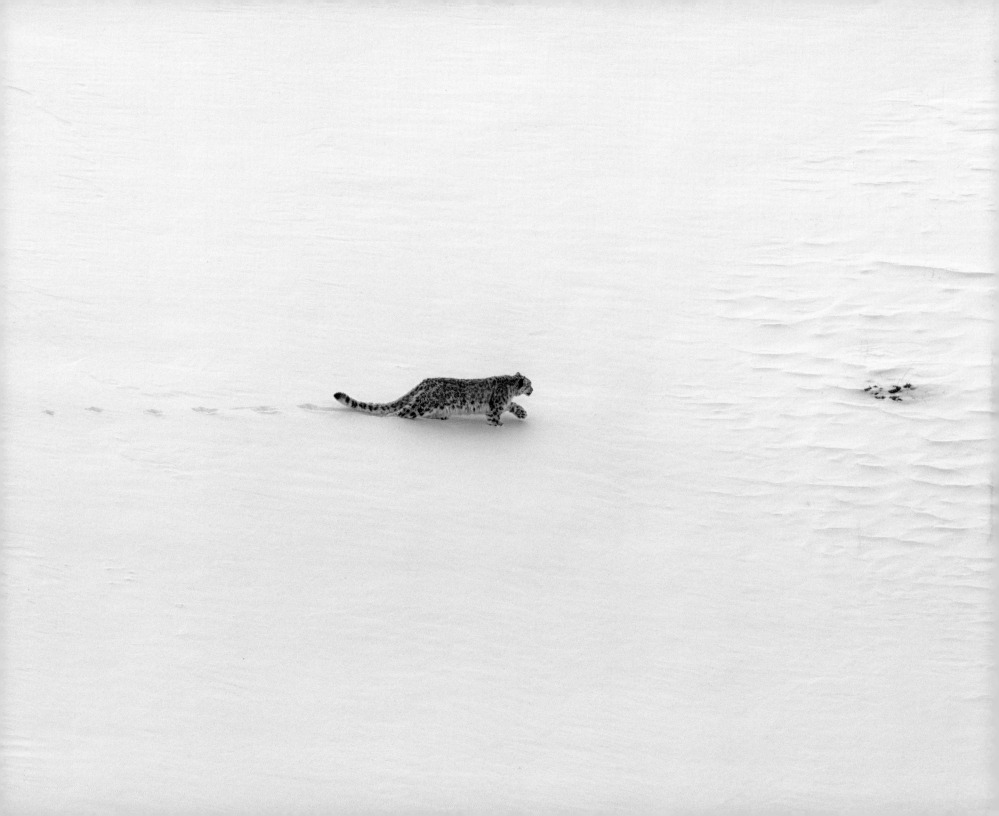

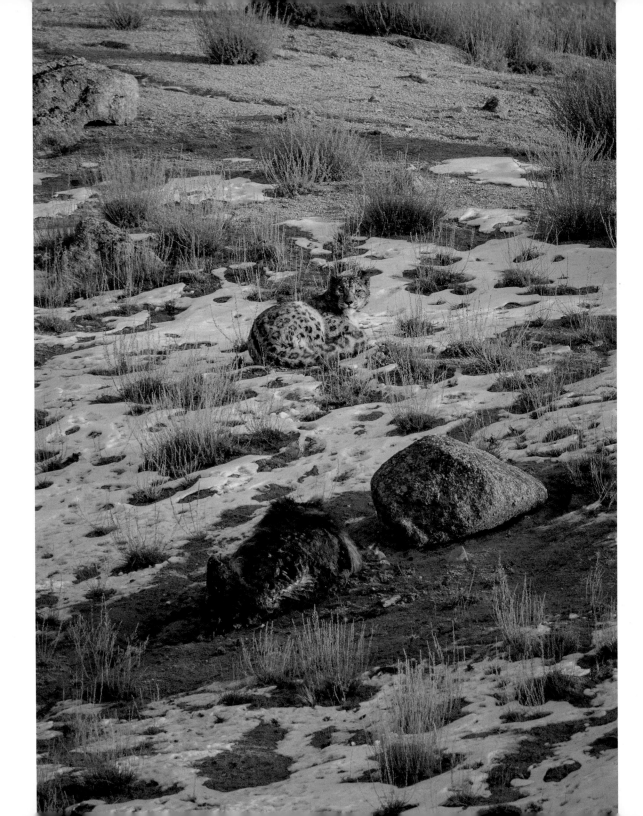

# THE SNOW LEOPARD REVEALED

## JAK WONDERLY

After a wearying eight-thousand-mile journey, I found myself at the base of a seventy-one-foot-tall golden Buddha. Near Stok Monastery in Ladakh, India, we strapped old military camping gear to the backs of ponies and trekked into the colossal Himalayan landscape. With equal parts excitement and trepidation, I hiked along the faint and rugged trail into Hemis National Park, stopping near prayer flags and engravings of stupas to catch my breath.

I had been fortunate to photograph all the other big cats in the wild, and I expected the snow leopard expedition to be the most difficult. I was untested at both high altitudes and winter camping, and I was about to climb to 14,000 feet and sleep in a tent at −20 °F. The latter in particular seemed downright dangerous, but I trusted my team and was driven to find the famously elusive grey ghost.

The snow leopard was a near-mythical creature in my mind, an animal of haunting beauty and mystery, dwelling halfway between heaven and earth in terrain wholly un-suited to humans.

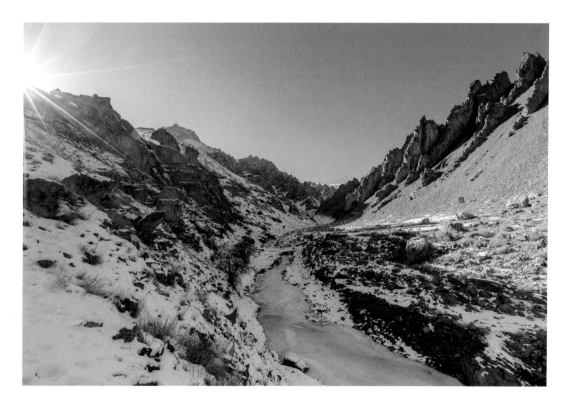

When I woke that first morning in my tent, everything inside was covered in frost. My down parka and pants, which I had piled on top of my sleeping bag for warmth, were frozen rigid. Most of the battery-powered equipment would not turn on. Anything liquid that wasn't inside my sleeping bag was now solid ice, including my sunscreen and contact lens (I only wear one, the result of an old injury to my left eye). Lines of dried blood ran across my face from a midnight high-altitude nosebleed. But my fingers and toes still had blood flow, and when I stepped outside in the predawn hour, I was treated to an ink-blue starry sky with snow-capped peaks all around.

Each morning we climbed to a higher vantage point and spent all ten hours of daylight looking through scopes, hoping to see the flick of a tail or the twitch of an ear, something to give away the snow leopard's legendary camouflage. Occasionally, we would spot blue sheep—a staple of the snow leopard diet—in the distance or a golden eagle circling high above.

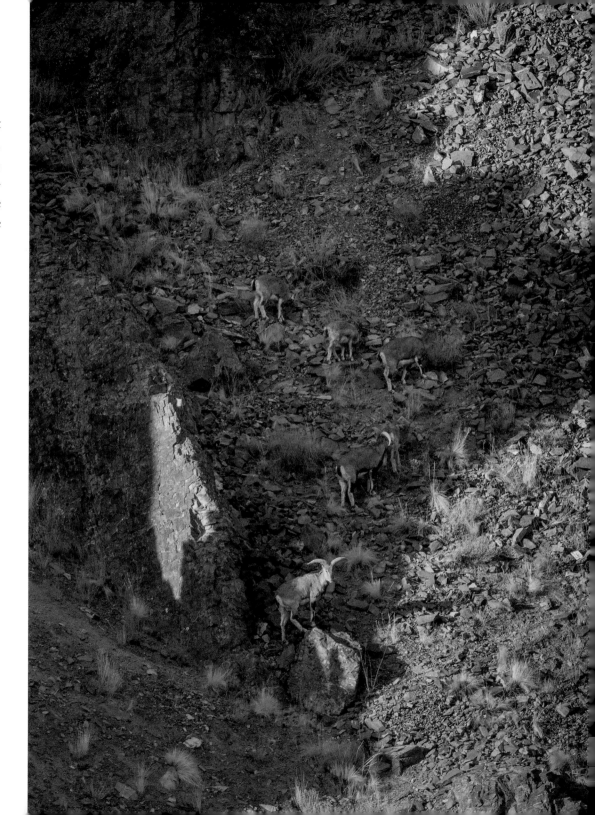

My eyes were magnetically drawn to a distant ridge covered with ancient stone ruins. When the sun rose over the mountain peaks late in the morning, the ruins were suspended in rays of light, a beckoning mystery.

In the evening, I would burrow into my tent again for fourteen hours of bitter darkness. The eBook reader I had packed was frozen, leaving my mind free to hallucinate dizzying variations on finding leopard spots among the endless patches of rock and snow.

After a few days of searching, we discovered pugmarks in the snow. The tracks were a couple of days old already, and as the grey ghost can travel twenty-five miles in a single night, there was no point in trying to follow them. But just seeing the paws' outline in the crystalline snow and knowing that my path had crossed with hers made the already exhausting journey feel worthwhile.

Trekking for snow leopards is so single-focused and challenging that each moment necessarily becomes a meditation. The ground is nothing but ice and sharp-edged rock, so each step must be taken mindfully. The thin air demands you move slowly, always conscious of your breathing. Hemis National Park is easily the quietest place I have ever been, and as my team spoke Ladakhi and little English, my conversation or any noise at all for that matter was limited to just moments a day.

One morning, after I was a little more acclimatized, we decided to climb up to the ruins, which I now called "the castle," for a vantage point. At the base of the ridge, I found a worn-thin horseshoe, which I took as a sign of good luck until I found a pony skull close by in the riverbed. The climb was steep and slippery, ninety minutes of heart-pounding effort. Eventually, we arrived at the sprawling complex of crumbling stone walls, precariously perched, with views of peaks for miles in every direction. It felt completely outside of time, a home worthy of my mythical estimation of the snow leopard.

The next day when our team split up to cover more ground, I was compelled to make the climb again, alone, to soak in the sheer majesty of this ancient castle. I later learned that the structures were a citadel built approximately a thousand years ago.

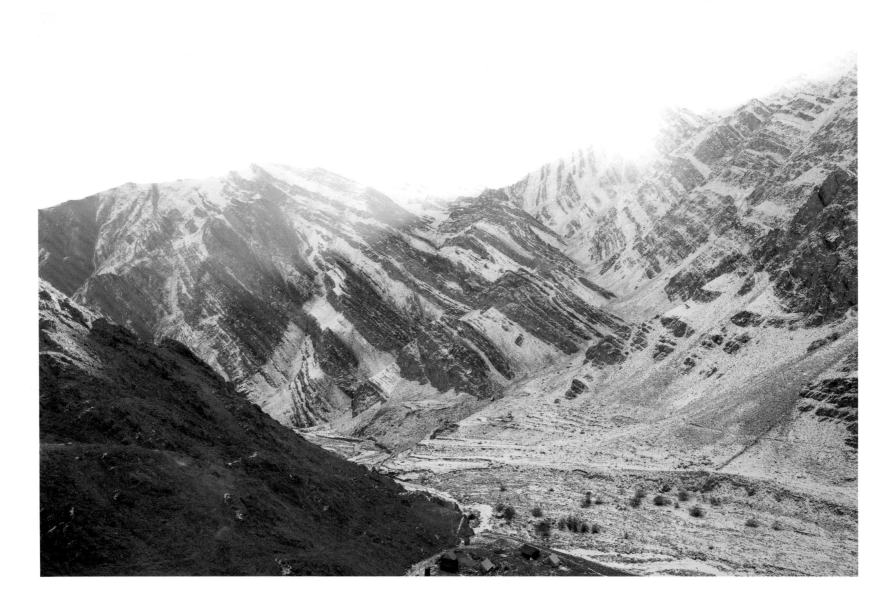

We hiked farther and higher each day. My guide discovered the tracks of what appeared to be a mother and two cubs, but again, the tracks were not fresh. I tried to remain patient, as the days left on my two-week expedition were down to just a few and we had not yet seen a snow leopard.

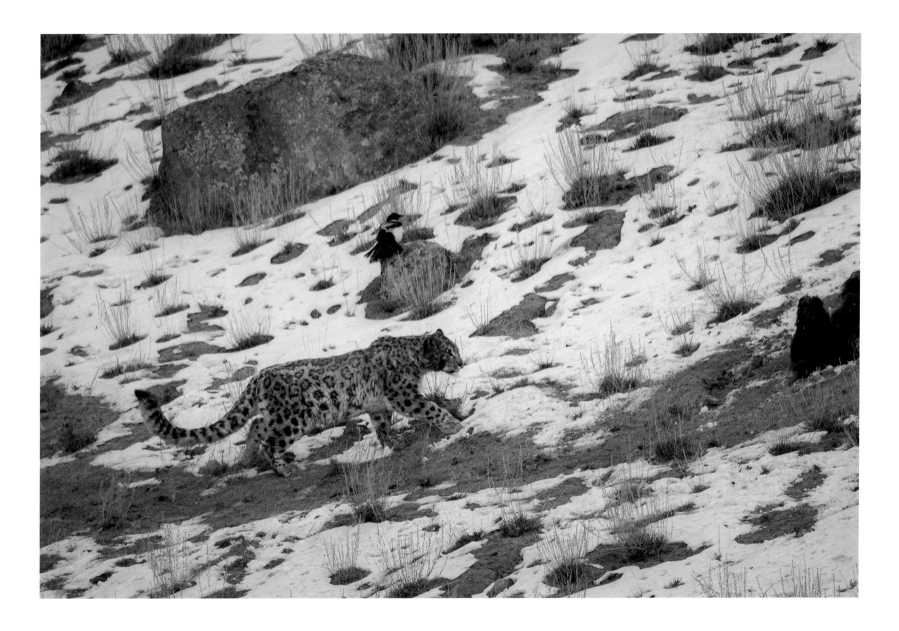

As the days passed in this silent stone kingdom, I felt increasingly strong, quiet, and adapted to winter life in the Himalayas. My eyes were better at spotting wildlife half a kilometer away, my lungs were less strained by the altitude, and my feet were more confident on the uneven rocks (although my brand-new boots had already split a seam). With each day, I felt a hair more akin to the grey ghost.

Eventually, we decided we'd better try our luck in a new location. Early the next morning, we tore down camp, loaded the ponies, and trekked out of the valley. As soon as we could get a cell phone signal, we checked in with Jigmet Dadul from the Snow Leopard Conservancy India Trust. He had exciting news: a report had come in from a remote village that a snow leopard had killed a yak during the night. Jigmet assured me that the leopard would likely remain in the area for several days to feed on the carcass. With goosebumps, I ended the call, and we hiked quickly back to the roadside, where we hopped in a vehicle and made the dicey three-hour drive to the new location.

When we arrived, I learned that the yak was a livestock animal belonging to one of the six families in the tiny village. Snow leopards preying on livestock are a serious problem. It is not uncommon for farmers and herders to kill a snow leopard in retribution. This would be a tragedy, but I could understand their motivation. Loss of livestock to predators is a real threat to a family's food source and/or livelihood.

We hiked outside of the village to an open valley, where the yak carcass lay in the sun. A couple of red foxes were feeding on the meat, and the leopard was nowhere to be seen. She was, however, almost certainly on the mountain within eyesight of the yak and us. Our team set up scopes and searched for any sign of the cat, staying several hundred meters from the kill site.

Despite a group of expert spotters, it wasn't until a young boy from the village pointed out the ridgeline where the cat was last seen that we finally got a glimpse of the grey ghost.

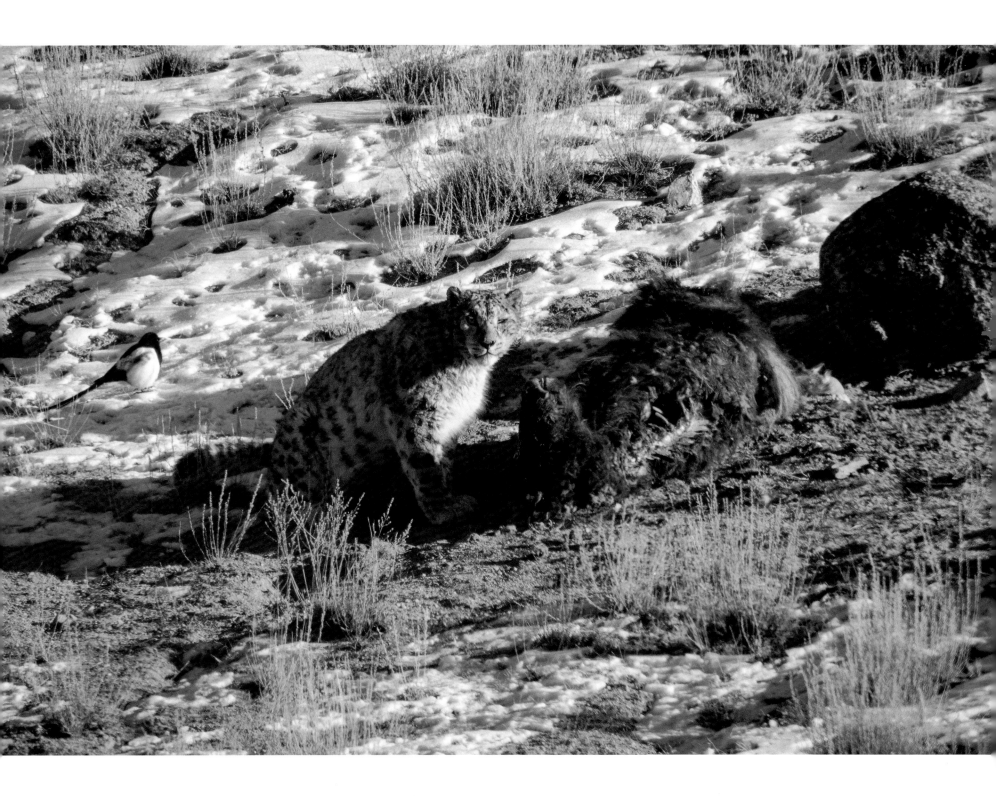

I saw a gray rock in the golden sunshine among many other gray rocks, but this one was a little softer around the edges. And then it lifted its head and looked directly toward us. She was beautiful, darker than I had expected, and being backlit by the sun gave her the appearance of having a mane.

We measured her at six hundred meters away, much too far for a clear photograph, but I was ecstatic that we had finally gotten a glimpse of one of the world's most elusive creatures. After a few minutes, she stood up and disappeared over the ridge. I was afraid that was the last we would see of her but tried to trust she would inevitably come down to the yak. Our team hid behind another small ridge to ensure that we were not dissuading her from returning to feed on her kill.

Finally, as the sun fell behind the jagged mountains, she emerged again and sauntered down toward the yak, but the light was much too dim for usable photographs. We soon returned to the village with hopes we would find her there again in the morning.

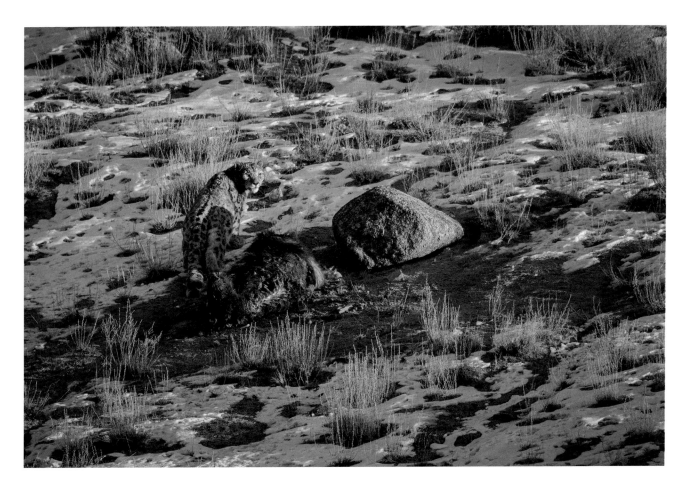

Well before the sun was up, we walked in blackness toward the kill site, because we didn't want to risk disturbing the leopard with flashlights. We set up a tent blind about two hundred meters from the yak, and then most of the team retreated to ensure minimal noise and movement. As daylight crept up, I could make out the snow leopard sitting right next to the carcass.

She was facing my direction, no doubt keeping watch on the human presence. I squinted into the 800mm lens, closing my previously injured left eye to better focus my right one into the viewfinder. To my dismay, I saw that she had been injured. Her left eye was swollen shut, and there was blood running from the eyelid down her cheek. I had spent months preparing for this trip, traveled to the other side of the world, and after great exertion had not only seen a snow leopard but discovered I had something in common with her. I sat in the blind, having a one-eyed staring contest with the grey ghost, for hours.

I had expected to find her high in the mystical Himalayan mountains, but here she was on the edge of the village, seriously injured and at risk of human conflict.

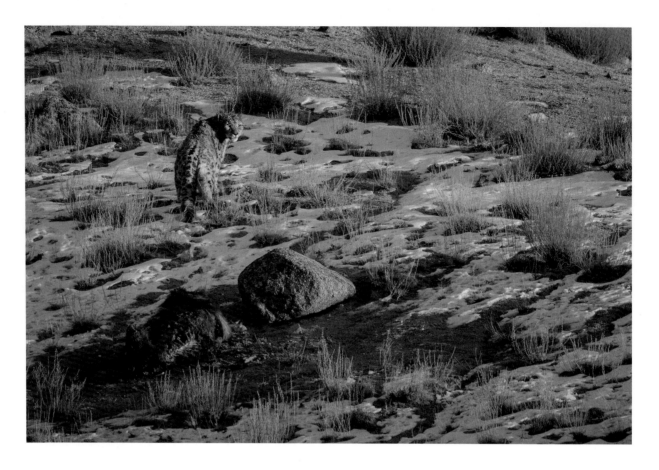

During the day, when the harsh light made photography difficult, I inquired about the loss of the yak and interviewed the farmer it belonged to. A yak of this age would be worth approximately $US150, several weeks if not several months of pay for people in this region. Fortunately, the Snow Leopard Conservancy had already established a livestock insurance program in this village, and the farmer who'd lost the yak was a participant. He would be reimbursed in full for the loss. In addition, our team and several other parties that passed through the farmer's land to see the leopard made a cash donation. I personally handed him some money because I felt so grateful to have seen this animal, and it was a once-in-a-lifetime opportunity to buy a snow leopard a yak burger.

The Conservancy has worked with the locals to establish homestays, so that visitors have a comfortable place to sleep when pursuing snow leopard sightings in the region, earning the villagers additional money from snow leopard activity. The local people also make small animal figurines out of wool, a process that takes an entire day, and sell them for $US20–25.

These conservation programs have turned the leopard from a threat into a blessing for this small community and many others like it.

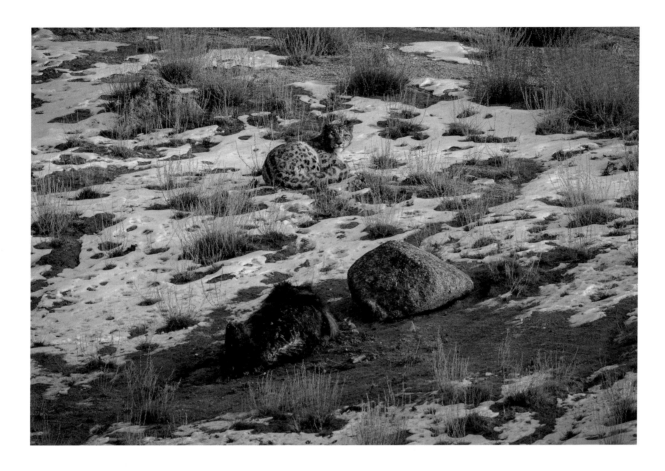

Over three days, I had a total of twelve to fifteen hours with the snow leopard. Fortunately, by the third day, the swelling on her face had diminished, she had cleaned off the blood, and the eye looked intact. The last time I saw her, she stood in beautiful evening light, looking right at me. Teary-eyed, I said thank you to her and to everyone who helps protect the grey ghost.

For me, the snow leopard represents that precious part of us—mystical and often hidden from the world—that holds great power. Spending time in her world and finally seeing her was like a dream, one that continues to empower me.

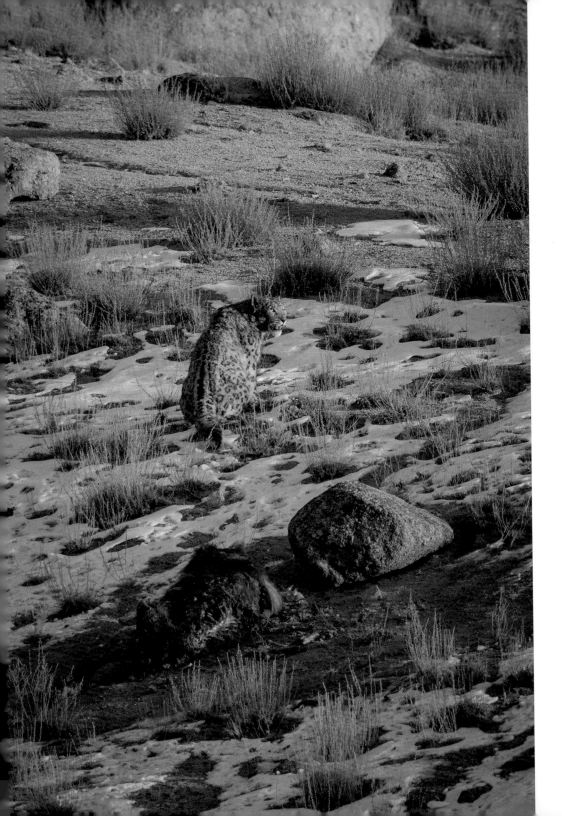

The snow leopard needs vigorous protection so that she can continue to inspire our souls.

# BY SAVING THE SNOW LEOPARD, WE ARE SAVING OURSELVES

Even with all the natural beauty around us, our world can be a harsh, ugly place. Day after day, we are fed news of wars, starvation, racism, and human injustice. Our thirst for optimism and beauty has probably never been stronger. But in our quest for spiritual well-being, we forget that true natural beauty is already out there. The snow leopard is one of nature's most exquisite creations. Long before humans appeared, it was roaming the snow-capped ridges of the mountains. Unmoved by human destruction and with wisdom reflecting in its iridescent blue-green eyes, it still patrols the ridges as it has done for so many centuries, watching over the world.

And so we must do whatever we can to protect the snow leopard, not only because its presence ensures the stability of the high mountain ecosystem, but also because this mysterious cat in some way provides hope for humanity. When we save the snow leopard, we're not just saving a species from extinction, we are saving ourselves.

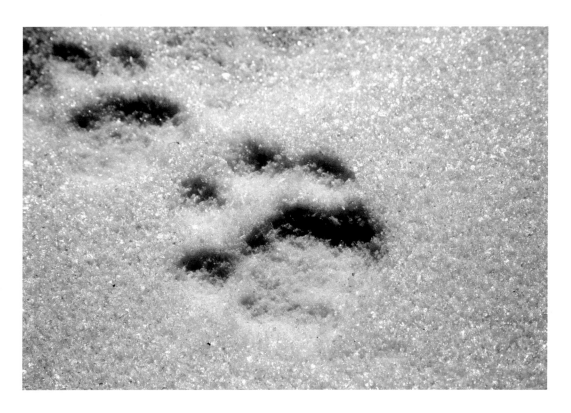

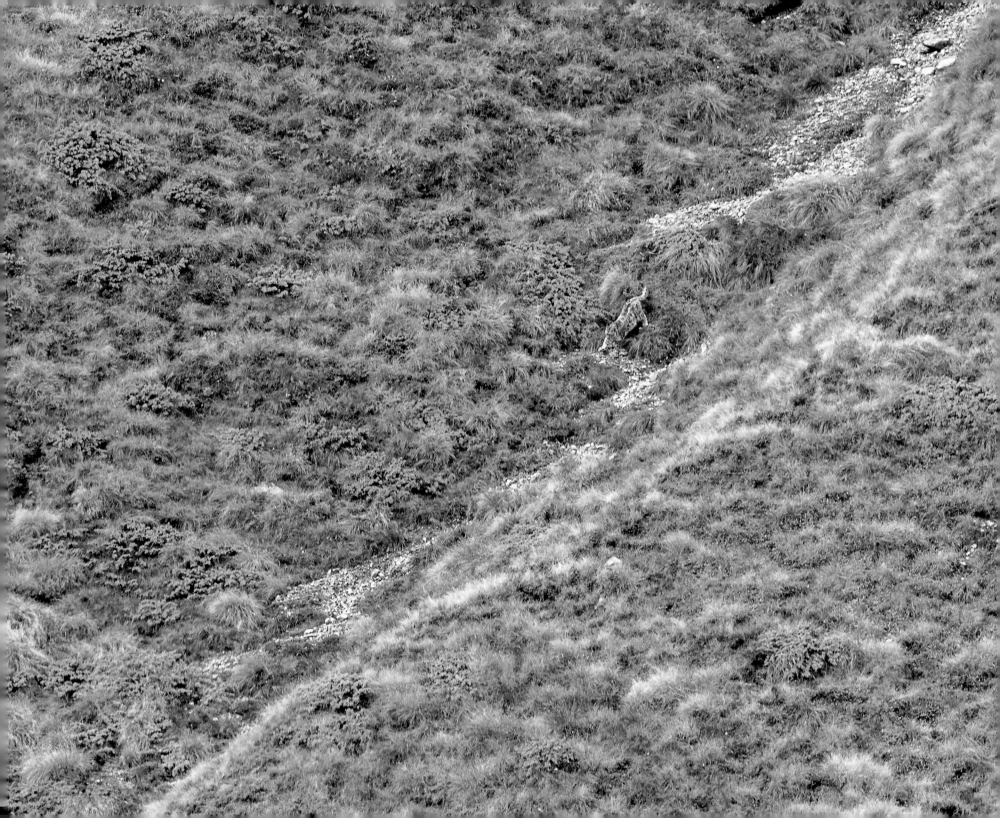

# EXPLORING SNOW LEOPARD CONSERVATION

## The Ecological Value of the Snow Leopard Species

The snow leopard, a keystone species, has a huge impact upon the health and stability of the mountain ecosystem within which it lives.[106] Being an apex predator, at the top of the food chain, the snow leopard maintains the balance of the ecosystem by controlling both the size and the health of its prey population.[107] Without the presence of the snow leopard, there could well be an explosion in the number of wild sheep and goats it preys upon, leading to overgrazing. This in turn would trigger a domino effect of soil erosion, landslides, and flooding, resulting in the deterioration of a fragile yet valuable ecosystem.

The Central Asian ecosystem is of immense importance. Referred to as the Third Pole, this mountainous region surrounding the Tibetan or Qinghai Plateau contains the third largest store of fresh water on the planet, in the form of permanent ice.[108] Melting ice feeds Asia's ten largest rivers, which provide water for drinking and irrigation to more than 1.3 billion people, approximately 20 percent of the world's population.[109] To preserve this crucial ecosystem, maintaining the biodiversity and stability of the region is necessary. The snow leopard is an essential part of the equation.

## The Coexistence of Two Apex Predators

The big cat is not the only apex predator in its domain. It shares its home with the Himalayan wolf, *Canis lupus chanco*. Although there is some overlap of prey, wolves and snow leopards occupy different predatorial niches in the ecosystem, determined by a number of factors such as type of terrain; seasonal migration, hibernation, abundance, and variety of prey; hunting strategies; and social behaviors.[110] The wolf is approximately the same size as a snow leopard, but it prefers hunting in flat open areas such as meadows and grasslands, whereas the snow leopard is better adapted to hunting on rugged, steep terrain.[111] The type of prey similarly differs. According to a study performed in Nepal, wolves preyed more upon plains dwellers and less upon cliff dwellers than their felid neighbors.[112] Differences in hunting strategies also resulted in a difference in desired prey. The snow leopard is a solitary hunter, using a stalk-and-ambush method, while the wolf is a pack hunter that runs down its prey and doesn't rely as heavily on cover. Both species, being opportunists, were found to widen their prey base depending on the lack of availability of preferred prey, including attacking unattended livestock.[113]

The Nepal study is one of the few performed thus far on the coexistence of wolves and snow leopards.[114] More research is necessary in order to better understand the complexity of the relationship of these two apex predators that share a similar prey base. Specifically, questions still exist as to whether competition for food between wolves

and snow leopards threatens either species' survival. What is known, however, is that the human-predator conflict is a threat to both species, which rely to some degree on domestic livestock for food, the wolf perhaps to a greater extent. The Himalayan Wolves Project,[115] while working in Nepal, has identified conflict mitigation strategies for the wolf are similar to those of the snow leopard. Perhaps interventions could be geared toward an inclusive approach to better ensure successful conservation of both species and the stability of the ecosystem.[116]

## Threats the Snow Leopard Species Faces

Despite its importance, the snow leopard faces many challenges. As a species with large home ranges and low population density within those ranges,[117] the big cat is already at a disadvantage, but it must also contend with a wide spectrum of threats.

### Lack of Awareness

An actual threat is posed by the lack of public awareness of the snow leopard and little to no understanding of its value to the environment. This might not seem important; however, for conservation efforts to succeed in preserving a specific species, people need to be aware of it and understand its value. Unfortunately, from local community members to people worldwide, the snow leopard is probably the least well known of all the cats in the *Panthera* genus.[118]

### Loss of Habitat

Another threat to the snow leopard is one common to most imperiled wildlife species today: habitat loss. Due to an ever-encroaching human population, with its expanding infrastructure and industry, the snow leopard must deal with a shrinking habitat.

### Disruption of the Habitat

Disruption of the habitat is also a threat. As range countries undergo rapid economic growth, major infrastructure development has started to pose real problems for the snow leopard and all wildlife species within its range. This

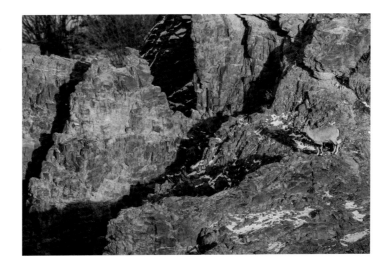

development includes new road and rail line construction; mining operations for gold, semiprecious stones, copper, and other minerals; and construction of pipelines for extracting resources such as oil and natural gas.[119] Hundreds of dams for harnessing hydroelectric power are already in existence or being planned, as are a multitude of fences and barriers along international borders.[120] If these types of projects are not carefully planned with wildlife in mind, or if they are poorly managed, the result will be the dissection and disruption of the snow leopard's range, possibly eliminating access to food and water sources and potential mates, which could result in lower genetic diversity of the species.[121]

### Reduction in Wild Prey

Snow leopards face the threat of reduction in wild prey.[122] This is due in part to the wild herbivorous prey species

131

having to compete for grazing land with the increasing size and numbers of domestic flocks. Population declines are also attributed to the hunting of wild ungulates.[123] Although these species are often hunted for meat, illegal hunting in protected areas or even poorly managed trophy hunting can result in a variety of deleterious effects on the species being hunted, the predators like the snow leopard that prey on them, and the local communities.[124] Managed trophy hunting programs currently exist in many of the range countries. However, careful planning and oversight are necessary for these programs to contribute successfully to conservation.[125] They need to involve and directly benefit the local communities and stabilize and maintain the populations of herbivorous species, thus improving the chances of survival for the snow leopard.[126]

## Poaching of Snow Leopards

Another major threat is the illegal poaching of snow leopards.[127] Since 1975, the snow leopard has been included in Appendix I of the Convention on International Trade of Endangered Species (CITES), which lists species that are threatened with extinction. This means it is illegal to trade in snow leopards or their body parts internationally.[128] All the snow leopard range countries, with the exception of Tajikistan, are parties to CITES. In addition, all twelve range countries have enacted legislation making it illegal to hunt and trade snow leopards.[129] However, enforcement of those laws is weak and inconsistent.[130] At the International Snow Leopard and Ecosystem Forum of 2017, the Bishkek Declaration, endorsed by all range

countries, acknowledged that among the risks to snow leopards, poaching and illegal trafficking were "key threats" and pledged to "strengthen" and "intensify conservation and monitoring efforts."[131] Sadly, there is strong evidence that killing and illegal sale of snow leopards continues— for their fur and skin; for body parts, including bones, claws, and teeth; and even for meat.[132]

## Secondary Killing and Feral Dogs

Secondary or "bycatch" snaring and poisoning, meant for other species such as wolves, is another unfortunate cause of snow leopard deaths.[133] A more recently recognized yet increasing cause of death is attacks by feral dogs, with whom snow leopards also compete for prey.[134]

## Disease

Snow leopards and their prey, as inhabitants of cold, dry environments, may be particularly susceptible to diseases carried by domestic and other wild animals, transmitted either through direct contact or parasitic infestations.[135] Though there is little recorded information, there have been reports of diseases in wild snow leopards such as canine distemper, feline leukemia, tuberculosis, and anthrax, among others,[136] including one lone report of rabies in the 1940s.[137]

## Military Conflict

Military conflicts within the snow leopard's range can have an indirect effect on population numbers by increasing the incidence of other threats such as poaching or loss of

prey species due to the presence of weapons and the lack of wildlife management during these times.[138]

## Climate Change

Climate change will most likely have an extreme effect on the biodiversity of our planet because of changes in habitat. This has already been noted in mountainous regions. For example, with climatic warming, the permafrost layer found beneath most of the snow leopard's range will warm. This will result in a lowering of the water table. Lush meadows will be replaced by less-productive grasslands. Springs, streams, and ponds will begin to disappear. This transformation of the landscape will result in smaller populations of the wild prey species the snow leopard depends on for food.[139] Also, as the planet warms, the tree line will advance to higher elevations, which could result in a loss of snow leopard habitat.[140] In addition, expected weather extremes could result in droughts; exceptionally heavy, early, or late snowfalls; and partial melting and freezing of snow, all which could result in high mortality of prey species.[141] Prediction models of climate change impacts on snow leopard habitat throughout its range show that in the future the size of the southern portion

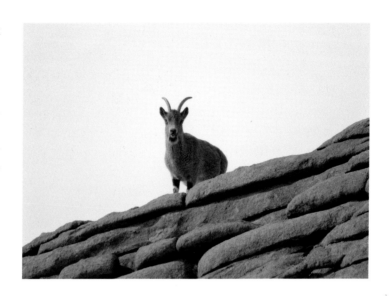

of its range will decrease, while suitable habitat in the northern portion will possibly increase. However, the models also show increased fragmentation of the entire habitat caused by the upward shift of the tree line.[142] This would have a harmful effect on the species by isolating individual snow leopards from one another, similar to the effect of infrastructure development, thereby reducing the genetic diversity that maintains the health of the species.[143]

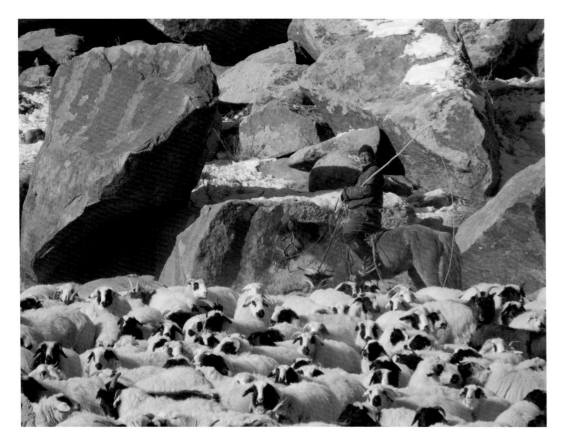

## Conflict with People

The most prevalent threat to the snow leopard is conflict with people. This conflict arises because of livestock depredation by snow leopards, which sometimes results in retaliatory killing. But why would snow leopards risk being in close proximity to humans to prey upon domestic animals? The answer lies in the ever-increasing human population.

As human communities in the region grow and expand, so do their flocks. The resultant overgrazing by large numbers of domestic animals damages the fragile mountain grasslands. Because available grazing land directly correlates with the number of wild sheep and goats that can be supported by the ecosystem, a decrease in the grasslands would likewise result in a decrease in the size of the wild herds. With wild prey less available, the snow leopard becomes more and more dependent on domestic livestock to meet its dietary needs. This is not good news for a marginalized agropastoral[144] society whose livelihood centers around its livestock. Loss from depredation can be devastating. And for the snow leopard, the situation is equally concerning.

## The Complexity of Conservation

As a mediator of the conflict between the wild animal predator and the human animal, the conservationist faces an important yet complicated challenge. While biological science has historically taken the lead, today's conservationists realize that in order to protect wild species from extinction, the focus of their efforts needs to be directed toward the local human communities. As Jim Sanderson, who directs the Small Wild Cat Conservation Foundation, says, "Work with the people to make their lives better, and they'll help us save the wildlife."[145] It's all about changing attitudes and improving livelihoods. Biological research is still a good starting point, and continued study of an imperiled species is a necessary component. But a culturally based approach, encompassing a broad spectrum of disciplines, including sociology, anthropology, religion, economics, and politics, is the key to successful conservation of a species.

## The Importance of Monitoring

The main purpose of biodiversity conservation is to ensure stable and healthy ecosystems by preserving the variety of life within them. To do this, it's necessary to gain an understanding of the different species within the ecosystem, including humans, and how they work together to maintain the ecological balance.

Conservationists study and monitor threatened predators like the snow leopard and the other species who live within their range and then interpret the data collected and use it to direct conservation measures. Specifically, they obtain information about how many snow leopards there are in given areas, how far they range, and their preferred habitat. Data is also gathered regarding preferred prey and the location, movements, and abundance of those animals. Documenting interactions with domestic livestock is of great importance, as snow leopards are at times mistakenly blamed for losses that are in fact due to depredation by wolves.[146] Since perception often outweighs reality, such instances of misplaced blame can lead to unwarranted retaliatory killings. Having accurate information is essential when attempting to alter perceptions and change attitudes toward snow leopards from negative to positive.

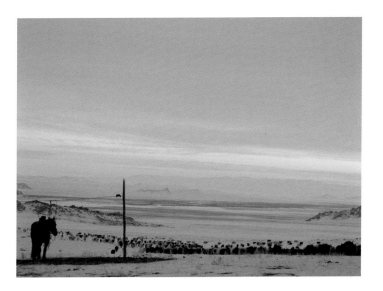

### Snow Leopard Sign

Conservationists employ a variety of monitoring methods. One method that is relatively simple, noninvasive, and doesn't require any special equipment is looking for sign, such as scrapes and spray markings, but it's not especially helpful in determining population numbers or density.

### Radio and GPS Collaring

Another monitoring method is the use of VHF radio collar or GPS collar telemetry in order to measure population density and track movements of both individual snow leopards and family groups of mothers with cubs. One study proved to be useful in monitoring the eventual disbursement of the cubs.[147] The data generated by these collars can be extensive, but there are disadvantages too.[148] First, the snow leopard isn't easy to capture and collar; doing so takes a lot of time in the field and poses safety risks to both the researcher and the cat. Also, the equipment is expensive, up to ten times the cost of other techniques, and is not always reliable. However, collars provide information on individual's movements, home range utilization, habitat preference, and interactions with other snow leopards,[149] all important aspects in understanding this species.

### Camera-Trap Technology

A noninvasive method of monitoring that has proven as equally insightful as collars is camera-trap, also known as trail camera technology. It allows for better estimates of population and density, movement and distribution of individual animals, and preference for habitat and habitat use.[150] It also gives evidence of successful breeding. However, this equipment can also be quite costly and can be damaged due to severe weather conditions or even stolen. Its use requires specific training for setup and monitoring and then someone to review the captured images, which can be a lengthy and labor-intensive process.[151] To improve efficiency and increase results in Nepal, an educational program called the Snow Leopard Scouts teaches local teenagers how to set up and maintain trail cameras. Local herdsmen who are knowledgeable about the location and movements of snow leopards instruct the students where the cameras are best placed, while local conservationists teach them how to maintain the equipment and what to look for in the images.[152] This is a win-win-win situation. The snow leopards are better monitored, the students learn about the local ecosystem and the important role the big cats play, and the community is included in the process, empowering them to be stewards of the landscape.

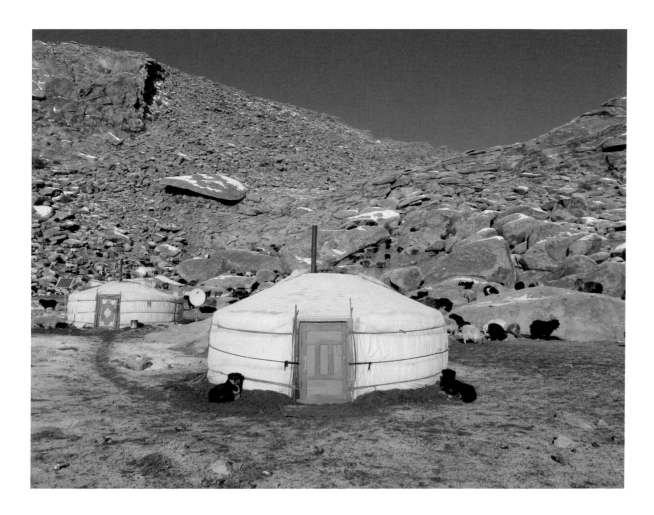

## Fecal Genotyping

Scat is often gathered at trail camera locations for genetics testing. Fecal genotyping is an easy-to-conduct field study, but testing samples requires special laboratory facilities with highly trained personnel, and results are often not immediate. Genetic material also deteriorates over time. However, the results from these studies can show the relationships of individual cats and the diversity of the population in any given area, not to mention the choice of prey and any preference of wild versus domestic animals.[153]

All these methods contribute to a better understanding of how best to help the snow leopard species thrive in their natural environment while at the same time maintaining balance with the ever-increasing human population.

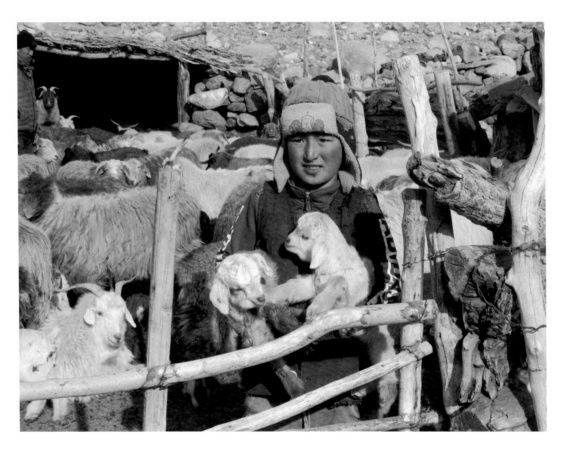

## Working with People

Although research and study provide us with a great deal of the information needed to protect species like the snow leopard effectively, today's conservationists devote the majority of their time to working with local communities. Their main objectives are to foster positive attitudes and develop a sense of responsibility, focusing on the snow leopard's cultural, spiritual, and economic value to the community as well as its importance to the ecosystem. They also look for ways to enhance livelihoods and improve quality of life for people living in close proximity to this apex predator. In this manner, they empower the local communities to become stewards of their mountain ecosystem, including the snow leopard and the other wild species that share its home.

## Improving the Economic Picture

To reduce the economic impact of depredation, conservation organizations work with the local people to establish livestock compensation and insurance programs that are managed by the community. Ecotourism programs like Himalayan homestays and photo-trekking expeditions have proven to be an excellent means of boosting local economies while at the same time changing attitudes toward the snow leopard from being seen as something detrimental to the community to an animal whose presence is beneficial.

## Education and Creating Awareness

Education is a key component of successful snow leopard conservation. In addition to providing environmental education to school-age children in the classroom, opportunities for learning are provided for the entire community through a variety of unique approaches.

One approach developed for remote communities in Mongolia is the Nomadic Nature Trunk program. These trunks are "traveling classrooms" that include a three-week curriculum of written lesson materials and hands-on activities.[154] They offer children a fun and interesting way to learn about the environment.

In Nepal, the Snow Leopard Scouts environmental camp program was created for middle school children. The goal of the program is to nurture an understanding and appreciation of the snow leopard as the apex predator of the high-mountain ecosystem and to develop the skills needed for students to create their own awareness programs as citizen scientists. During the two-week camp, the student participants explore the reasons for the human-predator conflict and work together to develop possible solutions. They are also paired with local elder herdsmen, from whom they are able to gain knowledge about snow leopards' habits and movements. The student-herder teams are then taught monitoring techniques, including how to collect scat for laboratory analysis and how to set up and maintain remote camera traps.[155] The Snow Leopard Scouts garnered media attention when they captured an image of the common leopard, *Panthera pardus*, with a trail camera positioned to record snow leopards, proving that the two species do occur within the same habitat at lower elevations.[156] Students from the program have also gone on to share messages of snow leopard conservation within their communities through art, drama, and village gatherings.[157]

The Snow Leopard Day festival is a multi-age educational activity developed in the Altai Republic of Russia. The culture and spirituality of the indigenous people of the Altai Republic is deeply connected with nature, and for them, the snow leopard is a sacred or totem animal.[158] Since the dissolution of the Soviet Union, the indigenous communities have been reviving ancient ceremonies that reaffirm "the community's spiritual connections to their sacred lands and animals."[159] Unfortunately, also since that time, poaching of snow leopards and their prey has increased.[160] So in 2010 and annually thereafter, festivals have been held with the goal of creating awareness by drawing upon the spiritual connection the people have with snow leopards.[161]

*Foxlight Electronic Light Deterrent*

## Mitigation of Conflict

Snow leopard conservationists also seek to mitigate human-predator conflict directly by implementing a wide variety of animal husbandry programs such as

- livestock veterinary assistance plans that offer vaccinations in exchange for cessation of snow leopard retaliatory killings and reduction in domestic herd sizes to increase available grazing land for wild herbivores;[162]
- creation of livestock-free rangeland to increase the wild prey population base;[163]
- introduction of improved management plans for pasture and grazing land that balance carrying capacity with herd size to reduce soil erosion and prevent desertification;[164]
- predator-proofing corrals with stronger fencing materials and roofs to limit depredation by snow leopards and wolves;[165]
- installation of solar-powered electric fencing and nighttime electronic light deterrents that intermittently flash on and off at night to scare predators away.[166]

# THE SNOW LEOPARD CONSERVANCY

The Snow Leopard Conservancy is a nonprofit conservation organization devoted entirely to the preservation of this important feline predator.

Founded by Rodney Jackson, the Snow Leopard Conservancy is actively involved with its partners in eight of the twelve snow leopard range countries, working with local communities in Bhutan, India, Kyrgyzstan, Mongolia, Nepal, Pakistan, the Altai and Buryat Republics of Russia, and Tajikistan.

The Snow Leopard Conservancy's mission is one of "advancing community-based stewardship of the snow leopard through education, research, and grassroots conservation action."[167] Their goal is "to transform snow leopards from being perceived as pests by herders into assets of more value alive than dead and to create innovative, highly participatory, self-governing, community-based conservation programs that serve as models for others, while simultaneously building in-country capacity of individuals and organizations for snow leopard conservation, research, and education."[168]

One of the Snow Leopard Conservancy's ongoing projects is the Land of the Snow Leopard Network, with the members representing the Altai Republic and Buryat Republic of Russia, Kyrgyzstan, Mongolia, and Tajikistan. The project focuses on the cultural and spiritual importance of the snow leopard to local communities.[169] The people who live in its range adhere to a broad spectrum of religious traditions and beliefs. However, most share a belief in the interconnectedness of the spiritual and the natural world, seeing nature through religion and religion through nature.[170] It follows that the snow leopard, as a top predator within the ecosystem, would be considered a spiritual guardian of the sacred mountains, in itself a sacred species. When looking for ways to save this cat from extinction, how local cultures and religions influence people's perception of animals like the snow leopard is an important aspect to consider.

# LAND OF THE
# SNOW LEOPARD NETWORK
## DARLA HILLARD

The Land of the Snow Leopard (LOSL) Network, part of a groundbreaking collaboration between western and indigenous science, has two overriding goals: reviving ancient conservation practices and creating pathways for Indigenous Cultural Practitioners (ICPs) to be coequal partners in research and planning for the conservation of snow leopards.

The catalyst for this effort is the Global Snow Leopard Ecosystem Protection Program (GSLEP), whose leaders recognize that achieving the program's objectives will require collective action, including the full participation of local communities.

The LOSL Network includes more than one hundred organizations and individuals. The founding members and network guides include shamans, sacred site guardians, and revered elders. These are referred to as Indigenous Cultural Practitioners: an ICP is defined as one who communicates with and receives support and guidance from the spirits/creator/ancestors/guardians.

Supporters of the LOSL Network include lifelong herders who know the ancient practices for reading and living in their environment; indigenous educators, historians, and traditional hunters striving to maintain or revive their cultures; program funders; and a handful of boots-on-the-ground natural scientists.

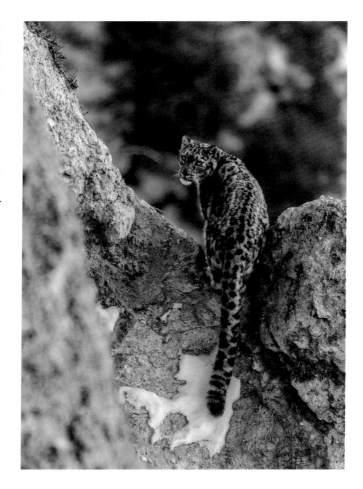

The network is striving to help the GSLEP governments understand and embrace the snow leopard's spiritual nature and fundamental place in indigenous practices, as well as to share knowledge of how to protect the species. This is the network's strength: the members' collective knowledge of the spiritual and cultural importance of these cats and the imperative to embrace this knowledge in securing landscapes for their preservation.

They are overcoming the challenges of communicating in more than five languages and working in remote, mountainous snow leopard habitat across more than 600,000 square miles of the Altai Republic, Buryatia, Kyrgyzstan, Mongolia, and Tajikistan.

The LOSL Network has created two database structures, one of which is unique to this program: a platform that enables the members to collect interviews, stories, folklore, photos, and videos. These materials are summarized, categorized, and translated into Russian and English. This structure allows them to easily share the data, identify commonalities, create reports, and develop tools for the revival/preservation of traditional practices. Before now, no one has ever attempted this kind of effort to standardize the integration of culturally important data into conservation planning and action for snow leopards. The other structure is a geospatial app for recording wildlife sightings, poaching incidents, and other data in a way that supports the goals of the GSLEP.

ICPs and other LOSL Network members are already developing tools and taking an active lead in reviving traditional practices that save snow leopards.

# EPILOGUE

The searcher never knows if or when they will see the snow leopard. Even if they are fortunate and the snow leopard is revealed to them, the encounter may be brief, perhaps for just a moment. And though understanding of the bond we share with this cat of the high mountains is as elusive as the snow leopard itself, it will remain a source of empowerment and inspiration throughout the lives of those who have been successful in their search.

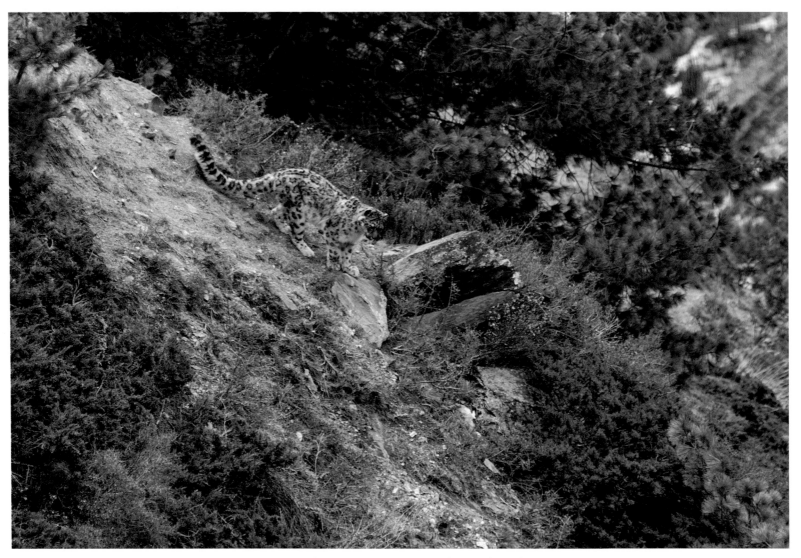

For more information about snow leopards and snow
leopard conservation, contact:
Snow Leopard Conservancy
75 Boyes Blvd., Sonoma, CA 95476
(707) 938-1700
www.snowleopardconservancy.org
Email: info@snowleopardconservancy.org

# NOTES

1   Rodney Jackson and Darla Hillard, "Tracking the Elusive Snow Leopard," *National Geographic*, June 1986.

2   Sonia Phalnikar, "Tying Conservation with Faith to Protect a Big Cat," *DW* online, September 9, 2014, https://www.dw.com/en/tying-conservation-with-faith-to-protect-a-big-cat/a-17925539.

3   George B. Schaller, foreword to *Snow Leopards. Biodiversity of the World: Conservation from Genes to Landscapes*, ed. Philip J. Nyhus, Thomas McCarthy, and David Mallon (San Diego: Academic Press, 2016), xxiii–xxvii.

4   Joseph L. Fox and Raghunandan S. Chundawat, "What Is a Snow Leopard? Behavior and Ecology," in *Snow Leopards. Biodiversity of the World*, 13–21.

5   Don Hunter, Kyle McCarthy, and Thomas McCarthy, "Snow Leopard Research: A Historical Perspective," in *Snow Leopards. Biodiversity of the World*, 345–353.

6   Ibid.

7   Hunter, McCarthy, and McCarthy, "Snow Leopard Research: A Historical Perspective," 345–353; Don Hunter, "Introduction: Giving Voice to the Snow Leopard," in *Snow Leopard: Stories from the Roof of the World*, (Boulder: University Press of Colorado, 2012), 1–11.

8   George B. Schaller, *Wildlife of the Tibetan Steppe*, (Chicago and London: University of Chicago Press, 1998).

9   George B. Schaller, "The Snow Leopard," in *Tibet Wild: A Naturalist's Journeys on the Roof of the World,* (Washington, DC: Island Press, 2012), https://play.google.com/books/reader?id=uZy7dpGII8kC&hl=en&pg=GBS.PA355.w.1.0.237.

10  Hunter, McCarthy, and McCarthy, "Snow Leopard Research: A Historical Perspective," 345–353.

11  Hunter, "Introduction: Giving Voice to the Snow Leopard," 1–11; Hunter, McCarthy, and McCarthy, "Snow Leopard Research: A Historical Perspective," 345–353.

12  "Who We Are," Snow Leopard Conservancy, accessed April 28, 2019, http://snowleopardconservancy.org/who-we-are/; "Rodney M. Jackson: Defending the Snow Leopard," Rolex.org, published in 1981, https://www.rolex.org/rolex-awards/environment/rodney-m-jackson.

13  Jackson and Hillard, "Tracking the Elusive Snow Leopard"; "Who We Are," Snow Leopard Conservancy.

14  Hunter, McCarthy, and McCarthy, "Snow Leopard Research: A Historical Perspective," 345–353.

15  George B. Schaller, foreword, xxiii–xxvii.

16  "Snow Leopard Network Links," Snow Leopard Network, accessed April 28, 2019, http://www.snowleopardnetwork.org/sln/Links.php.

17  "Who We Are," Global Snow Leopard & Ecosystem Protection Program, published 2014, http://www.globalsnowleopard.org/who-we-are/gslep-program/.

18  Rodney M. Jackson and Wendy Brewer Lama, "The Role of Mountain Communities in Snow Leopard Conservation," in *Snow Leopards. Biodiversity of the World*, 139–149.

19  Ibid.; Rodney Jackson et. al., eds., *Snow Leopard Survival Strategy*: Revised Version 2014.1 (Seattle: Snow Leopard Network, 2014), 40–48, http://www.snowleopardnetwork.org/docs/Snow_Leopard_Survival_Strategy_2014.1.pdf;.

20  Jackson et. al., *Snow Leopard Survival Strategy*, 40–48.

21  Ibid.

22  Jackson and Lama, "The Role of Mountain Communities in Snow Leopard Conservation," 139–149.

23  Ibid.

24  Ibid.; Jackson et al. 40–48.

25  Ibid.; Ibid., 67–88; Jackson and Lama, "The Role of Mountain Communities in Snow Leopard Conservation," 139–149.

26  Ibid., 139–149; Jackson et. al., *Snow Leopard Survival Strategy*, 67–88.

27  Ibid., 40–48; Ibid., 67–88.

28  Ibid., 33–39.

29  Ibid., 29–32.

30  Ibid., 67–88.

31  Ibid., 29–32.

32  Betsy G. Quammen, introduction to "Religion and Cultural Impacts on Snow Leopard Conservation," in *Snow Leopards. Biodiversity of the World*, 198–199.

33  Jon Letman, "Asia's Indigenous Voices: Defending Sacred Lands," *The Diplomat*, December 1, 2016, https://thediplomat.com/2016/12/asias-indigenous-voices-taking-a-stand-for-sacred-lands/; Quammen, introduction to "Religion and Cultural Impacts on Snow Leopard Conservation," 198–199.

34  Letman, "Asia's Indigenous Voices: Defending Sacred Lands."

35  Ibid.

36  Jackson, et. al., *Snow Leopard Survival Strategy*, 7–28; Andrew Kitchener, Carlos A. Driscoll, and Nobuyuki Yamaguchi, "What Is a Snow Leopard? Taxonomy, Morphology, and Phylogeny," in *Snow Leopards. Biodiversity of the World*, 3–11.

37  Rodney Jackson, online interview, March 2020.

38  "Young Village Chief and Snow Leopards," Snow Leopard Conservancy, June 13, 2014, http://snowleopardconservancy.org/2014/06/13/the-young-village-chief-and-snow-leopards/; Darla Hillard, et. al., eds. "Environmental Education for Snow Leopard

Conservation," in *Snow Leopards. Biodiversity of the World*, 245–255.

39   David Mallon, Richard B. Harris, and Per Wegge, "Snow Leopard Prey and Diet," in *Snow Leopards. Biodiversity of the World*, 43–55.

40   Jackson et. al., *Snow Leopard Survival Strategy*, 7–28; Joseph L. Fox and Raghunandan S. Chundawat, "What Is a Snow Leopard? Behavior and Ecology," in *Snow Leopards. Biodiversity of the World*, 13–21.

41   Mallon, Harris, and Wegge, "Snow Leopard Prey and Diet," 43–55; Tshewang R. Wangchuk and Lhendup Tharchen, "South Asia: Bhutan," in *Snow Leopards. Biodiversity of the World*, 449–456.

42   Wangchuk and Tharchen, "South Asia: Bhutan," 449–456.

43   "Eurasian Lynx," Felidae Conservation Fund, published 2013, modified 2020, http://www.felidaefund.org/?q=species-eurasian-lynx.

44   Wangchuk and Tharchen, "South Asia: Bhutan," 449–456.

45   Bikram Shrestha, et. al., "Nepal's First Pallas's Cat," IUCN/SSC The Cat Specialist Group. *CatNews. 60* (2014), https://www.researchgate.net/publication/264081386_Nepal's_first_Pallas's_cat.

46   Hunter, "Introduction: Giving Voice to the Snow Leopard,"1–11.

47   Ibid.

48   Ibid.; Shavaun Kidd, "The Snow Leopard" (educational outreach presentation for anthrozoology graduate class at Western Illinois University, Macomb, Illinois, 2019).

49   Helen Freeman, "Magic Valley," in *Snow Leopard: Stories from the Roof of the World*, 171–174.

50   "Conservation Program: Snow Leopard Sign and Marking Patterns," Snow Leopard Conservancy, 2011. http://www.snowleopardconservancy.org/text/conservation/conservation2.htm.

51   Ibid.

52   Ibid.

53   Ibid.

54   Andrew Kitchener, Carlos A. Driscoll, and Nobuyuki Yamaguchi, "What Is a Snow Leopard? Taxonomy, Morphology, and Phylogeny," 3–11; Fox and Chundawat, "What Is a Snow Leopard? Behavior and Ecology," 13–21; Jackson et. al., *Snow Leopard Survival Strategy*, 7–28.

55   Kitchener, Driscoll, and Yamaguchi, "What Is a Snow Leopard? Taxonomy, Morphology, and Phylogeny," 3–11; Fox and Chundawat, "What Is a Snow Leopard? Behavior and Ecology," 13–21.

56   Ibid., 13–21.

57   Kitchener, Driscoll, and Yamaguchi, "What Is a Snow Leopard? Taxonomy, Morphology, and Phylogeny," 3–11.

58   Ibid.

59   Ibid.

60   Ibid.

61   Ibid.

62   Ibid.; Jackson et. al., *Snow Leopard Survival Strategy*, 7–28.

63   Hunter, "Introduction: Giving Voice to the Snow Leopard," 1–11.

64 Kitchener, Driscoll, and Yamaguchi, "What Is a Snow Leopard? Taxonomy, Morphology, and Phylogeny," 3–11.

65 Kidd, "The Snow Leopard"; Hunter, introduction: "Giving Voice to the Snow Leopard," 1–11.

66 Jan E. Janecka, "Tracks of My Soul," in *Snow Leopard: Stories from the Roof of the World*, 25–31.

67 Fox and Chundawat, "What Is a Snow Leopard? Behavior and Ecology," 13–21.

68 Hunter, Introduction: "Giving Voice to the Snow Leopard," 1–11; Fox and Chundawat, "What Is a Snow Leopard? Behavior and Ecology," 13–21.

69 Hunter, Introduction: "Giving Voice to the Snow Leopard," 1–11.

70 Ibid.

71 Ibid.

72 Ibid.

73 Jackson et. al., *Snow Leopard Survival Strategy*, 7-28.

74 "Snow Leopard: Cat Facts—Behavior & Ecology," Global Snow Leopard & Ecosystem Protection Program, 2014, http://www.globalsnowleopard.org/the-snowleopard/cat-facts/behavior-ecology/.

75 Fox and Chundawat, "What Is a Snow Leopard? Behavior and Ecology," 13–21.

76 Mallon, Harris, and Wegge, "Snow Leopard Prey and Diet," 43–55; Jackson et. al., *Snow Leopard Survival Strategy,* 7–28.

77 Mallon, Harris, and Wegge, "Snow Leopard Prey and Diet," 43–55.

78 Ibid.

79 Fox and Chundawat, "What Is a Snow Leopard? Behavior and Ecology," 13–21.

80 Kitchener, Driscoll, and Yamaguchi, "What Is a Snow Leopard? Taxonomy, Morphology, and Phylogeny," 3–11.

81 Ibid.

82 Ibid.

83 Kidd, "The Snow Leopard."

84 Tom McCarthy, "Cubs," in *Snow Leopard: Stories from the Roof of the World*, 103–111.

85 Ibid.

86 Kyle McCarthy, "Epiphany," in *Snow Leopard: Stories from the Roof of the World,* 113–119; Hunter, Introduction: "Giving Voice to the Snow Leopard," 1–11.

87 Jackson, et. al., eds., *Snow Leopard Survival Strategy*, 5–6.

88 Joseph L. Fox, "Face-to-Face with Shan," in *Snow Leopard: Stories from the Roof of the World*, 21–24.

89 Ibid.

90 Katey Duffey, online interview, 2018.

91 Apela Colorado and Nargiza Ryskulova, "Shamanism in Central Asian Snow Leopard Cultures," in *Snow Leopards. Biodiversity of the World*, 205–209.

92 Ibid.

93 Irina Loginova, "The Snow Leopard in Symbolism, Heraldry, and Numismatics: The Order 'Barys' and Title 'Snow Leopard,'" in *Snow Leopards. Biodiversity of the World*, 214–217.

94  Colorado and Ryskulova, "Shamanism in Central Asian Snow Leopard Cultures," 205–209.

95  Snow Leopard Conservancy, "Western and Indigenous Science Unite," December 15, 2013, YouTube video, 14:52, https://youtu.be/B7NgwiwSh2A.

96  Loginova, "The Snow Leopard in Symbolism, Heraldry, and Numismatics: The Order 'Barys' and Title 'Snow Leopard,'" 214–217.

97  Colorado and Ryskulova, "Shamanism in Central Asian Snow Leopard Cultures," 205–209.

98  Loginova, "The Snow Leopard in Symbolism, Heraldry, and Numismatics: The Order 'Barys' and Title 'Snow Leopard,'" 214–217.

99  Ibid.

100 Darla Hillard, online interview, October 11, 2019.

101 John Mock, "Snow Leopards in Art and Legend of the Pamir," in *Snow Leopards. Biodiversity of the World*, 210–213.

102 Ibid.

103 Ibid.

104 Ibid.

105 WISN/Snow Leopard Conservancy, "Spirit of the Snow Leopards," March 17, 2015, YouTube video, 21:31, https://youtu.be/BAVkxvA9h6E.

106 Kidd, "The Snow Leopard."

107 Ibid.

108 "What Is the Third Pole?" Thethirdpole.net. Understanding Asia's Water Crisis, accessed April 28, 2019, https://www.thethirdpole.net/en/about/; "The Earth Has a Third Pole—And Millions of People Use Its Water." World Wildlife Fund, June 4, 2015, https:// www.worldwildlife.org/stories/the-earth-has-a-third-pole-and-millions-of-people-use-its-water.

109 Ibid.

110 Madhu Chetri, Morten Odden, and Per Wegge, "Snow Leopard and Himalayan Wolf: Food Habits and Prey Selection in the Central Himalayas, Nepal," *Plos One,* February 8, 2017, https://doi.org/10.1371/journal.pone.0170549.

111 Ibid.

112 Ibid.

113 Ibid.

114 Ibid.

115 Himalayan Wolves Project, accessed February 2020, http://www.himalayanwolvesproject.org/.

116 Geraldine Werhahn, "Himalayan Wolf Discovered to be a Unique Wolf Adapted to Harsh High-Altitude Life," Department of Zoology. University of Oxford (February 20, 2020). https://www.zoo.ox.ac.uk/article/himalayan-wolf-discovered-be-unique-wolf-adapted-harsh-high-altitude-life; Himalayan Wolves Project, accessed February 2020, http://www.himalayanwolvesproject.org/.

117 "Threats to Snow Leopard Survival," Snow Leopard Conservancy, accessed April 28, 2019, http://snowleopardconservancy.org/threats-to-snow-leopard-survival/.

118 Jackson, et. al., eds., *Snow Leopard Survival Strategy*, 29–32.

119 Ibid., 62–66.

120 Ibid.

121 Ibid.

122 Ibid., 33–39; Ibid., 104–112.

123 Ibid., 33–39.

124 Ibid., 104–112.

125 Ibid.

126 Ibid.

127 "Threats to Snow Leopard Survival"; Jackson, et. al., eds., *Snow Leopard Survival Strategy*, 49–56.

128 "CITES Appendices," CITES. Convention on International Trade in Endangered Species of Wild Fauna and Flora, accessed April 28, 2019, https://www.cites.org/eng/app/index.php.

129 Aishwarya Maheshwari and Stephanie von Meibom, "Monitoring Illegal Trade in Snow Leopards," in *Snow Leopards. Biodiversity of the World*, 77–84.

130 Ibid.

131 "Bishkek Declaration 2017: Caring For Snow Leopards and Mountains—Our Ecological Future," Global Snow Leopard & Ecosystem Protection Program, accessed April 28, 2019, http://www.globalsnowleopard.org/blog/2017/08/28/the-bishkek-declaration-2017-caring-for-snow-leopards-and-mountains-our-ecological-future/.

132 Maheshwari and von Meibom, "Monitoring Illegal Trade in Snow Leopards," 77–84.

133 Jackson et. al., *Snow Leopard Survival Strategy*, 29–32.

134 Ibid.

135 Stéphane Ostrowski and Martin Gilbert, "Diseases of Free-Ranging Snow Leopards and Primary Prey Species," in *Snow Leopards. Biodiversity of the World*, 97–112.

136 Ibid.

137 Ibid.

138 Jackson et. al., *Snow Leopard Survival Strategy*, 29–32.

139 John D. Farrington and Juan Li, "Climate Change Impacts on Snow Leopard Range," in *Snow Leopards. Biodiversity of the World*, 85–95.

140 Ibid.

141 Ibid.

142 Ibid.

143 Ibid.

144 Rodney M. Jackson and Wendy Brewer Lama, "The Role of Mountain Communities in Snow Leopard Conservation," 139–149.

145 Wildlife Conservation Network, "WCN Fall Expo 2019: Small Wild Cat," November 16, 2019, YouTube video, 17:34, https://youtu.be/2ue4H0Tw_mg.

146 Jackson et. al., *Snow Leopard Survival Strategy*, 40–48.

147 Orjan Johansson, Anthony Simms, and Thomas McCarthy, "From VHF to Satellite GPS Collars: Advancements in Snow Leopard Telemetry," in *Snow Leopards. Biodiversity of the World*, 355–365.

148 Kidd, "The Snow Leopard."

149 Ibid.

150 Ibid.

151 Ibid.

152 Ibid.

153 Ibid.

154 Darla Hillard, et. al., eds., "Environmental Education for Snow Leopard Conservation," 245–255.

155 Ibid.

156  Ibid.

157  Ibid.

158  Ibid.

159  Ibid.

160  Ibid.

161  Ibid.

162  Jackson et. al., *Snow Leopard Survival Strategy,* 67–88.

163  Ibid., 33–39.

164  Ibid.

165  Ibid., 40–48; Ibid., 67–88.

166  Kidd, "The Snow Leopard."

167  "About Us," Snow Leopard Conservancy, 2019, https://archive2019.snowleopardconservancy.org/about-us/.

168  Ibid.

169  "Land of the Snow Leopard Network," Snow Leopard Conservancy, 2019, https://snowleopardconservancy.org/land-of-the-snow-leopard/.

170  Quammen, introduction to "Religion and Cultural Impacts on Snow Leopard Conservation, 198–199.

# BIBLIOGRAPHY

"About Us." Snow Leopard Conservancy. 2019. https://archive2019.snowleopardconservancy.org/about-us/.

"Bishkek Declaration 2017: Caring for Snow Leopards and Mountains—Our Ecological Future." Global Snow Leopard & Ecosystem Protection Program. Accessed April 28, 2019. http://www.globalsnowleopard.org/blog/2017/08/28/the-bishkek-declaration-2017-caring-for-snow-leopards-and-mountains-our-ecological-future/.

Chetri, Madhu, Morten Odden, and Per Wegge. "Snow Leopard and Himalayan Wolf: Food Habits and Prey Selection in the Central Himalayas, Nepal." *Plos One.* February 8, 2017. https://doi.org/10.1371/journal.pone.0170549.

"CITES Appendices." CITES. Convention on International Trade in Endangered Species of Wild Fauna and Flora. Accessed April 28, 2019. https://www.cites.org/eng/app/index.php.

Colorado, Apela and Nargiza Ryskulova. "Shamanism in Central Asian Snow Leopard Cultures." In *Snow Leopards. Biodiversity of the World: Conservation from Genes to Landscapes,* edited by Philip J. Nyhus, Thomas McCarthy, and David Mallon, 205–209. San Diego: Academic Press, 2016.

"Conservation Program: Snow Leopard Sign and Marking Patterns." Snow Leopard Conservancy. 2011. http://www.snowleopardconservancy.org/text/conservation/conservation2.htm.

"The Earth Has a Third Pole—And Millions of People Use Its Water." World Wildlife Fund. June 4, 2015. https://www.worldwildlife.org/stories/the-earth-has-a-third-pole-and-millions-of-people-use-its-water.

"Eurasian Lynx." Felidae Conservation Fund. Published 2013, modified 2020. http://www.felidaefund.org/?q=species-eurasian-lynx.

Farrington, John D. and Juan Li. "Climate Change Impacts on Snow Leopard Range." In *Snow Leopards. Biodiversity of the World: Conservation from Genes to Landscapes,* edited by Philip J. Nyhus, Thomas McCarthy, and David Mallon, 85–95. San Diego: Academic Press, 2016.

Fox, Joseph L. "Face-to-Face with Shan." In *Snow Leopard: Stories from the Roof of the World*, edited by Don Hunter, 21–24. Boulder: University Press of Colorado, 2012.

Fox, Joseph L. and Raghunandan S. Chundawat. "What Is a Snow Leopard? Behavior and Ecology." In *Snow Leopards. Biodiversity of the World: Conservation from Genes to*

*Landscapes,* edited by Philip J. Nyhus, Thomas McCarthy, and David Mallon, 13–21. San Diego: Academic Press, 2016.

Freeman, Helen. "Magic Valley." In *Snow Leopard: Stories from the Roof of the World,* edited by Don Hunter, 171–174. Boulder: University Press of Colorado, 2012.

Hillard, Darla, Mike Weddle, Sujatha Padmanabhan, Som Ale, Tungalagtuya Khuukhenduu, and Chagat Almashev. "Environmental Education for Snow Leopard Conservation." In *Snow Leopards. Biodiversity of the World: Conservation from Genes to Landscapes,* edited by Philip J. Nyhus, Thomas McCarthy, and David Mallon, 245–255. San Diego: Academic Press, 2016.

Himalayan Wolves Project. Accessed February 2020. http://www.himalayanwolvesproject.org/.

Hunter, Don. "Introduction: Giving Voice to the Snow Leopard." In *Snow Leopard: Stories from the Roof of the World,* 1–11. Boulder: University Press of Colorado, 2012.

Hunter Don, Kyle McCarthy, and Thomas McCarthy. "Snow Leopard Research: A Historical Perspective." In *Snow Leopards. Biodiversity of the World: Conservation from Genes to Landscapes,* edited by Philip J. Nyhus, Thomas McCarthy, and David Mallon, 345–353. San Diego: Academic Press, 2016.

Jackson, Rodney and Darla Hillard. "Tracking the Elusive Snow Leopard." *National Geographic.* June 1986.

Jackson, Rodney, David Mallon, Charudutt Mishra, Sibylle Noras, Rishi Sharma, and Kulbhushansingh Suryawanshi, eds. *Snow Leopard Survival Strategy: Revised Version 2014.1.* Seattle: Snow Leopard Network, 2014. http://www.snowleopardnetwork.org/docs/Snow_Leopard_Survival_Strategy_2014.1.pdf.

Jackson, Rodney M. and Wendy Brewer Lama. "The Role of Mountain Communities in Snow Leopard Conservation." In *Snow Leopards. Biodiversity of the World: Conservation from Genes to Landscapes,* edited by Philip J. Nyhus, Thomas McCarthy, and David Mallon, 139–149. San Diego: Academic Press, 2016.

Janecka, Jan E. "Tracks of My Soul." In *Snow Leopard: Stories from the Roof of the World,* edited by Don Hunter, 25–31. Boulder: University Press of Colorado, 2012.

Johansson, Orjan, Anthony Simms, and Thomas McCarthy. "From VHF to Satellite GPS Collars: Advancements in Snow Leopard Telemetry." In *Snow Leopards. Biodiversity of the World: Conservation from Genes to Landscapes,* edited by Philip J. Nyhus, Thomas McCarthy, and David Mallon, 355–365. San Diego: Academic Press, 2016.

Kidd, Shavaun. "The Snow Leopard" Educational outreach presentation for anthrozoology graduate class at Western Illinois University, Macomb, Illinois. April 2019.

Kitchener, Andrew, Carlos A. Driscoll, and Nobuyuki Yamaguchi. "What Is a Snow Leopard? Taxonomy, Morphology, and Phylogeny." In *Snow Leopards. Biodiversity of the World: Conservation from Genes to Landscapes,* edited by Philip J. Nyhus, Thomas McCarthy, and David Mallon, 3–11. San Diego: Academic Press, 2016.

"Land of the Snow Leopard Network" Snow Leopard Conservancy. 2019. https://snowleopardconservancy.org/land-of-the-snow-leopard/

Letman, Jon. "Asia's Indigenous Voices: Defending Sacred Lands." *The Diplomat.* December, 1, 2016. https://thediplomat.com/2016/12/asias-indigenous-voices-taking-a-stand-for-sacred-lands/.

Loginova, Irina. "The Snow Leopard in Symbolism, Heraldry, and Numismatics: The Order 'Barys' and Title 'Snow Leopard'." In *Snow Leopards. Biodiversity of the World: Conservation from Genes to Landscapes,* edited by Philip J. Nyhus, Thomas McCarthy, and David Mallon, 214–217. San Diego: Academic Press, 2016.

Mallon, David, Richard B. Harris, and Per Wegge. "Snow Leopard Prey and Diet." In *Snow Leopards. Biodiversity of the World: Conservation from Genes to Landscapes,* edited by Philip J. Nyhus, Thomas McCarthy, and David Mallon, 43–55. San Diego: Academic Press, 2016.

Maheshwari, Aishwarya and Stephanie von Meibom. "Monitoring Illegal Trade in Snow Leopards (2003–2012)." In *Snow Leopards. Biodiversity of the World: Conservation from Genes to Landscapes,* edited by Philip J. Nyhus, Thomas McCarthy, and David Mallon, 77–84. San Diego: Academic Press, 2016.

McCarthy, Kyle. "Epiphany." In *Snow Leopard: Stories from the Roof of the World,* edited by Don Hunter, 113–119. Boulder: University Press of Colorado, 2012.

McCarthy, Tom. "Cubs." In *Snow Leopard: Stories From The Roof Of The World,* edited by Don Hunter, 103–111. Boulder: University Press of Colorado, 2012.

Mock, John. "Snow Leopards in Art and Legend of the Pamir." In *Snow Leopards. Biodiversity of the World: Conservation from Genes to Landscapes,* edited by Philip J. Nyhus, Thomas McCarthy, and David Mallon, 210–213. San Diego, CA: Academic Press, 2016.

Ostrowski, Stéphane and Martin Gilbert. "Diseases of Free-Ranging Snow Leopards and Primary Prey Species." In *Snow Leopards. Biodiversity of the World: Conservation from Genes to Landscapes,* edited by Philip J. Nyhus, Thomas McCarthy, and David Mallon, 97–112. San Diego, CA: Academic Press, 2016.

Phalnikar, Sonya. "Tying conservation with faith to protect a big cat." *DW* online. September 16, 2014. https://www.dw.com/en/tying-conservation-with-faith-to-protect-a-big-cat/a-17925539.

Quammen, Betsy G. Introduction to "Religion and Cultural Impacts on Snow Leopard Conservation." In *Snow Leopards. Biodiversity of the World: Conservation from Genes to Landscapes,* edited by Philip J. Nyhus, Thomas McCarthy, and David Mallon, 198–199. San Diego, CA: Academic Press, 2016.

"Rodney M. Jackson. Defending the Snow Leopard." Rolex.org. Published in 1981. https://www.rolex.org/rolex-awards/environment/rodney-m-jackson.

Schaller, George B. Foreword to *Snow leopards. Biodiversity of the World: Conservation from Genes to Landscapes,* edited by Philip J. Nyhus, Thomas McCarthy, and David Mallon, xxiii–xxvii. San Diego: Academic Press, 2016.

Schaller, George B. "The Snow Leopard" In *Tibet Wild: A Naturalist's Journeys on the Roof of the World,* 350–381. Washington, DC: Island Press, 2012. https://play.google.com/books/reader?id=uZy7dpGII8kC&pg=GBS.PA325.

———. *Wildlife of the Tibetan Steppe*. Chicago and London: University of Chicago Press, 1998.

Shrestha, Bikram, Som Ale, Rodney Jackson, Neeru Thapa, Lal Prasad Gurung, Sudip Adhikari, Lalit Dangol, Binod Basnet, Naresh Subedi, and Maheshwar Dhakala. "Nepal's First Pallas's Cat." IUCN/SSC The Cat Specialist Group. *CatNews.60* (2014). https://www.researchgate.net/publication/264081386_Nepal's_first_Pallas's_cat.

"Snow Leopard: Cat Facts—Behavior & Ecology." *Global Snow Leopard & Ecosystem Protection Program*. 2014. http://www.globalsnowleopard.org/the-snowleopard/cat-facts/behavior-ecology/.

Snow Leopard Conservancy. "Western and Indigenous Science Unite." December 15, 2013. YouTube video, 14:52. https://youtu.be/B7NgwiwSh2A.

"Snow Leopard Network Links." Snow Leopard Network. Accessed April 28, 2019. http://www.snowleopardnetwork.org/sln/Links.php.

"Threats to Snow Leopard Survival." Snow Leopard Conservancy. Accessed April 28, 2019. http://snowleopardconservancy.org/threats-to-snow-leopard-survival/.

Wangchuk, Tshewang R. and Lhendup Tharchen. "South Asia: Bhutan." In *Snow Leopards. Biodiversity of the World: Conservation from Genes to Landscapes,* edited by Philip J. Nyhus, Thomas McCarthy, and David Mallon, 449–456. San Diego, CA: Academic Press, 2016.

Werhahn, Geraldine. "Himalayan Wolf Discovered to Be a Unique Wolf Adapted to Harsh High-altitude Life." Department of Zoology, University of Oxford. February 20, 2020. https://www.zoo.ox.ac.uk/article/himalayan-wolf-discovered-be-unique-wolf-adapted-harsh-high-altitude-life?fbclid=IwAR2wvnbgElTE_pkhFitweA9gGW1cz5dB0cPrCOhYNuJihJhqLXAa5Z8yzko.

"What Is the Third Pole?" Thethirdpole.net. Understanding Asia's Water Crisis. Accessed April 28, 2019. https://www.thethirdpole.net/en/about/.

"Who We Are." Global Snow Leopard & Ecosystem Protection Program. Published 2014. http://www.globalsnowleopard.org/who-we-are/gslep-program/.

"Who We Are." Snow Leopard Conservancy. Accessed April 28, 2019. http://snowleopardconservancy.org/who-we-are/.

Wildlife Conservation Network. "WCN Fall Expo 2019: Small Wild Cat." November 16, 2019. YouTube video, 17:34. https://youtu.be/2ue4H0Tw_mg.

WISN/Snow Leopard Conservancy. "Spirit of the Snow Leopards." March 17, 2015. YouTube video, 21:31. https://youtu.be/BAVkxvA9h6E.

"Young Village Chief and Snow Leopards." Snow Leopard Conservancy. June 13, 2014. http://snowleopardconservancy.org/2014/06/13/the-young-village-chief-and-snow-leopards/.

# ABOUT THE CONTRIBUTORS

**Shavaun Kidd** is the outreach conservation educator for the Snow Leopard Conservancy and speaks to a variety of audiences about the snow leopard and the conservation of this iconic species. She also serves as social media manager, maintaining the Conservancy's presence on a variety of platforms. Shavaun is responsible for the online newsletter and maintains the Conservancy's website. In addition, she handles online fundraising sales. Shavaun joined the Conservancy team as an education intern while completing her masters of liberal arts and sciences, which was centered around a post-baccalaureate certificate program in zoo and aquarium studies, with the focus on conservation education and anthrozoology. While at Western Illinois University, she conducted anthrozoological research examining the adoption of animal companions. As an intern, Shavaun developed a multi-age snow leopard conservation education program, including educational activities appropriate for school-age children.

Shavaun has an enduring passion for wildlife—in particular, the big cats. She was a zoo docent for seventeen years and was the program developer and coordinator/advisor of a junior zookeeper program at a local zoo for eight of those years. She also spent one summer at the Nashville Zoo as an instructor in their summer camp program. Shavaun owned and operated a pet supply and gift shop and was a medical and radiation oncology transcriptionist and editor for more than twenty years. She continues to serve periodically as a guest science teacher at the intermediate and high school grade levels and has been a guest lecturer at Western Illinois University.

**Björn Persson** is an internationally renowned artist based in Stockholm, Sweden. He has spent many years traveling around the world in search of adventure and spectacular images. His passion for this planet's beautiful wildlife and humans is reflected in his images. Björn looks upon his work as an art form rather than pure nature and documentary photography. He sees the animals as they truly are: emotional, thinking, and conscious beings with different personalities. He tries to portray their souls and translate their

wisdom with his camera as his paintbrush. Instead of creating despair about their threatened situation, he wants to give people the urge and inspiration to get involved.

Apart from fine art photography, Björn is committed to documenting and raising awareness of the situation of threatened species. His passion for wildlife was born when he trained in field care and worked with anti-poaching projects in South Africa, where he discovered the critical state of the wildlife. Since then, Björn has used his camera as a weapon against wildlife poaching and is a sponsor of wildlife conservation. See his work at http://bjornpersson.nu/.

**Rodney Jackson,** director of the Snow Leopard Conservancy, is widely considered the leading world expert on the snow leopard, having devoted more than forty years to researching and conserving this elusive cat in South and Central Asia. Upon receiving the 1981 Rolex Award for Enterprise, Jackson launched a pioneering radio-tracking study of snow leopards in the Nepalese Himalayas. The four-year study resulted in a cover story in *National Geographic* in June 1986. He has been a finalist for the Indianapolis Prize in 2008, 2010, 2012, 2016, and 2018 and was the first person to be nominated three times consecutively. The prestigious Indianapolis Prize, awarded biennially from six finalists, is the world's largest individual monetary award for animal conservation. He has trained biologists across many of the snow leopard's twelve range countries, although his real passion is for helping local people coexist with this elusive predator. His and Darla Hillard's work with rural communities led to the establishment of the Snow Leopard Conservancy in 2000 and the development of grassroots interventions, including predator-proofed corrals, Himalayan homestays, and a suite of other economic incentives to transform the snow leopard from a pest to a valuable asset in the eyes of local people.

**Oriol Alamany** is a photographer from Barcelona, Spain. An enthusiast of nature, photography, and film since childhood, he studied biology and graphic design. In the 1980s, Alamany combined working as a naturalist, specializing in mountain fauna, with graphic design, cinema, and photography. He finally established himself as a professional photographer, having published in magazines such as *National Geographic* Spain, *BBC Wildlife*, *Terre Sauvage*, *Geo*, *Lonely Planet*, etc. He also has written and illustrated several books.

Mountains and felines are two of his favorite subjects. He tells the Conservancy, "I have done photographic works on the Pyrenees, particularly about its scarce brown bear population, the Alps, the mountains of Ethiopia, the Andes, the Rocky Mountains, the Atlas, and the Himalayas. I was a member of the managing board of Aigüestortes i Sant Maurici National Park in the Pyrenees as a representative of conservationist NGOs." He is a member of the European nature photographers collective Nature Photo Blog. See his work at https://www.alamany.com/en/.

**Kathryn (Katey) Duffey** is a zoologist living in Canton, Ohio, with an interest in human carnivore coexistence and One Health. She served in the US Army National Guard for six years, including a year in Iraq and relief for Hurricanes Gustav and Ike. Growing up with a passion for studying carnivores in remote environments, Katey knew she wanted to enter the field of wildlife conservation as a career. After returning from Iraq, Katey received a bachelor's degree in zoo and wildlife biology from Malone University in Ohio, where she worked with more than seventy species of reptiles. She has also worked with both captive and wild wolves.

Katey first became involved in snow leopard research while pursuing a master's degree in zoology at Miami University. As a final project to support her master plan for mitigating human-wildlife conflict, she joined an opportunity with the Mongolian Academy of Sciences and Irbis Mongolia to survey for snow leopards in western Mongolia and study snow leopard–herder interactions. Since earning her degree, she has continued her independent research, working with local organizations in the snow leopard range.

Katey has supplemented her past training in wilderness medicine by becoming certified as a Medicine in Remote Areas (MIRA) and First Response Emergency Care (FREC) emergency first responder in remote and hostile environments, in the hope of using her growing skills in wilderness medicine to help other field researchers learn how to prevent and handle different situations that come with the risks of working in austere environments. She currently freelances as a field medic with Taffs TV, an expedition and TV support company that helps support future conservation projects.

https://kateyduffey.wordpress.com/

**Tashi R. Ghale** is a true mountain man and Himalayan wildlife photographer. Mountains and snow leopards are two of his favorite subjects, as he was profoundly influenced by the natural splendor of his childhood home in the Annapurna region of Manang, Nepal, where he now runs a trekker lodge, Hotel Mountain Lake, and takes photographs of people, mountains, and wildlife.

Ghale monitors snow leopards as a citizen scientist for Third Pole Conservancy and has captured multiple live images of the snow leopard. He was the first to document camera-trap evidence of Pallas's cats in Manang, Nepal, and he captured the first photographs in four decades of the endangered Himalayan wolves in the Manang Valley. Now considered a local authority on camera-trap technology, he installs and maintains camera traps that monitor a variety of species in several different locations of the high-altitude rocky terrain in Manang. Ghale was the recipient of the 2016 Abraham Conservation Individual Award, which is administered by the World Wildlife Fund-Nepal, in recognition of his outstanding contribution to conservation of nature and sustainable development in Nepal. He was also selected as a 2018 Disney Conservation Hero, receiving the award for his dedication to conservation of snow leopards and their habitat in his community. See his work at https://tashirghale.com/home.html.

**Jak Wonderly** is an outdoor commercial and editorial photographer from Sonoma County, California. He worked as an animal photographer for National Geographic Society books and *National Geographic Kids* magazine, creating images of jellyfish, giraffes, snakes, bears, and many other species. His photographs have appeared in numerous publications, including *National Geographic*, *Sunset*, the *Los Angeles Times*, *Alaska Beyond Magazine*, and *Ranger Rick*, as well as on CNN. He is represented by National Geographic Image Collection.

Jak uses his photography to help raise awareness and funds for select conservation organizations, including the Nature Conservancy, Natural Resources Defense Council, and Wild Wonders of China. He is passionate about large cats in particular, and his expedition for the Snow Leopard Conservancy to find and photograph snow leopards in the Himalayas was his most challenging and adventurous project yet.

Jak is often seen working with vintage Rolleiflex film cameras, even with wild animals in remote locations, as a way to bring more mindfulness into his photography. "Photography is an opportunity to be present, see the world as beautifully as I can, and share that vision with others. This is not just a job; it's a life purpose."

When not traveling, Jak spends every Sunday with his young daughter, volunteering at his local wildlife rescue. See his work at http://www.jakwonderly.com/.

**Darla Hillard** serves as the Snow Leopard Conservancy's facilitator for the Land of the Snow Leopard (LOSL) Network. Her role includes fundraising for LOSL, organizing annual gatherings, and overseeing, monitoring, and reporting on education initiatives developed by LOSL members.

Darla was fundraiser and logistical organizer for Dr. Jackson's original Nepal radio-tracking study, bringing more than a decade of administrative experience to the role. She cowrote the June 1986 National Geographic article, followed by the book, *Vanishing Tracks: Four Years Among the Snow Leopards of Nepal*.

Darla has written for *Travelers' Tales: San Francisco* and *Bay Nature* magazine and was the lead author for the "Environmental Education for Snow Leopard Conservation" chapter in *Snow Leopards*, published in 2016 to launch the Elsevier Press series Biodiversity of the World: Conservation from Genes to Landscapes.

**Eulàlia Vicens**, a veteran traveler and meticulous organizer from Barcelona, Spain, has extensive experience in the organization of trips specifically oriented to photography and nature watching. She works with photographer Oriol Alamany and is the author of several books and articles about hiking in nature, including *Parques nacionales de España* and *Itinerarios por los Pirineos*. She has been the director of the section on walking routes in *Altaïr* and *Peninsula* magazines.

**Susan Leibik** is a visual artist and writer living in Vancouver, Canada. Her work is inspired by mountain travel and the lives of animals and birds.

164

# PHOTOGRAPHIC CREDITS

The images found within the pages of *Searching for the Snow Leopard* appear as the researcher and photographers first viewed them through the lens of their cameras. All were taken manually, without the use of trail cameras or drone technology, and other than minor cropping remain unenhanced to maintain their authenticity and best portray the experience of seeing a snow leopard in the wild.

Oriol Alamany: Front cover, *ii*, *viii–ix*, *xviii*, 7, 8, 11, 14, 15, 16, 25 (bottom left), 28, 30, 31, 32, 33, 42, 43, 44, 45, 46, 63, 78, 80, 81, 82, 83, 84/84, 85, 104, 106, 107, 108, 109, 110, 111, 142, 160, 166

Karen Czekalski: 160

Katey Duffey: 9, 19/19/19, 22, 23, 24, 25 (top right), 25 (bottom right), 26, 27, 34, 35, 37/37, 39, 130, 133, 134, 135, 137, 138, 140, 161

Tashi R. Ghale: *x*, 40, 41, 48, 49, 50, 51, 52, 53, 54, 55, 56, 57, 58/58, 59, 60, 61/61, 62, 86, 102, 128, 143, 146, 161, back cover

Darla Hillard: 162

Rodney Jackson: 160 (see Karen Czekalski)

Shavaun Kidd: 159

Susan Leibik: 163

Björn Persson: *xiv*, *xxi*, 17, 18, 20, 21, 29, 38, 47, 64, 65, 66, 67, 68, 69, 70, 71, 72, 73, 74, 75, 76, 77, 79, 87, 88, 89, 90, 91/91, 92/92, 93, 94, 95, 96, 97, 98, 101, 103, 127, 145, 159, 164, 168

Snow Leopard Conservancy: 10, 141

Eulàlia Vicens: 163

Jak Wonderly: *vi–vii*, 3, 5, 12, 13/13, 36, 112, 113, 114, 115, 117, 118, 119, 121, 122, 123, 124, 125, 126, 131, 144, 162

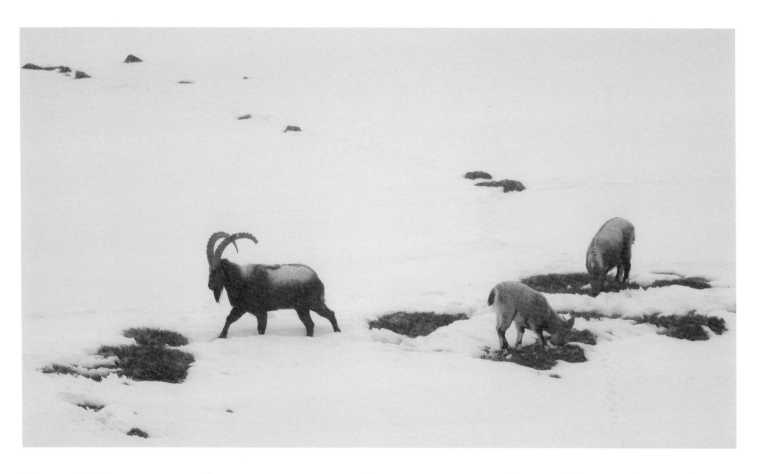

We would like to recognize the various companies and individuals who sponsored the contributing photographers.

BJÖRN PERSSON
Expedition sponsor, Wild World India. https://www.wildworldindia.com/

ORIOL ALAMANY
FotoTecnica Import, Spain, for Benro tripods and a G-Technology SSD drive. https://www.fototecnica.com.
The Heat Company, Austria, who provided winter gloves and chemical warmers. https://www.theheatcompany.com.

DiseFoto, Spain, who provided camera batteries. https://www.disefoto.es.

JAK WONDERLY
Rodney Jackson and Darla Hillard for their wisdom and insights on planning an expedition to not only locate a snow leopard but get close enough for photography.
Jigmet Dadul of the Snow Leopard Conservancy India Trust, who provided superb on-the-ground logistics and support in Ladakh.
Susan Janin, for her generous sponsorship and tireless wildlife conservation efforts.

# ILLUSTRATION CREDIT

Susan Leibik: 1

Shan
(Ladakhi for "snow leopard")

Artist Susan Leibik traveled to Ladakh, India, in search of the snow leopard, which was a transformative experience for her. She was able to capture the snow leopard both visually in her charcoal drawing and through the written word.

*Some eighty feet away on a flat throne of rock, the snow leopard sat. Stepping up to the scope, I peered through as if to another dimension. That face, the hidden spirit of the mountains themselves revealed. The snow leopard was sitting atop her kill, the carcass of a blue sheep. The long fur of her pelt gleamed and changed in the light. It was spotted with dark rosettes along her flank and down her extraordinary long and lush tail. The tawny buff-gold of her coat was luminous, seeming to generate its own rare light. Her face, all the sensory graces of her converging there; the soft tufts of fur on her inner ears, the unique patterns of spots and ink-dark calligraphed curves of marks above her eyes; the broad nose; whiskered muzzle; dark-lipped mouth. Her huge forepaws were resting in front of her, instruments of agility and athleticism. They grip rocks, float through deep snow, and lead her leaps in pursuit of prey. Her eyes were green amber, like some rare and unusual gem. Looking through the scope, she seemed to be staring straight back, full on. Her gaze overturned me. I could not take my eyes away from her mesmerizing presence. We all watched, transfixed, as she rose. The long fur of her pelt gleamed and changed in the light. Suddenly, she was in motion, moving up the rocks in a supple fluid flow. This lightness of form came from honed strength, a synchronous arc and tension of muscle and mind. Reading the terrain by sight and feel, she was in perfect duet with the earth itself.*

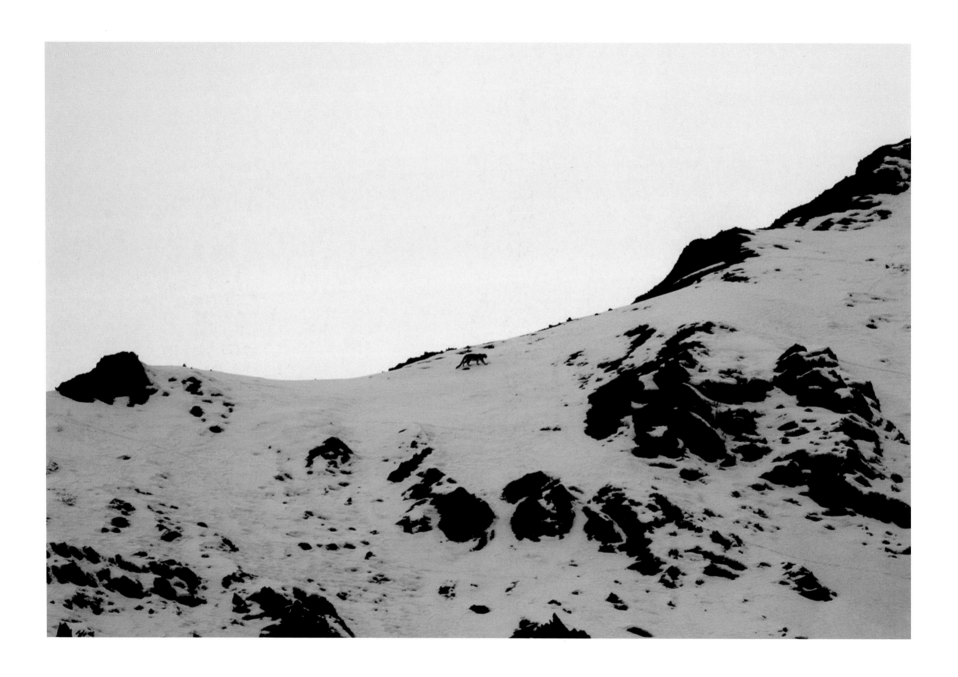